TO THE SEA BY TRAIN

TO THE SEA
BY TRAIN

THE GOLDEN AGE OF RAILWAY TRAVEL

ANDREW MARTIN

Profile Books

First published in Great Britain in 2025 by
Profile Books Ltd
29 Cloth Fair
London
ECIA 7JQ
www.profilebooks.com

1 3 5 7 9 10 8 6 4 2

Typeset in Dante by MacGuru Ltd
Printed and bound in Great Britain by
CPI Group (UK) Ltd, Croydon CRO 4YY

Our product safety representative in the EU is Authorised
Rep Compliance Ltd., Ground Floor, 71 Lower Baggot Street,
Dublin, D02 P593, Ireland. www.arccompliance.com

ISBN 978 1 80522 155 5
eISBN 978 1 80522 156 2

CONTENTS

A NOTE ON HISTORY AND TERMINOLOGY

Pre- and Post-Grouping Companies

Until the Railway Grouping of 1923, there were about 120 railway companies in the United Kingdom, a relatively sensible number compared to 1846, when there'd been 272. The multiplicity of companies caused confusion both by their separateness and by their entanglement. A 'Correspondent' wrote to the *Railway Magazine* of October 1906 to say that he'd seen, near Basingstoke on the London & South Western Railway main line, a train drawn by an LSWR engine and consisting of, as he put it:

1. South Western Railway's carriage
2. North Eastern Railway's horse box
3. Great Northern Railway's carriage
4. Great Eastern Railway's horse box
5. Great Western Railway's horse box
6. Great Central Railway's carriage

He added, 'I should think it is quite an unusual thing for six different railways to be represented in a train of only six vehicles, and I thought it would interest *Railway Magazine* readers.'

A number of pre-Grouping companies are mentioned in this book, including some very obscure ones, which tend to be mentioned only once, because their reward for having reached the seaside was to be swallowed up by the bigger pre-Grouping companies, such as the North Eastern Railway, the Great Northern Railway and the Great Western Railway.

In 1923 this multiplicity of companies was distilled down to four – 'The Big Four', the *Railway Magazine* called them – and these were:

The London Midland & Scottish Railway (LMS)
The London & North Eastern Railway (LNER)
The Southern Railway (SR)
The Great Western Railway (GWR)

It will be seen that one name signifies both a pre- and a post-Grouping company: the Great Western, and indeed there is a GWR today. I read a post on a railway forum in which the writer said that when he mentioned the Great Western he meant 'the real one'. Whether by this he meant the pre- or post-Grouping company I wasn't sure, but I was confident he didn't mean the modern-day one. John Betjeman called the Grouping 'dismal' for its rationalism, but the Big Four have come to embody railway romance. Since they were in competition with each other, and with the motor car, they waged PR campaigns in which they glamourised themselves, and the period of the Grouping coincided with the golden age of the seaside railway poster. The names of the Big Four haunt the modern railway, so besides the GWR we have brands called 'Southern' and 'London Northwestern Railway', and an operator called 'London North Eastern Railway', the names of which complicate any internet search for their more illustrious predecessors.

Nationalisation

The railways were nationalised in 1947; British Railways came into being in 1948. From 1965 the organisation traded as British Rail, for much the same reason that Anthony Wedgwood Benn became Tony Benn – to sound more democratic and modern. In that same year, a 'corporate identity' was rolled out, in emulation of London Transport. A new sans serif typeface, Rail Alphabet, was introduced as BR's equivalent to the Johnston Sans of LT, and the double arrow logo became BR's equivalent of the roundel, displacing the 'cycling lion' (a lion straddling a locomotive wheel). The double arrow survives in many places, including on railway tickets and road signs showing the direction to the station in sleepy seaside towns.

BR was subdivided into regions, mirroring the territories of the Big Four.

Beeching

Dr Beeching used to be the second most infamous doctor after Crippen, but his notoriety seems to have faded, hence his inclusion here. He was chairman of BR from 1961 to 1965. His report of 1963, *The Reshaping of British Railways*, proposed not so much a reshaping as a reduction of the network by about a third. Most of his proposed cuts were implemented over the rest of the decade.

Privatisation

I have been mentioning modern-day private operators. I had better give the date when the railways were privatised: 1997. In 2024, however, the Labour Government partly renationalised the system.

Steam Locomotives

Steam locomotives are either tank engines or tender engines. A tank engine is a single unit, carrying its coal in a bunker and its water in tanks, and, being small engines, they are picturesquely associated with the smaller holiday resorts, like Hayling Island or Southwold. Bigger steam engines carry their coal and water in a trailer or tender. They are all members of 'classes', for example the King class of the GWR, associated with one of the most famous seaside trains, the *Cornish Riviera Express*.

Steam locomotives are also described by their wheel formations. Some wheel formations have names, and the only one we will be bothering about is 'Pacific' (denoting 4-6-2).

Units

Most modern trains are not hauled by a locomotive. They consist of units, which is to say that the power is distributed along the length of the train. There are diesel multiple units (DMUs) and electric multiple units (EMUs), and bi-modes capable of running on electrified and non-electrified lines. Units normally come in clusters or 'families', and are then subdivided by numbers indicating different iterations of the same basic vehicle. The numbers of the antiquated Sprinter family of DMUs, for example, run from 150 to 159. Readers can rest assured that I will be largely ignoring these numbers.

DMUs, being smaller and cheaper than loco-hauled trains, often ran on the fading seaside lines. Today units carry no such stigma. Even our main-line trains are units, albeit with streamlined front ends that do appear locomotive-like.

SPECIAL TRAINS AND SPECIAL DAYS

Blackpool, July 2023, mid-afternoon. Heavy rain falls, the light's already gone from the day, but on Albert Street, Blackpool's old ally, electricity, is doing its best to compensate. The facades of the tall Victorian guest houses are illuminated, as are some of the modest come-ons: 'Open All Year', 'Lift to All Floors', 'Full Central Heating'. Through a propped open front door you might see, glowing in the darkness of a hall, a small red neon sign denoting a cubbyhole by the stairs and reading 'RECEPTION'. Albert Street is at right angles to the front, and at its seaward end the word 'Casino' is illuminated by gold-coloured bulbs, blurred by the rain. This is not *the* Casino of Blackpool. *The* Casino is not actually a casino but an elegant Deco lounge, opened in 1939 at the Pleasure Beach funfair at the south end of town as a reception space for LMS excursionists. The Casino viewable from Albert Road is part of the sprawling Coral Island amusement arcade, the one room where you can gamble face to face with a human being – the croupier – as opposed to a machine. Coral Island can be counted a pleasure zone of sorts, but it cannot generate the excitement of what was there before.

It stands on the site once occupied by the head-building – ticket hall and concourse – of Blackpool Central station,

Anyone determined to strike a positive note about
the demolition of Blackpool Central station could
argue that the site is still given over to pleasure.

which closed on 1 November 1964, on the last, rainy night
of the Illuminations. The next day Blackpool Central was
still there, but there weren't any trains – only cars, already
parked on the platforms, so it was as if the killer had moved
into the house of the victim. For a while the head-building
was used as a bingo hall. The hands of the station clock on
its facade were removed and replaced with the number '90'
– 'blind ninety', the top number in bingo. The piecemeal
demolition of Central was completed in 1973, when the site
became an even bigger car park – the biggest car and coach
park in Europe, according to the Blackpool railway historian

Barry McLoughlin.[1] In a retrospective piece of 23 October 2023 the online magazine *Live Blackpool* contended that the closure 'tore the heart out of Blackpool and was possibly the worse decision ever made by Blackpool Council'.

What do they mean by 'heart'?

In the 1890s Blackpool was receiving 2 million visitors a year, the majority arriving at Central station, which had opened as Hounds Hill in 1863. *Live Blackpool* repeats the oft-made assertion that in 1911 Blackpool Central was the busiest station in the world. It had fourteen platforms (the same as Paddington at the time), half of them excursion platforms, and it was the intensity of summer use that was remarkable. Numbers for Central tend to be tangled up with those for Blackpool's other big station, Blackpool North, and it is generally hard to differentiate between the stations, each of which might receive trains from anywhere in Britain. On Saturday 13 August 1910, 200 ordinary and special trains ran into North and Central, bringing 92,000 visitors.[2] In photographs taken in the early twentieth century you can't see the Central platforms for people, just as you can't see the beach over the road for people. Blackpool made a habit of publicising these 'crush photos', the logic being that even more people might want to come to Blackpool when they saw how busy it was. (An Edwardian cartoon has a Central station porter calling down to a beach attendant, 'Yer'll 'ave to move 'em all up a bit, Stanley, 'ere's another train in.')

There were 36 licensed photographers on Blackpool foreshore in 1895 (alongside 62 sellers of fruit, 47 of sweets, 57 of toys and jewellery, 52 of ice-cream, 21 of oysters and prawns), but most people arriving at Central would not need a picture to remember the experience.[3] Their visit to Blackpool was a special occasion, and many of them had arrived on 'special', or excursion, trains that were not listed in the

normal timetables, but advertised on leaflets or posters. Some of the specials brought textile workers from northern towns in their 'Wakes Weeks', which arose out of religious festivals, and crystallised as weeks or fortnights – Saturday to Saturday – when the mills closed for maintenance, allowing an entire town (a few misfits and the men checking over the mill machinery aside) to decamp to the seaside. So the memorability of the event was increased by the fact that it was communal.

The train might have been hauled by a big, black L7 class loco of the Lancashire & Yorkshire Railway, commonly known as 'High-Flyers' on account of their high-set boilers, which made them seem to gallop. Bottles of beer would have been opened soon after departure, which might account for the joyful screaming as the train went through tunnels, the sticking of heads out of the window, despite the risk of a fly slamming into your eye or your hat being whisked away, the on-board canoodling – more serious on the journey back, perhaps, after love matches had been formed (and on nocturnal returns, the lightbulbs might be removed from compartments for this purpose). The rattliness of the train – excursion rakes often comprising superannuated carriages held in reserve for most of the year – might have been erotically stimulating to some; it would certainly have increased the sense of speed and drama, the speed of a heartbeat; and emerging from Central station almost directly in front of the sea, would have done the same.

I am old enough and Northern enough (born in York) to have taken a train to Blackpool for a week's holiday. Our family had a succession of cars, but never very good ones, and the seaside was largely beyond their range. Besides, my father worked for British Rail, so we had free train travel, a perk slightly

overshadowed by the unfashionability of trains at the time, and I'd have traded it in for the Ford Capri in our driveway. We might as well get the stats out of the way. Between 1951 and 1972 the proportion of holidaymakers travelling by car rose from 27 to 70 per cent, or from 53 to 85 per cent if coaches and buses are included in road transport. Over the same period, the railways' share declined from 47 to 12 per cent.[4]

My father was involved in 'costings' in the British Rail Eastern Region's headquarters in York, and his task, in that twilit industry, was not to increase costs but to reduce them, which he resented having to do, and which I resented on his behalf. I became sentimentally attached to BR, which seemed then – and still seems in retrospect – a competent and socially useful organisation, not least because it took people to the seaside.

Reading timetables, I expected to see sand in the page gutter, and the destinations that looked most pleasing on the page were the seaside towns. They were the first ones you noticed, since they were the termini, a happy ending: Cleethorpes or Bridlington for Sheffield and environs; Scarborough for Leeds; Skegness and Great Yarmouth for Nottingham and Leicester, and so on.

On *Rail UK Forums*, a contributor styling himself '30mog' wrote:

> Many my age love trains because they were the saviour of families who didn't have cars in the 1970s … Bank holiday Monday 9 a.m. was rush hour at Sheffield. Specials to Cleethorpes, Skegness and Blackpool in quick succession. I would say that 90 per cent of the time my family travelled by train was an excursion – with bargain basement tickets.

The best-known BR excursions were 'Merrymakers', a brand created in 1971, perhaps as a counterweight to the less merry continuous coal trains serving power stations under the name 'Merry-go-Round'. In the next ten years, almost half a million people were carried on Merrymakers, usually to seaside destinations. But BR excursions had many names, the most straightforwardly joyous being the Western Region's Bucket and Spade Specials of 1964, with a free bucket and spade for every child.

Some seaside expresses, like the *Atlantic Coast Express* or the *Cornish Riviera Express*, ran regularly and were in the timetable; others were intermittent enough to be identified as 'specials'. Within living memory, for instance, were the Intercity Holidaymakers, long-distance trains that joined the dots between unlikely places: Nottingham and Paignton; Manchester and Eastbourne. Specials were conjured out of a much baggier railway than today, with great reserves of spare rolling stock. As Simon Bradley notes, 'In 1959 BR had 6,000 carriages that made no more than ten to eighteen return journeys a year.'[5]

In its *Encyclopaedia of Titled Trains*, the *Railway Magazine* brings its forensic microscope to the question of which seaside trains were specials and which were not. The case of the *Eastern Belle*, they state, is 'an odd one'. It was launched in 1929 as a service from London Liverpool Street to a different resort each day, the destinations including Felixstowe, Aldeburgh, Frinton, Yarmouth, Cromer, Hunstanton and Skegness. But on Sundays it *always* went to Clacton, and this working featured in the timetables owing to its steadiness. (Clacton, incidentally, was the *Eastern Belle's* most popular destination because it was the nearest to Liverpool Street, so you'd have a longer time in Clacton than the other places – and a *much* longer time than in Skegness.)

But would it matter very much if you ended up in Frinton when you'd been expecting Yarmouth? It was all the seaside. In the 1970s people would say, 'We're off to the seaside next week,' and leave it at that, just as they might say, 'We're off out to tea.' I am reminded of a series of LNER posters created in 1931 by Tom Purvis: in rich, Mediterranean colours they depicted activities – picnicking, swimming, boating and so on – in generic seaside places under the title 'East Coast Joys', the one constant being the intense blueness of the sea – and the sea was the point, not the places or the people, who lacked facial features. The nearest thing to a ticket to the sea *per se* might have been the BR Holiday Runabout tickets: unlimited travel for a week in 'Holiday Areas', whether 'Cornish Riviera', 'Glorious Devon' or 'Smiling Somerset'. But to travel by BR to the seaside in the 1970s was to be conscious of having missed out on something more momentous. The trains tended to be small, oil-smelling DMUs; the posters in the stations seemed to be directing people elsewhere. In 1978 BR came out with 'Sleep Your Way to Europe', and in 1980, 'Do the Continental'.

The golden age of the British seaside had only recently passed. It was in the 1950s, when the effects of the Holidays with Pay Act 1938 were finally being felt, having been delayed by the war. As a milestone, the Act is comparable to the Bank Holiday Act of 1871 and the founding, in 1842, of the Early Closing Association, which lobbied for Saturday to be a half-day holiday, although it wasn't until the 1930s that the full weekend off became the norm.

Even in the 1950s there was a golden-ness still about railway posters. In 1956 a man encumbered by golf bag, binoculars and fishing rod is nonetheless so elated that he leapfrogs a radiant deckchair above the words, 'Herne Bay on the Kent Coast'. The image is by Bromfield (a one-name

artist), and it reminds me that Herne Bay is now known as 'Hernia Bay', on account of its ageing population. Also in the mid-1950s, a beachball on a bucket has a smiling face in an image by Tom Eckersley. Below is the word 'Bridlington'. (Bridlington inspired some excellent railway posters, perhaps because the artists felt strongly motivated to help it escape the shadow of Scarborough.) In 1960 an image of a cartoon-ish man in a swimming costume who obviously can't believe his luck holds hand with a mermaid above 'Porthcawl Has Everything' – the creation of Reginald Montague Lander. Lorna Frost writes that the 'informality' of railway posters in the 1950s and 1960s reflected the growing informality of the seaside itself, that 'the image of the upper-class spa town had finally gone.'[6]

The art of the seaside railway poster added perhaps even more to the gaiety of the nation than the trains themselves, whether harmonising with a summer's day or glimpsed out of season, a little tattered on a station wall. In *The Fortnight in September*, R. C. Sherriff's novel of 1931 about the Stevens family's annual holiday in Bognor, young Ernie Stevens excitedly indicates a poster advertising Bognor on a wall at Dulwich station, where their journey begins. It reads 'BOGNOR REGIS – FOR HEALTH AND SUNSHINE', and shows 'a smiling girl upon a beautiful yellow foreshore'. 'It ought to look like that this afternoon,' muses Ernie's older brother, Dick.

The railway poster came into focus after the Grouping, a product of competition for holiday traffic between the Big Four, and between them and the growing numbers of cars, charabancs and coaches, hence the GWR slogan of the 1934, later taken up by the other three, 'It's Quicker by Rail'. See for instance the LNER poster of about 1935, by Tom Purvis: 'Cleethorpes: It's Quicker by Rail', showing a cloche-hatted

mother and cherubic child pressed up against the window of a shadowy train compartment. In contrast to the shadow, the view from the window is the yellow glare of the awaiting beach. But more often the people in the posters were already on the beach. The LNER 'Quicker by Rail' series was notably erotic: blondes are shown being chatted up by caddish-looking men on sea walls at Bridlington, Whitley Bay and Scarborough, although the Scarborough man, to do him credit, carries a walking stick, implying wartime heroics.

The LNER produced the dreamiest seaside images: the strangely anonymous, sun-dazed figures of Tom Purvis, while Dame Laura Knight offered thin, balletic women playing ball games on some Yorkshire beach, under a slightly overcast sky, for once. Not all the posters emanated from a railway company. In *Happy Holidays* Michael Palin suggests that a poster featuring the legend, 'Guernsey: The Sunshine Island', must have been generated by the Guernsey tourist authority, given its even-handed approach to trains: 'Services via Weymouth or Southampton by Great Western or Southern Railways'. The poster, incidentally, shows another chat-up scene: the couple on a headland, looking down on a tranquil bay, the man, according to Palin, 'chiefly remarkable for the enormity of his trousers'.[7] (These being Oxford bags.)

In their posters and publicity, railway operators made weather boasts about their regions, and there was something endearing about this mild hucksterism. In 1907 the GWR launched what Michael Palin called 'one of history's longest and most dubious slogans': 'There is a great similarity between Cornwall and Italy in shape, climate and natural beauties,' hence the *Cornish Riviera Express*.[8] The Great North of Scotland Railway promoted Moray Firth as 'the Scottish Riviera', while the Furness Railway called Grange-over-Sands 'the Naples of the North!', the exclamation mark

presumably acknowledging that they knew they were being a bit silly. Still more tenuous, the Cheshire Lines Committee's brochures said of Southport that if 'a shower should happen to fall, the porous nature of the soil ensures that it should not have a permanent effect upon the health and spirits.'

An article by Alistair F. Nisbet in *Backtrack* magazine of May 2024 describes a 'riot' that occurred on Easter Monday 1952, when a beautiful, sunny morning in Southport turned into an afternoon of torrential rain. Excursionists who'd arrived from Lancashire cotton towns on twenty-five 'specials' gave up on their day out and crammed into Southport's Chapel Street station demanding immediate return to their home towns; the staff were overwhelmed and locked the station doors, causing greater unrest among those locked out, who, clad in skimpy summer clothes, not only could not get home but also lacked the shelter of the station roof. Southport generally seemed a hard sell. The Lancashire & Yorkshire Railway tried 'Come to Southport for mild winters!', a slogan Palin calls 'suicidally inoffensive'.[9]

The most robust weather claims were made by the Southern Railway. In 1930, it launched Sunny South Sam, a smiling railway guard who looked not so much suntanned as sunburned, and who appeared in various publicity guises, sometimes presenting Met Office sunshine indices. In an advert from his debut year, Sam holds up a sort of scroll showing the top 19 sunniest resorts. At number 1 is Ventnor, on the Isle of Wight; Brighton is at number 10. All 19 are in Southern territory except the Isles of Scilly, at 6, and Lowestoft at 13, and these are not underlined, which all the others are. Presumably number 20 was also outside the Southern's area, hence the awkwardness of a 'top 19'.

Southern sunniness was also promoted in a poster of 1936, in which a small, cherubic boy holding a commensurately

small suitcase is addressed by the crewman of an engine from what seems a very high footplate, over the slogan, written in childish handwriting: 'I'm taking an early holiday cos I know summer comes soonest in the south.' The child was Ronald Witt, and he had been photographed speaking to the fireman (a Mr Woolf) of a King Arthur Class locomotive, the *Red Knight* (which was green, like most Southern passenger locos), by Charles A. Brown at Waterloo. When John Elliot, head of Public Relations at the Southern, saw the photo he realised, 'We must go all out with it as a poster.'[10] Ronald Witt was not actually bound for the seaside, but for Southampton, from where his family would be emigrating to California.

The LNER took on the Southern's weather boasting with the not very convincing 'The Drier Side of Britain', sometimes used on posters featuring sunny East Coast scenes, with a threatening shadow, like thick black smoke, encroaching from the left. In a way, the railways got what they deserved. If you go about comparing Cornwall to the Riviera, you ought not to be surprised when people investigate the actual Riviera, which Freddie Laker would allow them to do when in 1966 his charter airline Laker Airways opened for business.

John Hassall's 'Jolly Fisherman' poster ('Skegness is SO Bracing') was commissioned to advertise an excursion from King's Cross to Skegness on Good Friday 1908. The excursionists would have had an afternoon in Skegness. A slightly later GNR poster, also by Hassall, advertised Sunday and Thursday excursions giving '5½ Hours At Skegness'. Note the half-hour. Every minute was important, but perhaps every minute was also slower, given the intensity of the experience. When Charlie Chaplin recalled a visit to Southend in 1903, when he was six, he described it as a 'holiday' even

though it lasted *only* a day. Back then, the seaside was more differentiated from the rest of the country: not only did it have the sea, and a much cleaner sky than one's home town, but it was also stranger, a place where clocks were 'floral', golf was 'crazy'; castles were made of sand; piers offered a walk to nowhere, and chairs (deckchairs) were designed for lying down on.

The British seaside is not so exotic today. In 1972 John Betjeman made two short TV travelogues, both called *Thank God It's Sunday*. In one of them he travelled to Southend from Fenchurch Street station. The film was repeated on TV in 1995, with an introduction by Alan Bennett, who said, 'In 1972, England wasn't curling at the edges in quite the same way it is today, the seaside still cocky and cheeky rather than seedy and run-down.' That curling at the edges has been investigated with increasing anxiety ever since, and a very thorough and readable account of it is given in *The Seaside, England's Love Affair*, by Madeleine Bunting. Here is the key sentence from her prologue:

> For over two decades, seaside resorts have been found to have the worst levels of deprivation in the country, while a raft of shocking indicators – from poor health, shortened lives, drug addiction, high debt, low educational achievement to low income – demonstrate the blighted communities which cluster along English coastlines.[11]

Today the seaside railway terminus is more likely to be seen as 'the end of the line' in a baleful metaphorical sense rather than some joyful culmination. A certain percentage of people travel to Blackpool, Scarborough or Penzance with no firm intention of returning, but just because they can't go any further. Or because they know the rents are cheap;

or because they had a nice holiday in happier times. This book reflects the decline to some extent, and readers are duly warned that most of the journeys I undertook were aboard runtish units terminating at stations with rusty tracks, a car park lying adjacent (signifying former sidings) and a megastore or some other inappropriate thing where station buildings once stood. On my walks to the front I sometimes encountered street drinkers, charity shops, semi-derelict buildings, but I don't offer only the past as a corrective to such melancholic scenes, and the magic hasn't entirely disappeared. Sometimes the sun swinging out from behind a cloud is enough to bring it back.

THE TRAINS GO TO THE SEA

Transcending Coal

'Holiday Memory', Dylan Thomas's long poem of 1954, recollects seaside holidays in Mumbles, to which the young Thomas was taken on 'the trams that hissed like ganders'. It begins:

> August Bank Holiday. A tune on an ice-cream cornet.
> A slap of sea and a tickle of sand. A fanfare of sunshades
> opening. A wince and whinny of bathers dancing
> into deceptive water. A tuck of dresses. A rolling of
> trousers. A compromise of paddlers …

Thomas is too preoccupied with childhood delights to bother about railway arcana, but the Swansea & Mumbles Railway, which closed in 1960, had a claim to be the first railway in Britain to carry fare-paying passengers on seaside excursions, although, strictly speaking, it was a horse-drawn tram when it started doing so in 1807, running exhilaratingly along the coast of South Wales from Swansea to Mumbles via Oystermouth. The Swansea & Mumbles became a true railway in 1877, when steam locomotives were introduced, but then it became a tram again, albeit an electric one with enormous double-decker tramcars, in 1929.

The Swansea & Mumbles, which began operations the year before laying on those excursions, was built to carry coal, iron ore and limestone, and coal played a role in the three intertwined causes of the British seaside holiday: a change of attitude towards the sea; the connection of railways to the coast; the growth of leisure time and paid holidays. Coal was important to the first and third causes because it caused the pollution to which the coast was an antidote, and to the second in that the commonest early motive for running rails to the sea was to export coal.

It is hard to believe the purpose of the Swansea & Mumbles was ever anything other than to skirt Swansea Bay on a golden summer's day. Thomas's poem is about happiness. The children on the beach are 'moving jewels, who might never be happy again', and the happiness of the beach gives way to, and is possibly even exceeded by that of, the funfair, as it comes into its own after dark when the naphtha jets are lit. The railway played a big role in facilitating the pleasure: yes, the vigorous children and younger adults of Swansea could have walked the six miles around the bay to Mumbles beach and pier, but not the very young or old. They could have taken the bus, of course, and they would have to after 1960, when the railway closed. But would the buses have been as much fun as the tall, double-decked, red-and-cream trams that hissed like ganders? After closure, one of the tramcars was acquired by the Middleton Railway, one of the earliest heritage lines. But it was little used, and much vandalised. It did not belong on that inner-city line; it's easy to imagine it anthropomorphised and pining for the sea.

★

The Kilmarnock & Troon Railway, commissioned by the Duke of Portland to carry coal from his collieries at Kilmarnock to his docks at Troon, opened in 1811 and is considered the first public railway in Scotland. It was converted for locomotive operation in 1837, and it had carried passengers from the start, at first in two open carriages with straw on the floor, then in custom-built carriages named *Caledonia* and *The Boat*. The K&T (swallowed up by the Glasgow & South Western Railway in 1899) made Troon a fashionable destination. The passenger cars were 'very busy in the summer evenings and on holidays carrying to the "saut watter" and back the Kilmarnock weavers, who were in fact the first seaside trippers'.[1]

Troon has two stations: outlying Barassie, then Troon. As I approached the former one sunny afternoon, on the Desiro electric unit from Glasgow, it seemed as if the whole world had taken up golf and quickly become good at it. On the golf courses to both sides of the line I observed a series of elegant swings, followed by confident marches along the fairways. There are about thirty courses around Troon, roughly half of them links – that is, by the sea, if we can so call the Firth of Clyde. Sitting across the aisle from me was a young man, with a small golf bag, a practice set, perhaps. He didn't look at any of the passing games, suggesting a confidence in his own ability, an impression reinforced by the fact that he was reading *The Collected Poems of Louis MacNeice*.

The current Troon station dates from 1892, or rather 2021, when it was rebuilt following a disastrous fire on a very hot July day, so it was as if the conflagration – of mysterious origin – were caused by the sun itself. This is why the station looks pristine, with a spacious and airy waiting room, and paintings of local scenes proudly displayed. On the road outside, a busy signpost indicates 'Town Centre', 'South

Beach', 'Royal Troon Golf Club', 'Municipal Golf Courses'. The station was quiet on my arrival, but tens of thousands of extra passengers use it when the Open Championship is held at Royal Troon. Cyril Reid, a schoolboy in the 1930s, recalls 'the letting folk' descending on Troon in droves, mostly arriving by train, courtesy of the LMS:

> I remember well, as a young boy, going up with my brother to the station with our 'bogies' to earn some money transporting luggage for the holiday makers. The going rate was one penny per load. My brother will never forget the time he piled cases on his 'bogie', collected his penny, and then was told the destination was Collenan – a good two miles away.[2]

I headed towards the front beneath a high, clean sky, nicely offset by the pink sandstone of the Troon houses, some of the larger ones built for Glasgow coal merchants. Many were also once guest houses. There is a pleasing spaciousness about Troon: wide streets, handsome detached houses beneath a big sky, besmirched fairly regularly, it must be admitted, by planes approaching Glasgow Prestwick Airport. It seems logical that in 1938 the LMS carried nearly 400,000 people to the Ayrshire coast on cheap-ticket 'evening breather' trains, mainly from Glasgow.[3]

The South Beach commands a view of an enigmatic triangular lump out to sea. A man sitting on a bench overlooking the sandy beach, with eyes serenely closed and face uplifted towards the sun, told me, without opening his eyes or altering the angle of his face, 'That's the Ailsa Craig, where the stone for curling comes from.' Adjacent to the South Beach until the 1980s was an Art Deco open-air swimming pool. In the 1930s this hosted a beauty pageant, 'Archie McCulloch's

The Art Deco pool at Troon, where Archie
McCulloch searched for a 'holiday queen'.

quest for a holiday queen'. Photographs from the 1930s show
as many people spectating as swimming – eyeing up the
talent, in other words. Today a 'Dementia-Friendly Garden'
occupies the site.[4]

On the front, I climbed a grassy hummock called the
Ballast Bank, which, being made of spoil from the Duke of
Portland's excavation of the harbour, symbolically connects
Troon's coal exporting days and its evolution as a resort.
Troon is a highly respectable place; it is no surprise that
arson was quickly ruled out as the cause of the station fire.
The drinks being sipped on the benches looking out to sea
from the Ballast Bank were always Irn Bru or tea from flasks,
never super-strength lager. From the top of the Bank it's pos-
sible to see the harbour, which is cleaner than in the coal
days, timber exporting being the main activity. The adjacent
marina, full of expensive-looking craft, gave Troon a Med-
iterranean aspect on this fine late afternoon.

From the train back to Glasgow it seemed the lineside golfers were moving faster than before, taking less time to savour their shots. Well, the sun was beginning to set over the courses; the many rounds underway must all be finished while the light lasted.

The Canterbury & Whitstable Railway opened in 1830, mainly to convey coal brought by lighters arriving at Whitstable from Northumberland. So here was the new world reaching out to the old, given that George and Robert Stephenson built the line's first locomotive, *Invicta*; that Thomas Telford built the harbour where the line terminated, and Isambard Kingdom Brunel inspected the line's tunnel at Canterbury, the first in the world through which passengers were transported.

The C&W also carried passengers, and its nickname, the Crab & Winkle, implies seaside merrymaking. One myth about the line was that the Canterbury end featured the tunnel because it would be an entertaining novelty for passengers. In an article for the November 1930 edition of the *Railway and Locomotive Historical Society Bulletin*, the Reverend Reginald B. Fellows chides two 'writers of repute', C. E. R. Sherrington and W. J. Gordon, for perpetuating this fantasy in railway books. Noting that it also appeared in *The Big Book of Railways* – 'a charming book for very small children published by Oxford University Press' – Fellows writes, 'in the guise of a nursery story it is, I think, at its best.'

The Canterbury & Whitstable was acquired by the South Eastern Railway in 1853. In 1931 it stopped carrying passengers, and it closed entirely in 1952. It is now a cycle track. The C&W terminated at Whitstable Harbour, a worthy target, having always been the heart of the town, whose beaches stretch away on either side. Today the harbour – once a

mass of sidings – still bustles, albeit with boats and people (usually eating in restaurants), not trains. Among the survivals of the railway is a pair of handsome mid-blue gates inscribed SE&CR, the name of the outfit resulting from the South Eastern having formed a partnership with the London Chatham & Dover Railway in 1899. A Canterbury historian, Mike Page, mentions that 'an unsightly works for processing gravel for motorway maintenance' stands at the Whitstable Harbour end of the line. 'That and the fact that the line is marked at the Canterbury end by a bus station', he continues, 'is surely rubbing salt into Whitstable's wound.'[5]

The name 'Crab & Winkle' ignores the crustacean for which Whitstable was famous – the oyster – and was dictated by the initial letters of the two termini. There were at least two later 'Crab and Winkles', both in Essex. One of them will be dealt with in the section on Beeching closures. The other is the Kelvedon & Tollesbury Light Railway, which from 1904 connected Kelvedon on the Great Eastern Main Line to the coastal village of Tollesbury at the mouth of the river Blackwater, and eventually to Tollesbury Pier beyond the village, where the promoters of the line hoped to establish an elegant yachting marina and resort. But the prosperous, blazered mariners failed to materialise, and the fading of the line was signified by the gradual disintegration of the old railway carriages used as shelters at the stations. The pier extension closed in 1921, and the pier began to rot. The entire line closed to passengers on Saturday, 5 May 1951, prompting the local MP, the maverick Tom Driberg, to make a rare constituency appearance in order to ride the footplate as honorary fireman. The locomotive's bunker bore the ominous legend, scrawled in chalk, 'There may be many a poor soul have to walk.' The remains of the pier were demolished in that year, and if anything *remained* of the remains,

the great East Coast flood of 1953 erased them. The line closed to goods in 1962.

If anyone did walk from Kelvedon to Tollesbury, it would be across eight miles of ghostly salt marsh.

The main coal exporting area was South Wales, and Cardiff Docks station was a true railway magnet, served by half a dozen railways. It was in fact over-subscribed, and a supplementary coal dock was opened at nearby Barry, where Barry Island would develop as a raucous working-class resort. It was at Barry Island on a rainy day that the young Billy Butlin conceived the idea of something jollier: his particular brand of holiday camp.

As coal exports from Barry declined, some railway sidings remained. They became a death row for steam locomotives condemned by BR to be scrapped in the wake of the commitment to diesel in the 1955 Modernisation Plan. So engines that had taken happy tourists to the sea were themselves towed there by smug diesels that would be returning inland, whereas the steam engines were supposed to be on a one-way trip. It didn't work out like that: of the 297 engines taken to Barry, 213 survived, partly owing to the commercial nous of the owner of what had become Barry scrapyard. Dai Woodham prioritised the scrapping of the wagons over locomotives – a quicker and cheaper job. Woodham was also sympathetic towards the growing number of rail fans who wanted to buy the engines and run them (sometimes at the seaside) on Britain's preserved railways, most of which could never have existed were it not for the Barry hiatus.

Other dock towns that became dedicated to both work and play include Great Yarmouth, Lowestoft and Silloth.

The Lure of the Sea

The main seaside connections were made in the 1840s. Victoria to Brighton, 1841; York to Scarborough, 1845; Poulton to Blackpool, 1846. Southport, Eastbourne and Torquay were also reached in that decade. By 1914 nearly 200 coastal towns and villages were served by the railway and, as Stuart Hylton writes, 'By the 1920s holiday traffic was a major part of the railways' business.'[6]

Trains were not themselves sentimentalised or romanticised in those pivotal 1840s. It was the time of the stressful 'Railway Mania' investment bubble, together with the usual dozen or so serious railway accidents that characterised the mid-nineteenth-century decades. The picturesque conjunction of trains and the seaside was a long way off. Trains were a means to an end, not really part of the experience. Passengers were conveyed to the seaside in perfunctory compartments, sitting facing each other, as in stagecoaches, or they travelled in open carriages, just as some stagecoach passengers sat on the roof. The trains might as well have been strings of stagecoaches with an engine at the front instead of a horse. Most passengers did not carry luggage on their outings, since they were usually only going for the day, so there were no attractive luggage labels. If they did stay overnight, it would probably be at an inn. Hotels in the modern sense arose a couple of decades later, direct products of the railways. Insofar as posters advertised these services, they showed lists of destinations and fares, rather than seaside scenes.

Railways would not become romantic until they ceased epitomising modernity, until they attracted sympathy rather than awe. Ian Carter finds an early indication of this of this in 'Cuckoo Valley Railway', a short story of 1893 by the Cornish folklorist Arthur Quiller-Couch, in which a railway line is depicted as fading back into the landscape:

We climbed on board, gave a loud whistle and jolted off. Far down, on our right, the river shone between the trees, and these trees, encroaching on the track, almost joined their branches above us. Ahead, the moss that grew upon the sleepers gave the line the appearance of a green glade ...

'Quaintness', Carter writes, 'replaced puissance. Whimsy supplanted power.'[7] Many bucolic railway evocations followed, including Edith Nesbit's novel of 1906, *The Railway Children* (in which the children actually play on the tracks), Edward Thomas's poem 'Adlestrop' and much of the writing of John Betjeman, for whom the friendliest trains went all the way to the coast.

But the seaside *was* being romanticised in the 1840s, and with a capital 'R'. In *A Writer's Britain* Margaret Drabble writes that 'Appreciation of the grandeurs and beauties of the sea was largely a Romantic innovation.'[8] Let one quotation stand for many: in 1712, Joseph Addison wrote in the *Spectator* that 'there is none which affects my imagination so much as the sea or ocean. I cannot see the heaving of this prodigious bulk of waters, even in a calm, without a very pleasing astonishment.'

It was an acquired taste, though. Britons generally did not particularly like to be beside the seaside. In *The Lure of the Sea*, Alain Corbin describes how the 'cosmogonical' theories of classical theology represented the sea as something frightful, untamed by the Creation: 'There is no sea in the Garden of Eden'; it was an instrument of punishment in the Flood.[9] This gave way to natural theology, which saw 'the external world as an image given by God to his most perfect creature', and this included the seas.[10] Corbin describes how 'The coasts of the ocean began to appear as a recourse against the

misdeeds of civilisation'; how the first seaside visitors were 'cure-takers' seeking relief from anxieties associated with an increasingly urbanised existence.[11]

The therapeutic possibilities of Scarborough 'Spaw' were promoted in the 1660s by a Dr Robert Wittie of Hull, in terms combining quackery and snobbery. The waters were efficacious against ailments 'from wind to leprosy', and the Spaw was 'well known to the citizens of York, and the gentry of the county, who do constantly frequent it; yea and to several person of quality in the nation'. Drinking the salty spa water, swimming in the sea and walking along the strand were recommended – these last two elements foreshadowing the modern holiday. (The Scarborough water was apparently still being drunk for curative reasons in the 1960s, but laced with orange juice, as opposed to wine, which had been used to take the taste away in the eighteenth century.)

Almost a century would elapse between Robert Wittie's promotion of Scarborough, and the publication, in 1761, of *A Short History of Brighthelmstone with Remarks on its Air and an Analysis of its Waters*, by Dr Anthony Relham, which detailed the advantages of Brighthelmstone, which became Brighton. Brighton would overtake Scarborough as a fashionable destination, but Scarborough was the first seaside resort – in Britain and perhaps the world. It also presents us with a figure who had one foot in the world of seaside convalescence, the other in the recreational, railway-made seaside.

To Scarborough

Pre-tourist Scarborough is represented by the quaint Old Town, a couple of hundred yards inland of the South Bay. Here fishermen lived in cottages usually facing, with

distaste, away from the sea, which was ever likely to be the death of them. The focus of Scarborough as a health resort was the first Spa building, constructed in the South Bay around the source of the mineral waters in 1839. Scarborough as a modern tourist town is symbolised first by the railway station – a pretty, colonnaded building with just two platforms when it opened in 1845 – and secondly by the Grand Hotel, reputedly the largest in Europe when it opened in 1867. All these locations are connected by Anne Brontë, although the Old Town only came into play at the end of her life, since she is buried just above it, in the graveyard of St Mary's Church.

The historical sequence was such that the cure takers went to the coast by horse and carriage, the pleasure seekers by train, but Anne Brontë is one of the exceptions. She had first visited Scarborough – by horse and carriage – in 1840, accompanying the family for whom she worked as a governess, and she fell in love with it. It is in Scarborough, although not named as such, that Mr Weston proposes to Agnes Grey, the eponymous heroine of Anne's novel.

In May 1849 Anne went to Scarborough for the old-fashioned, medicinal reason, but by the modern method: the train. As she had written to her friend Ellen Nussey on 5 April 1849, 'the doctors say that change of air or removal to a better climate would hardly ever fail of success in consumptive cases if the remedy were taken in *time.*' 'If only she could get to the sea she was sure she could be saved', writes Winifred Gérin in her biography of Brontë.[12]

She took the train from Haworth, changing at Leeds and York, a journey that would not be possible today but for the charitable intervention of the Keighley & Worth Valley heritage railway, which has reconnected Haworth to Keighley. Anne travelled with her sister Charlotte and Ellen Nussey.

They departed York on 25 May. 'The journey proved unexpectedly easy,' writes Gérin:

> Everywhere they met with the greatest kindness; burly-shouldered Yorkshiremen offered their strong arms wherever trains had to be changed ... The sea was announced many miles before Scarborough was reached or sight of it ... The low foothills fell away and there was a sense of going over the rim of the world that enlarged, inexpressibly, the universe.[13]

By 'announced', Gerin seems to be suggesting that Anne *sensed* the nearness of the sea; you can't actually see it from a train approaching Scarborough from York.

The first thing the party did was buy tickets 'that gave them unlimited use of the spa and its facilities'.[14] On that same day Anne rode a donkey trap alone across the sands, after chiding the boy who kept the donkeys for his maltreatment of them. The following day she went alone to the Spa to take the waters, but she collapsed as she walked back to her lodging house, which was on St Nicholas' Cliff, where the Grand Hotel now stands. Anne died in Scarborough on 28 May 1849, which begs a bad-taste question: was her train ticket a return?

The Grand Hotel, which is not merely sea-facing but seems an upward continuation of St Nicholas' Cliff on which it stands, bears a plaque commemorating Anne's Scarborough stay. The fading of the genteel Scarborough Anne visited, and the rise of the new, brasher version, might be evoked by juxtaposing the dates of some social events in the town with those marking the expansion of the railway station.

Scarborough's progress towards 'Kiss-Me-Quick' was slow. The town wanted a railway, and plans to connect

Scarborough to York had been mooted from 1833. It was not until 1846 that Robert Stephenson, who also engineered the 'first' seaside line, the Canterbury & Whitstable, got the job done on behalf of the Midland & Great Northern, the railway of the notorious George Hudson. There was resistance in the town, and in 1844 a certain George Knowles, who lived in Wood End, Scarborough's best address, wrote a pamphlet decrying Hudson's vision for Scarborough: a 'Brighton of the North' and a 'Queen of Watering Places' (an epithet Hudson seems to have borrowed from Brighton, and which would be used often in railway advertising for Scarborough). Knowles fretted that Scarborough would be infected by Brighton-ness. 'A railroad has been of no service to Brighton as a watering place,' he wrote, 'it [has] had the effect of driving several families to Scarborough.' The coming of a railway, he predicted, would result in an increase in Scarborough's poor rates, and the need to expand the jail.[15]

The arrival of the railway seems in the short term not to have taken Scarborough downmarket. Rather, it made it a town of hotels. In his history of the Grand, Bryan Perrett writes that 'During the last twenty years or so of La Belle Epoque, Scarborough in season had become a fashionable spectacle which bore some comparison with Rotten Row in London or the Bois de Boulogne in Paris.' This to the extent that the Corporation feared the less affluent might be deterred from coming, hence a town guide of the period 'at pains to point out that one did not actually require a frock coat to enjoy oneself in Scarborough!'[16] The opulent Grand was the focal point. From the galleries overlooking its triple-height entrance hall, ballgowned ladies could choose the moment to make their descent of the operatic main staircase. They would not want to do so at the same time as another woman, but the staircase was wide enough for two should such a

confluence occur. The Grand was so grand, it was enough to be seen walking *past* it on the Sunday morning promenades from St Nicholas Cliff and over the Spa Bridge, with its delicate pale green railings, that spanned the ravine on the Scarborough south side and led to the stuccoed houses of the Esplanade, from where the Italian Gardens rolled handsomely down towards the Spa and the sea.

In *Tickets Please!*, Paul Atterbury shows an Edwardian postcard depicting the promenaders. The inscription runs, 'Mr Johnson and myself are spending a weekend here. It really is smart. The journey via Coast Route was very beautiful. The weather fine and the folk quite giddy.'[17] At the time, four lines went to Scarborough: two from the west (from York and Pickering); one from the south and one from the north. The line from the south, also serving Filey and Bridlington, was, and is, only intermittently coastal, and not as beautiful as the one descending from Whitby to the north, which no longer exists. So this must be the one referred to, and the pleasure of the journey was obviously part of the holiday.

Tom Laughton describes the allure of the railway station in Edwardian times for himself and his two brothers, Frank and Charles (the actor). They lived in the Victoria Hotel, Scarborough, which their parents owned and ran. When he and his brothers visited the South Bay beach – 'Two little boys in sailor suits, equipped with buckets and spades and shrimping nets' – they liked to take a short cut via 'the station yard with the horse-drawn waggonettes and the sweet smell of horse dung'. On their way to the sea, along the Valley Road, they passed 'a line of one-horse phaetons drawn by horses driven by postilions dressed in faded jockey costumes'. These 'jockeys' did not serve the station directly but lay in wait around the corner. When the Laughtons visited the centre of town, they also went via the station:

Our favourite way was up the road at the back of the station, where through the tall railings we could watch the trains puffing smoke and blowing steam. The greatest treat of all was to see a train pull out, the train belching smoke with a frantic scrabbling of the wheels.[18]

In 1908 the Laughtons took over the Pavilion Hotel, which was almost as prestigious as the Grand, and directly over the road from the railway station. The complex included two lawn tennis courts, immediately to the side of the hotel, and so the sounds of the station would quickly have given way to the civilised sounds of tennis. The hotel had a 'station porter' called Bob Moore who waited on the platforms to greet important arrivals, of which there were many. They included Sir George and Lady Ida Sitwell, parents of Osbert and Edith, who, on coming up from London, would stay at the Pavilion while their large Scarborough house was being prepared. In recalling the VIPs Laughton gives an insight into how the over-dressed Edwardians conveyed their clothes to the holiday place. On arrival at the Pavilion Sir Tatton Sykes, a regular winter visitor, 'would strip off up to half a dozen top coats'. On one occasion he sank down on the hotel steps declaring, 'My God, I'm paralysed,' his trouble being that he had 'put on just one more overcoat than he could carry'.[19]

After the passing of the Bank Holiday Act in 1871, the numbers of railway-borne trippers arriving in Scarborough increased, prompting an expansion of the station. In 1883 two excursion platforms were added, one of which featured the longest railway bench in the world, a quarter of a mile long and capable of accommodating 230 people. Even in the days when the bench was well used, the posh Sunday promenaders would never have sat there, access to the two excursion platforms being separate from those serving the

The bench on the excursion platform at Scarborough station, whose quarter-mile length seemed about right in 1883.

main station. At the same time of this expansion, the station façade was extended – a flowering of the original style – and a flamboyant baroque clocktower added, its four-facets clock illuminated by gas. Other enlargements would follow.

In 1877 a vast underground aquarium was constructed on the South Bay, inspired by Brighton Aquarium and built by the same architect, Eugenius Birch. It didn't prosper, being not downmarket enough, with its whimsical 'Mohamedan-Indian' theme. After a couple of years the Aquarium was sold to William Morgan, manager of the Winter Gardens at Blackpool, who introduced alligators, optical illusions and a swimming pool, in which Ada Webb and her Champion Troupe of Lady Swimmers would frolic. What had been the Scarborough Aquarium was now the People's Palace and Aquarium, and we might see this as the start of the

Blackpool-isation of Scarborough, but it would be more accurate to say it was becoming a holiday town on three levels: catering to day trippers, the less well-off overstayers – accommodated in the Edwardian guest houses, arrayed like so many up-ended suitcases on the North Bay cliff – and the promenading types, who stayed in the Victorian hotels of the South Bay.

At the turn of the century the excursion platforms were proving insufficient, and in 1908 a whole new excursion station, Scarborough Londesborough Road, was opened, the original station coming to be known as Scarborough Central. Londesborough Road had one long, through platform and a shorter bay. Excursion trains from all over Britain ran into it and were stabled beyond the long platform on sidings adjacent to the Whitby line. Excursions continued to pour into Central as well, but Central was a cut above. Londesborough Road, functional and somewhat bleak, was further inland. People complained about the longer walk at the end of a tiring day's pleasure seeking. A North Eastern Railway poster of 1909, showing a cherubic boy skipping along a beach, proclaimed, 'Scarborough Braces You Up – It's The Air That Does It.' It also wears you out, especially on a hot day, if you have ranged over both the North and South Bays.

In railway terms Londesborough Road was the tradesman's entrance, receiving the Bertram Mills Circus Trains, which visited regularly in the 1950s, and the first diesel multiple unit into Scarborough, which arrived on a test run on 3 November 1955. The premier Scarborough train, the ex-King's Cross *Scarborough Flyer* (1927–62) wouldn't have been seen dead at Londesborough Road. The *Flyer*, which ran on Saturdays in the season, was also big news in York, because it was the fastest service there from London in the inter-war years.

In 1934, 614,959 passengers arrived at Central station; 124,695 at Londesborough Road. The station master of Central at the time, Mr F. W. Dawson, wrote that 'During the season the weekend traffic – both Saturdays and Sundays – taxed our resources severely.' In that decade promenading gents relinquished top hats or bowlers in favour of soft trilbies or Panamas. Black tie was displacing white tie in the Grand Hotel's several restaurants and ballrooms.

In 1960 Scarborough Central handled 800,000 passengers, a quarter of them in August alone, but this proved to be the peak.[20] Londesborough Road closed to passengers in 1963, and later in the decade Scarborough, having lost its 'Central' suffix, also lost part of its roof. In the 1950s lounge suits had become acceptable for dinner at the Grand, which was becoming reliant on visitors to the annual cricket festival and party-political conferences, once necessarily seaside affairs, being perks, or compensations, for the job of politician. The ones at Scarborough were held at the Spa. I think the last party conference to be held there was that of the Green Party in 2019, and surely they all came by train (or bike)? The Grand was still 'a seaside Savoy' in the late 1960s,[21] but in 1979 it was purchased by Butlin's, the start of a social descent under various owners. I have stayed at the Grand several times in recent years, usually when feeling broke. What was once the most expensive hotel in Scarborough has become the cheapest.

Scarborough remains an attractive town, but a concrete reverberation denotes some of the sites of its Victorian glamour. A dark, ghostly underground car park has been carved out of the Aquarium, which closed in 1966. In 1973 the Pavilion Hotel was demolished, and people arriving at the station are now confronted by a brutalist office block called Pavilion House. The former tennis courts are now a

car park, and there's another on the site of the three Scar-borough platforms decommissioned in 1985. The coastal line from Whitby to Scarborough was closed by Beeching in 1965. (The line from Pickering to Scarborough had closed in 1950.) The Serpell Report of 1982 proposed the closure of the York–Scarborough line, but then its author, David Serpell, a retired civil servant who had 'form' as an imple-menter of the Beeching cuts, had suggested the closure of the majority of the network. His report was badly received; people had had enough of railway closures, and today the ordinary TransPennine Express trains from York to Scarbor-ough are so crowded in summer that a friend of mine who once used them regularly no longer does so: 'It's the tension of wondering whether you'll get a seat on the train back.' In summer, the York–Scarborough services are supplemented by a 'special': the *Scarborough Spa Express*.

What became the *Scarborough Spa Express* started in 1978 as one of the first steam excursions operated by BR after the abolition of steam in 1968. It was a circular trip running between York, Leeds and Harrogate. In 1981 it was extended to Scarborough, after the renewal of the turntable there, and given its present name. These BR services ceased in 1988, but the National Railway Museum began operating steam excursions under the *SSE* name from York to Scarborough. In 2008, West Coast Railways took over, and their *SSE* ser-vices run from Carnforth to Scarborough via York.

In summer 2024 I awaited the SSE on Platform 4 of York station, at the north-eastern tip known as 'Scarborough corner'. As the train approached the high curved station roof did its old job of diffusing steam, and the decades dropped away: this, even though the engine – unlike, say, *Flying Scots-man*, which occasionally hauled the *Scarborough Flyer* – was

not an old York hand but *Tangmere*, one of Oliver Bulleid's Battle of Britain class 'Light Pacifics' for the Southern Railway.

Of those awaiting the train, about half were rail enthusiasts. To put it another way, the crowd consisted of railway enthusiasts and their wives, and there was much interest from the former in the class 47 diesel at the rear of the train, which was present to supply electricity for the central door locking now mandated by railway safety regulations. The carriages were BR Mark 2, although, as the train guard admitted, as we rumbled over Scarborough railway bridge, which is in York, not Scarborough, 'What the punters really want are Mark 1s.'

Whereas Mark 1s are redolent of the 1950s and 1960s, Mark 2s are redolent of the 1970s. They don't have the 'top lights' of the Mark 1s: the sliding windows at the tops of the main windows that are so evocative of the steam age because, when opened, steam and smoke often blew in through them. But the Mark 2s do have the drop lights in the carriage doors: that is, drop-down windows, and these were all open on the SSE, this being a sunny day, and I found the inrush of slightly manure-smelling country air powerfully evocative of childhood train journeys. As a boy I often stuck my head out of these windows, so I'm probably lucky to still have a head. I was sent time-travelling by other means besides: the signs on the loo doors reading 'Vacant' and 'Engaged', for example, which seem so charmingly verbose these days, as do the 'No Smoking' signs on the windows.

Most of the stations on the York–Scarborough branch were closed in the 1930s, and there's a run of 21 miles without a station before Malton. Their closure was a capitulation to cars and buses, and an acknowledgement of the magnetism of Scarborough. People wanted to get there fast. At least two

of the stations before Scarborough had several attractions of their own, Kirkham Abbey and Castle Howard – but Scarborough upstaged these refined offerings.

The countryside between York and Scarborough is low-key, slumbrous. Some stone-built trackside cottages have a railway air, perhaps with old gas or oil lamps in their gardens. The handsomest building, nestling cosily in the Derwent Valley, is the old station at Kirkham Abbey, with its retired signal box close by – both monuments now, like the picturesque ruin of the Abbey. Malton station today has a single platform face and has lost its overall roof. It seems little more than a milestone marking halfway to Scarborough, whereas in the 1920s it was a huge junction for farm produce with a hundred staff.

The mood was jolly on the *Scarborough Spa Express*, just as though the average age of the seaside-bound passengers were seven and not seventy. Nobody wore earphones or headphones; there was a hubbub of conversation, as at a good cocktail party. 'Lovely day … Bang on time … Fish and chips on the harbour wall – that's the plan … Look at those lovely shire horses.'

On the approach to Scarborough a member of the train staff pointed out the restored turntable, to which *Tangmere* would soon be heading, having run around its carriages. He also pointed out the site of the old Londesborough Road excursion station and, after we'd pulled into the excursion *platform* at Scarborough, I headed for it, a matter of walking twenty minutes inland. What was the station is now a small business park, mainly car-related, but the surrounding houses were smart Victorian villas, and it struck me that, whereas Londesborough Road had been a second-class station, it was in a first-class part of Scarborough. Probably the residents had not enjoyed having an excursion station on their

doorsteps, any more than they enjoy having the TransPennine Express service depot located nearby. The idling engines of the attractively dimpled class 68 diesels stabled at the depot made too much noise for the locals; they have now been banished from service on the Scarborough line.

With only a couple of hours in town before train time, I checked in on some of my favourite Scarborough spots: Mrs Lofthouse's Book Emporium on Queen Street; the quaint little guest house on King Street that inspired one of my novels; the tobacconists on Bar Street, where I bought a Nicaraguan (i.e. cheap) cigar to smoke on the harbour wall, with the bustle of tourism mixing harmoniously with that of the fishing industry. I had a walk on the beach, kicking the sand a bit, to verify its softness. There were just enough of my fellow beach walkers to prevent the scene from being depressing, but no children, the school holidays having not yet started. I liked to imagine that these mooching adults were scoping out the beach, sizing it up for when they returned with their children or grandchildren. Back at the station, about sixty of the Spa excursionists were getting into the holiday spirit by sitting on the long excursion bench, leaving a good four-fifths of it unoccupied. About sixty others were paying court to *Tangmere*.

As we boarded the train for departure, I could see the station clock tower (the excursion platform being unroofed). It told the correct time, but a Scarbrough-resident friend of mine had told me it had recently stopped being illuminated at night, a scarcely credible dereliction of duty on behalf of whoever's responsible, given that the clock has played a momentous role for about 130 years, signifying the start and end of magical times for so many people.

To Brighton

In the 1930s the station frontage at Brighton read, 'London in One Hour', and the town is too much a reflection of London cosmopolitanism to be a simple holiday resort. The Southern Railway's posters for Brighton reflected this worldliness. One shows sophisticated conversationalists on the front above the words 'Fame' and 'Fashion'. In another, a dapper man greets a glamorous woman on the prom. 'Very fit', he's saying, 'and you?' And the next unspoken or unwritten line is clearly, 'You wouldn't be free this evening, by any chance?' A third shows a dolly bird (as she might have been called at the time) on the sunny beach, the straps of her orange bathing dress slipping, with the caption, 'Come Down and See Me Sometime'. The London skyline is shown as a dark silhouette on the horizon: a place of unfulfilled desires, in contrast to Brighton, where they might well be fulfilled.

In a word association game, 'Brighton' might quickly be followed by 'dirty weekend', and most of the dirty week-enders were Londoners, Brighton being both conveniently near the capital and sufficiently distant. Genuine canoodling might be followed by a pretence of the same, because the Matrimonial Causes Act, 1923, allowed men or women to secure a divorce by proving adultery – so a failed marriage could be terminated by the man or woman checking into a Brighton hotel as 'Mr and Mrs Smith'. Brighton hotel staff were not in the prurient Basil Fawlty mould and could be relied on to attest to any amount of bad behaviour, especially if they'd been 'squared' in advance with a backhander.

Brighton became a sanatorium on the sea after Scarborough, but it preceded Scarborough in abandoning the pretence of being curative. The transition to hedonism was brought about by a royal personage. In the words of Travis Elborough,

the high-living George Augustus Frederick, Prince of Wales, sought 'the spoonful of sugar as much as the medicine'.[22]

He first visited the town in 1783. From 1787 he set up shop in the Brighton Pavilion, where he and his mistress, Maria Fitzherbert, became a social magnet for fashionable Londoners. They came by the turnpiked road, which took half a day, whereas the twenty or so stagecoaches from London took eight hours. The railway arrived in 1841, when George was ten years dead, cutting the journey from London to two and a half hours. The railway 'deliberately targeted first-class custom'.[23] A first-class annual season ticket could be had for fifty pounds – about £8,000 in modern money, which is about what that ticket would cost today. But the short journey time also meant that Brighton attracted day-tripping excursionists, so its double-identity began to take shape, poised between the mass and the elite.

On 8 August 1844 *The Times* reported:

A MONSTER TRAIN
Yesterday morning, at half-past eight o'clock, the train which started from London-bridge for Brighton consisted of 48 carriages, containing 1,600 persons, and was propelled by four engines. The majority of them were parties going to Brighton races with the cheap excursion tickets.

The trip, and others to Brighton, was organised by Rowland Hill, originator of the Penny Post and chairman of the LBSCR from 1843 to 1846. Surely it was almost impossible to go to Brighton races and not drink, and this early excursion was presumably a rowdier affair than the landmark event organised by the temperance campaigner and holiday entrepreneur Thomas Cook. He is taken to be the originator

of the railway excursion, having laid on a jaunt from Leices-
ter to Loughborough on 5 July 1841, which, given the absence
of sea, doesn't sound like it would have been much fun even
had alcohol been involved.

George's successor, William, remained loyal to Brighton,
as did Queen Victoria, for a short while. In 1845 she took the
train there for the first time. She went for a walk with Albert
on the chain pier, where the royal couple were chased by
some uncouth lads. She never went to Brighton again, having
decided the people there to be 'very indiscreet and trouble-
some'. Instead she would take her holidays at Osborne House
on the Isle of Wight, where there were no railways until 1862.

That line of 1841 was opened by the London & Brighton
Railway from Norwood Junction to Brighton; it connected
to London Bridge via the tracks of the London & Croydon
Railway. The L&B and the L&C would amalgamate in 1846
to form the London Brighton & South Coast Railway. Of
course, you can still go to Brighton from London Bridge,
via Thameslink, but the London end of the Brighton Line is
usually considered to be Victoria, a station with numerous
identities, but usually considered salubrious and a prelude
to excitement. Here it is, viewed through the eyes of Edwin
Clayhanger, a young man from the Potteries trying to make
his way in the world, in Arnold Bennett's novel of 1910,
Clayhanger:

> The very character of Victoria Station and of this express
> was different from that of any other station and express
> in his experience. It was unstrenuous, soft; it had none of
> the busy harshness of the Midlands; it spoke of pleasure,
> relaxation, of spending free from all worry and humil-
> iation of getting. Everybody who came towards this
> train came with an assured air of wealth and dominion.

Everybody was well dressed; many if not most of the women were in furs; some had expensive and delicate dogs; some had pale, elegant footmen, being too august even to speak to porters. All the luggage was luxurious; handbags could be seen that were worth fifteen or twenty pounds apiece. There was no question of first, second or third class at all on this train.

Victoria station was created on prime land, being close to new and elegant Belgravia. It overlooked a railway bridge across the Thames that had been built by the London Brighton & South Coast Railway in 1860, who took up occupancy of the station in that same year. But Victoria was too hot a property to be owned by a single railway; it was always the government's intention that it would be shared, and in 1862 the London Chatham & Dover Railway constructed an annex to the station. So Victoria was two stations in one until the Grouping, and still in a sense afterwards. One post-grouping station manager at Victoria compared himself to the happy father of twins. The old Chatham side is platforms 1 to 8, the Brighton side is 9 to 19. You can see the diverse origins in the way the station's two war memorials commemorate the fallen of the respective companies.

Originally the station comprised two basic train sheds with no ornamental facades. The LCDR side offered the most boat trains, but it was also, as Christian Wolmar writes, 'used much more by the working class, particularly for dockworkers and merchant seamen travelling either to the East End of London for the docks or Chatham for the shipyard.'[24] On balance, the LBSCR side was regarded as superior, as reflected in the famous line from *The Importance of Being Earnest*, Jack offering, as a grace note to his account of being found as a baby in a Victoria cloakroom, 'It was on

the Brighton side', to which Lady Bracknell responds, 'The line is immaterial.'

Perhaps she had never been in the Grosvenor Hotel, on the Brighton side, which had opened in 1862 and lent architectural grandeur to the north flank of the station. An advert of 1872 boasted that the hotel 'has a direct approach from the station', adding that it 'is situated in the most fashionable quarter of the Metropolis, near the Queen's Palace, and in the vicinity of the parks and clubs'. It was certainly more than a station hotel. In 1871 the Duke of Orleans had been proclaimed King of France there. In the early twentieth century the LBSCR acquired the hotel from a private owner and extended it around the corner, making in effect a station frontage. At the same time the LCDR, which in 1899 had joined forces with the South Eastern & Chatham Railway to become the South East & Chatham Railway, built an ornate frontage on its own side. In *London's Termini*, Alan A. Jackson writes, 'The style was French Second Empire with a maritime flavour bestowed by four mermaids contemplating their well-parted bosoms.'[25] You'd think the bosoms would have been more at home on the Brighton side, but a 'maritime flavour' was appropriate, in view of the SECR's continental services. But if any domestic train could match a boat train connection for glamour, it was a train to Brighton.

In *Clayhanger*, Edwin boards the Brighton train:

> When he sat down in the vast interior of one of those gilded vehicles he could not dismiss from his face the consciousness that he was an intruder, that he did not belong to that world. He was ashamed of his hand baggage, and his gesture in tipping the porter lacked carelessness.

It takes him to Brighton in 'an astounding short space of time', and this was because the line's engineer, John Rastrick, followed the 'straight through' doctrine. There are seven tunnels through the North Downs; then comes the graceful Balcombe Viaduct over the High Weald which, with its thirty-seven arches, is a popular Instagram spot ('Would have given it five-stars, but there was scaffolding at one end'). For all its bold engineering, however, the Brighton line is not considered scenic. It has not been appropriated for any Harry Potter atmospherics; the line is upstaged by its trains.

The Brighton trains had a dandified reputation. In his short story of 1892, 'The Private Life', Henry James wrote of a character, 'He's always splendid! as your morning bath is splendid, or a sirloin of beef, or the railway service to Brighton.' The LBSCR locomotives were in shades of green until William Stroudley became Chief Mechanical Engineer in 1870. He introduced 'Improved Engine Green', which was improved to the extent that it was not green at all, but a golden ochre – a shade it's hard to imagine coexisting with the coal mines and factories of the north of England. In 1903 Stroudley's successor, R. J. Billinton, changed the colour of the carriages from brownish to umber and cream, a livery luxurious enough to be adopted by the Pullman company in 1906.

Pullman, the American builder and operator of sumptuous carriages – or 'cars,' as they called them – came to Britain in 1873, in a partnership with the Midland Railway. The cars were in open formation (no compartments) to allow a flowing service of food and drink. There was always a freshly laundered tablecloth and a lamp with a pink or peach-coloured silk shade reminiscent (appropriately for Brighton) of an inverted pair of ladies' knickers. The seats were called 'chairs', and they *were* freestanding armchairs. A

train might incorporate just a single Pullman car or might be all Pullman. The cars might be first, second or third class, and the Pullman boast was that even its thirds were more luxurious than a first-class carriage of the ordinary sort, this being the justification for the 'Pullman supplement' added to the usual fare. The pre-grouping company most closely allied to Pullman was the LBSCR, and in 1928 a Pullman works was set up in Brighton at Preston Park, north of the station.

In 1881 the LBSCR introduced the *Pullman Limited Express*, the first all-Pullman train in Britain. It ran non-stop from London to Brighton. In 1908 this became the *Southern Belle*, billed as 'the most luxurious train in the world'. The LBSCR hosted a party at the Hotel Metropole in Brighton to celebrate. (The Metropole is described by the dangerously naïve Esther in *The West Pier* by Patrick Hamilton as 'that palace of mad, Oriental opulence, that haunt of the fantastically rich, the gorgeously successful theatrical, the aristocratic – that vast cathedral of Mammon'.) Reporting on that party, the *Daily Telegraph* of 2 November 1908 quoted the Earl of Bessborough, chairman of the LBSCR, as saying the train 'showed the railway were doing their best to encourage first-class traffic to Brighton'. One imagines a certain tension in the air, given the steely-sounding response of the mayor of Brighton, who said he 'hoped the new train would bring to Brighton the class of passenger the place wanted' – because the LBSCR, perpetually seeking to have its cake and eat it, was also the biggest provider of cheap excursion tickets in the country.

The *Southern Belle* took an hour to cover the 51 miles, and there were two round trips a day. After the introduction of the *Bournemouth Belle* in 1931 its name had begun to sound generic, and when, on 1 January 1933, the Brighton line became the first main line to be electrified, a PR opportunity arose. The all-electric, all-Pullman service introduced

on that day ran initially as the *Southern Belle*, but in 1934 it was renamed the *Brighton Belle*, the christening performed by Miss M. Hardy, Mayor of Brighton. The ordinary electric units of the Southern Railway resembled so many anonymous green worms, but the *Brighton Belle* was not anonymous: it had a name, and it was not green; it was liveried in the Pullman colours, umber and cream, but its interior represented Pullman modernity.

The *Belle* was a brasher, literally harder, train than its predecessor – commensurate, perhaps, with Brighton's stony beach, which came as a disappointment on my first visit. The silk table lamp shades were now celluloid, the brass luggage racks oxidised silver. There was linoleum as well as thick pile carpet on the floor. In place of vaguely eighteenth-century-looking carriages came Art Deco sunbursts in the marquetry and Jazz Age seat moquettes, in shades with decadent names like Lanvin blue, tango, hot pink. It was Pullman style to give cars names, and whereas those of the *Southern Belle* had been patrician or regal ('Alberta', 'Grosvenor', 'Belgravia' etc.), the six first-class cars of the *Brighton Belle's* fifteen (making three five-car units) suggested the kinds of women a male passenger might hope to bump into in Brighton: 'Hazel', 'Audrey', 'Gwen', 'Doris', 'Vera', 'Mona'. The *Belle* was more democratic than its predecessor, catering to a more diverse clientele: whereas the *Southern Belle* had only gained a third-class component from 1915, seven years after its inauguration the *Belle* had one from the off. The Southern Railway liked to suggest that people entering the *Belle's* third-class cars would dazedly ask, 'Are we in first or third?' and this was not completely fanciful, but how many holidaymakers used the *Belle*?

Its original departure times from Victoria were 11 a.m., 3 p.m. and 7 p.m., so even if you took the earliest train you'd

miss half a day at the seaside, and while those times would mutate, the *Belle* never did deign to run before 9.30 a.m. It's well known that Sir Laurence Olivier, who lived in Brighton, campaigned successfully to have kippers restored to the train's menu, but he ate these not for breakfast but as supper, on the 11 p.m. service that had been introduced in 1962 and was also no good for holidaymakers. Rather, it was used as a late-night return from West End performances by Olivier and his fellow theatricals, including Jimmy Edwards, Dame Flora Robson, Terrence Rattigan and Dora Bryan – people who lived in Brighton so as to be, as Julie Burchill (who lives in Brighton) said of herself, 'on holiday all the time'.

There is plenty of *Belle* footage on YouTube, and most of the passengers do not look like seaside holidaymakers: barely a single child is featured, and I doubt there were many buckets and spades on those oxidised silver luggage racks. The *Belle*, being a restaurant on wheels, was not particularly child-friendly and generally intimidating. The signs at the entrances to its platforms at Brighton and Victoria read 'Pullman cars only', a warning to passengers that their expenditure wouldn't stop with the purchase of ticket and supplement. They could not be compelled to eat and drink, but the attendants – as *Belle* waiters were called – were flinty little men (sometimes ex-jockeys, fittingly enough, since the *Belle* could be a rough ride), experienced at not taking 'no' for an answer. A family with kids would be a soft touch: 'Ice cream for the boy and girl, madam?'

That the attendants were tough characters might come in useful. Anthony M. Ford writes that 'razor gangs … frequented the use of the Brighton-line Pullmans and numerous recollections abound of some of their exploits and high-jinks aboard.'[26] He mentions slashed seats and table lamps thrown out of the window. The *Belle* doesn't feature in Graham

Greene's novel about Brighton gangland, *Brighton Rock*, although the film opens with a scene at the station. Colley Cibber, an important if short-lived character, alights from a compartment-stock train (therefore not the *Belle*) along with what looks like a genuine Brighton crowd – mainly of young women – which then flows like an outgoing tide towards the ticket barrier.

The *Belle* does feature in Patrick Hamilton's novel of 1941, *Hangover Square*. George Harvey Bone is 'in a Pullman car', sitting 'on the right facing Brighton'. He is going there for the same reason as Edward Clayhanger, to meet a woman he's obsessed with, in Bone's case the manipulative Netta. Bone has been drinking beer all day; he'd looked up his train time by borrowing an *ABC* timetable from a pub landlord; he also had a beer in the buffet at Victoria. He is still drinking beer (having declined lunch) as the train, relatively empty and with 'the lunch spotted white cloths ... still visible on the tables', rattles through the 'sunny, sticky, streaming after-noon'. But Bone begins to doubt that things will go well with Netta, and the train, too, seems suddenly doubtful, coming to stop amid fields near Haywards Heath: 'a wasp or bluebot-tle could be heard buzzing from the other end of the car ... A bored fellow passenger rattled a newspaper in turning it ...'

Hamilton depicts a supposedly glamorous train as seedy. Any discrepancy between image and reality lessened over time. In 1968 the *Belle* was ruthlessly repainted in BR's glum corporate livery: blue and grey, known as 'blue and dirt', and fitted with dowdier moquettes. That's when the *Belle* died, really, although it made its last runs on Sunday, 30 April 1972.

Any person of a certain age using the Brighton line today is bound to feel nostalgic for previous trains. If not the *Belle*, then at least the slam-door trains that persisted until 2005.

They had a certain lumbering appeal, with an interestingly uningratiating nomenclature. They might be designated 4CIGs, meaning a four-car unit, 'C' standing for 'corridor' and IG being the LBSCR telegraph code for Brighton (a rather ghostly hangover, therefore); or they might be 4BIGs, which had a buffet car. All the first-class seats on these trains were in compartments, with orange curtains that you might close against the glare of a sunny day as well as the dark of night, in which case they would billow gently in the breeze from the open top-lights. There were buffet cars, with attendants wearing blue waistcoats, and the crude wooden shelves looked like a shooting gallery, seeming slightly understocked, with quite wide gaps between the cans of beer or small bottles of fruit juice.

There are no longer any non-stoppers on the Brighton line. The fastest trains call at Gatwick Airport and Haywards Heath. They take 58 minutes to reach Brighton, shaving a couple of minutes off the *Belle's* timing, but the memorability of the old 'clock face' timings (departures from London on the hour) has gone, and the stop at Gatwick Airport is depressing, especially on the way back from a weekend in Brighton: all those people boarding with their suntans and big suitcases seem to be demonstrating the properties of a real holiday.

With their narrow, anti-social, high-backed seats and washed-out interiors, the Electrostars of the modern-day Southern company might be a deliberate refutation of the colour and character of the *Belle*. At Victoria I once asked for a first-class ticket to Brighton. 'Why?' said the ticket clerk. He was making the point that first class on an Electrostar is hardly any different from standard. In return for your antimacassar you have the stress, and guilt, of fretting that some of your neighbours do not appear to be first-class types.

'When it comes to class', a guard on the line once told me, 'all bets are off after East Croydon.' The trains of Thameslink and Gatwick Express are no more stylish, adding only to the operational confusion of what was once such a focused line. There's no buffet or dining car – hasn't even been a trolley service for about four years. Another ticket clerk at Victoria told me with a sort of perverse pride, 'The only train from this station that has catering is the Orient Express.' (The *Venice Simplon-Orient-Express*, a very expensive tourist train, departs from Victoria.)

The road from Brighton station leads straight down to the sea with the unerring aim of the line that has brought the train from London. Brighton is a railway town, in the sense that its population doubled (from 46,000) in the thirty years after its arrival, and in that the railways provided the only industry the town ever had, the LBSCR having established its railway works there.

And the station is beautiful. The head-building – basically a stucco Regency villa – is by David Mocatta, described by Simon Jenkins as the 'master of the so-called "Railway Italianate"'.[27] R. S. Surtees' novel of 1860, *Plain or Ringlets*, is set in Brighton, which Surtees calls Roseberry Rocks: 'The Roseberry Rocks Station was built quite on the "money-no-object" principle of the early development of railways – light, lofty, spacious, and elegant – with a fine holiday air about it.' The chalk cliff rising up to the west, with seagulls circling above, has always contributed to that 'holiday air'. The station canopy was added in the 1880s. Its rococo ironwork suggests a seaside pier, but it rather smothers Mocatta's original building. The elegance of the glass and iron train shed (rebuilt at the same time) owes something to the fact that it curves, like York's. The roof is high, as is the station clock dangling from it, so that it seems too small.

As the troubled George Harvey Bone arrives in Brighton, 'There was a huge outing of violent girls, down for the day from the "Lucky Tip" cigarette factory in London, shouting and sprawling over the town.' For 'Lucky Tip' read 'Black Cat' or some other brand manufactured at the Carreras cigarette factory in Camden. The Southern ran third-class Pullman excursions to Brighton for the women of the factory. Anthony M. Ford writes that 'crates of beer were served from the guards van' on these excursions and those laid on for employees of Hoover.[28] Ford adds that the same Pullman formations were used for excursions to Glyndebourne, on which the alcohol was presumably served more decorously.

Edwin Clayhanger, arriving in Brighton in Arnold Bennett's novel of only thirty years before Hamilton's, finds the place full of 'glossy', trotting horses and 'rich and idle people'. 'Idle' sets the tone – that streak of immorality, or loucheness, about Brighton that transcends its social classes. 'Edwin had only seen the pleasure cities of the poor and the middling, such as Blackpool and Llandudno. He had not conceived what wealth could do when it organised itself for the purposes of distraction.'

Brighton stands between what are called today the West Coastway line (which stretches to Portsmouth) and the East Coastway (to Hastings). More than half the latter runs inland, touching Lewes, for example. The West Coastway runs closer to the sea but affords only occasional glimpses of it. Whereas the East Coastway resorts (like Eastbourne and Hastings) seem free of Brighton's orbit, the West Coastway ones seem defined by the ways in which they are not Brighton.

Most of the West Coastway was built in the 1840s by companies that came to be incorporated into the LBSCR, and the

stretch immediately west of Brighton, including Hove, was opened in 1840, a year before the line from London reached Brighton. It was as though Brighton and Hove were saying to each other, 'Whatever happens next, we're in this together.' Hove is joined on to Brighton, hence the joke of 'Hove, actually', stressing the subtle distinction and the slight piety of Hove. It's more wholesome than Brighton, more respectable.

Further west is Worthing, which seems over-endowed with stations, having three: East Worthing, Worthing and West Worthing – or five if you include Durrington-on-Sea and Goring-by-Sea. But then Worthing is big, with a population of well over 100,000, and sprawls along the coast. Deemed the heart of the 'costa geriatrica', Worthing has a reputation for right-wing elderly staidness, wittily characterised by Travis Elborough, who grew up there: 'It was hard to come of age in a place where almost everyone had gone to die.' He fretted that he was spending his formative years 'at what felt like the wrong end of the line, biologically, chronologically and geographically'.[29] But Worthing's population is younger than it was, and its two MPs at the time of writing are Labour.

The most interesting destinations on the West Coastway are branches off it: first, Bognor; secondly, Littlehampton, which came as a revelation when I went there for the first time on a sunny summer's day in 2024. The LSBCR reached Littlehampton in 1863; the current station dates from the late 1980s, but the waiting room has photographic displays about the town's railway history. I took what turned out to be a circuitous route to the sea, passing red-brick villas and small public greens. This progress culminated in much bigger red-brick houses overlooking a much bigger green, these presaging a lovely sandy beach and hundreds of people, many of them in the sea, evidently having a great time. I was

reminded of Philip Larkin's poem, 'To the Sea', which speaks of the 'miniature gaiety' of the seaside, and the surprise of seeing that it's 'Still going on, all of it, still going on!'

To Blackpool (via Fleetwood)

Blackpool was, and is, Britain's leading coastal resort by visitor numbers, and it was the site of the definitive, and most dramatic, conjunction of train and sea. Seaside holidays, as against day trips, can be said to have been invented in Blackpool. In *The British Seaside*, John K. Walton describes how the habit of seaside holidaying was developed among Lancashire cotton workers in Blackpool's hinterland, 'a generation' before it took root elsewhere.[30] Walton points to the rapid urbanisation of those towns; the strong community ties that arose in the mills and the relative prosperity of the workforces, allowing insurance schemes and savings clubs. These were used to save for the holidays that evolved from the traditional 'Wakes' – holidays tied in with the commemoration of a parish church – which had supplemented the two days and eight half-days provided for by the Factory Act, 1833. The mill owners came to appreciate that industrial relations were improved by closing the mill for a period, which also gave an opportunity for maintenance work.

The principal magnet was Blackpool, whose natural assets were slight – a large, windy beach – but whose corporation became effective at luring trippers. The opening of a new promenade in 1870 marked the point at which Blackpool threw its arms open to greet all-comers. The number of lodging houses increased rapidly in the 1870s, most catering to working-class visitors, people interested less in the health-giving properties of the sea than in man-made excitement. By 1911 Blackpool had become 'one of the world's

leading leisure towns, with an unchallengeable claim to the status of the world's first working-class seaside resort'.[31]

But before Blackpool there was Fleetwood, seven miles north along the coast. Blackpool is a spin-off from Fleetwood, which is not how things seem today, when Fleetwood looks like nothing more than the pleasantly sleepy terminus of the Blackpool trams.

You see the posher, northern end of Blackpool on the tram to Fleetwood, as it rolls past scenes of depleted Victorian and Edwardian grandeur: the red villas of Claremont Park, where lived people aloof from the hurly-burly surrounding the Central and North railway stations. Blackpool's best hotel, the stately, wood-panelled Imperial, is along this way. Its Turkish bath is now closed; probably not many aperitifs, strictly so-called, are requested in the Aperitif Bar, and the photographs on the walls of Wilson, Heath, Thatcher are a reminder of one big market that Blackpool has lost but hopes to regain: the national party conferences. As the tram progresses, the grass verges gradually look healthier and the plastic sculptures, ready to be lit up for the Illuminations, give way to ordinary streetlights.

Whereas Blackpool, according to John K. Walton, was held back in the mid-nineteenth century by the lack of any 'dominant landowner with an interest in supervising the resort's development', Fleetwood did have one, in the person of Sir Peter Hesketh Fleetwood, owner of the Rossall Estate on the Fylde coast, who created Fleetwood from nothing – a rabbit warren at the mouth of the Wyre – and sought to develop it as a major port and resort.[32]

Hesketh-Fleetwood was an attractive character: a humane landlord and social visionary, an opponent of slavery and capital punishment, and an early rail fan: he had attended

the opening of the Liverpool–Manchester Railway. He was interested in the recreational possibilities of the seaside, and he made improvements to Southport, some of which he owned. As a young man he'd holidayed in St Leonards-on-Sea, whose success as a resort inspired neighbouring Hastings to go down the holiday route. Hesketh-Fleetwood sponsored the Preston & Wyre Railway, which from 1840 connected Preston to Fleetwood via Kirkham and Poulton. Its Fleetwood terminus was Dock Street station, and an associated Hesketh-Fleetwood enterprise was the Fleetwood Dock itself, which quickly prospered.

In 1840, Fleetwood was the northernmost point on the English railway network: passengers for Scotland took the train to Fleetwood where they transferred to a steamer for Ardrossan Pier station, in North Ayrshire, which connected to Glasgow. The timetables provided for a tight connection. To avoid the stress, wealthier passengers would overnight at the North Euston Hotel, designed by Hesketh-Fleetwood's architect friend Decimus Burton, whose father had developed St Leonards-on-Sea. It's a grand, classical building in sandstone, to match Dock Street station, but it would not have looked amiss alongside the original London Euston, after which it is named, and its curved façade echoes that of the Great Northern Hotel just off the Euston Road at King's Cross.

Fleetwood ceased to be a staging post for Scotland when the Shap summit was conquered for rail in 1846, and the current route of the West Coast Main Line was enabled. But Fleetwood still prospered as a port and a holiday spot. It was a popular destination for excursionists from Manchester, and in their history of railway excursions Arthur and Elisabeth Jordan evoke the 'Poor People's Annual Summer Excursion' from Preston to Fleetwood in 1848. The cost was 6d a head,

with an optional 2d extra for a bun and milk. A band played 'Over the Hills and Far Away' as the trippers set off from Preston, even though they wouldn't be going over any hills (the Fylde being flat). At Fleetwood another 2d would secure a place on a steamer trip around the offshore lighthouse. A flyer announced, 'The Booths [that is, the conveniences] at the North Euston Hotel will be open at 2 o'clock, one for males and the other for females, FREE.' There would be 'Dancing on the Lawn around the charity banner and bathing before High Water'.[33]

In 1846, a new branch of the Preston & Wyre Railway (now the Preston & Wyre Joint Railway, it having been vested in both the London & North Western Railway and the Lancashire & Yorkshire) opened from Poulton to Blackpool. The station was simply called Blackpool until it became Talbot Road in 1872, then Blackpool North in 1932. This was Hesketh-Fleetwood's attempt to capitalise on the holiday possibilities of Blackpool, the village of about 1,000 people towards which some of the more adventurous visitors to Fleetwood had been drifting, on foot or by carriage.

Earlier in 1846 the P&WJ had also built a line from Kirkham to Lytham, seven miles south of Blackpool, which possessed a small harbour and was another potential resort. But the cost of the new lines bankrupted Hesketh-Fleetwood, who had overstretched himself in Fleetwood. He departed for London, but the town continued to grow, albeit with a faltering progress. Railway stations came and went in a peculiar shuffle. Dock Street station was replaced in 1883 by another at Queen's Terrace, more excitingly located at the holiday end of town, nearer the North Euston than the previous one. In 1885, Wyre Dock station opened between the site of the previous and new stations, so Fleetwood now had two stations, both sea-oriented, as they would have to be

in this town with the Irish Sea to west, Morecambe Bay to north, the Wyre Estuary to east.

Dock Street was the main passenger station, a huge, bustling place bedecked with many clocks and flower baskets, and bristling with signs indicating boat-train connections for Belfast and the Isle of Man. There were also steamers to the village of Knott End-on-Sea across the estuary, where, from 1908, the charming, rickety Garstang & Knott End Railway terminated, having started out in Garstang, ten miles to the east. The line, a light railway, carried mainly agricultural produce and salt, but it had some veranda-ended carriages dating from the 1870s and originally intended for Africa – hence wooden, slatted seats. Those verandas would be quite crowded with holidaymakers in summer, some of them refugees from the brashness of Blackpool. The line closed to passengers in 1930 and finally expired in 1965.

Wyre Dock station served Fleetwood's biggest industry, fishing, which was already declining in 1964, when Dock Street station was closed by Beeching. Wyre Dock station was then renamed Fleetwood, so at last the town had a station bearing its name, but only until 1970, when Fleetwood station was closed and demolished. The line to Poulton remained open for some freight until 1999.

Today Fleetwood is a quiet town, sunk in reminiscence of its days as a major port, with many plaques and notices telling its history, and a statue of Hesketh-Fleetwood in Euston Gardens in front of the hotel. There's also an obelisk, a memorial to those lost at sea, and this, together with the two still-working Victorian stone lighthouses a couple of hundred yards apart – one tall, one short – suggests a chess board towards the end of a game, with most of the pieces removed. Nearby there's a roll-on, roll-off dock for freight to Ireland; there's the terminal of the ferry that plies back

and forth to Knott End, which stands alongside a cavernous café *called* the Ferry. A friend had recommended the fish and chips. 'I like the Ferry caff,' he said. 'Very Fleetwood, though', he added, by which he meant usually quiet.

The receptionist in the North Euston was very – perhaps *too* – helpful when I asked about the history of Fleetwood. As she fished out documents and photocopied a map, a queue of people wanting to check in accumulated. They were smart, trim-looking people who had come to dance in the ballroom, which is of national significance. Among the material handed over by the receptionist was a pamphlet about the ballroom, which, with its '28-foot-high domed ceiling, three large chandeliers and seven 12-foot windows overlooking the estuary and Morecambe Bay, is a stunning setting for your Wedding, Charity Dinner, Ladies' Evening or any other gathering you can think of'.

Walking away from the hotel, and looking back at those windows, I saw a couple dancing in the otherwise empty ballroom, albeit dressed casually and without music – rehearsing. It was a somehow poignant scene, but Fleetwood might soon be enlivened again. Since 2005 the Poulton & Wyre Railway Society has campaigned to restore the branch from Fleetwood to Poulton, and at the time of writing all the necessary green lights seem to have been lit. There had been a competing plan for a cycle track but, as David Evans, a trustee of the Society likes to say, 'You can put a bike on the train, but not the other way around.'

British Rail advertised Fleetwood as 'the Floral Resort' or 'Lancashire's Family Resort', slogans appearing over Sunday-ish scenes on the Fleetwood front, and whose real meaning was, 'Fleetwood is the opposite of Blackpool.'

In 1846 the Preston & Wyre Joint Railway built its line

from Kirkham to Lytham seven miles south of Blackpool, as well as its branch from Poulton to Blackpool Talbot Road. So two lines were groping towards what would become downtown Blackpool, part of a commercialisation that would include the opening of the Central Pier (essentially a funfair on stilts) in 1868, the Winter Gardens in 1878, and Britain's first electric street tram in 1885, which ran along a promenade bathed in electric light.

In 1863 an outfit called the Blackpool & Lytham Railway built a line from another Lytham station (not the P&WJ one) called Ballam Road, to a station in the middle of Blackpool called Hounds Hill. This was the initiative of a local landowner, a Colonel Clifton, whose humble aim was to bring fertiliser to his coastal fields. In 1871 the Colonel's line was taken over by the Blackpool 'Big Two', the Lancashire & Yorkshire Railway ('the Lanky') and the London & North Western. They then joined the dots, slightly relocating Lytham Ballam Road so that it connected to Kirkham and Preston beyond, creating a line approaching Hounds Hill along the coast from the south.

In 1876 the Lanky switched its flagship *Manchester Express* from Talbot Road to Hounds Hill, which was expanded and renamed Blackpool Central in 1878. In 1901 Central was completely rebuilt, blossoming into fourteen platforms. In 1903 a direct 7-mile line was inaugurated, running straight across from Kirkham (cutting out Lytham) to just south of Blackpool Central, where a new station, Blackpool Waterloo Road, opened as a junction with the coastal line to Central from Lytham. Four running lines were provided from there into Central (in 1932 Blackpool Waterloo Road would be renamed Blackpool South). This line became the main holiday chord, not only in Blackpool but in Britain.

In *The Railways of Blackpool & the Fylde*, Barry McLoughlin

writes that, between 1873 and the end of the nineteenth century, railway arrivals increased from 850,000 to at least 3 million.[34] The figure often given for overnight stays in the 1930s is 7 million a year, putting Blackpool far ahead of any competitor. Arrivals by coach and car would by then have constituted a significant amount, but the majority would have been rail-borne.

Within a mile of Central was 22 miles of track, enough siding space to hold 40 complete trains, which slumbered in the sun (ideally) while the trippers they had brought frolicked on the front. But we mustn't neglect the north station, Talbot Road, even though it was less dramatically situated, and had a sideline in freight from which Central was exempt, apart from coal for the trains and the adjacent gas and electricity works. Talbot Road was a five-minute walk from the prom. The station was rebuilt and enlarged in 1898, becoming a handsome neo-Gothic building, whereas Central was more Italianate. Both had delicate porte cochères in front. Talbot Road had six platforms under the train shed, and a further ten, the excursion platforms, in the open air beyond, so it had three more excursion platforms than Central. The present-day Blackpool North is built on the footprint of the Talbot Road excursion platforms.

There would have been common elements to arrivals at both stations. In his novel of 1937, *Carnival at Blackport*, J. L. Hodson describes a journey from 'Burnham' (which is probably Manchester) to 'Blackport' (which is definitely Blackpool). The passenger is Mr Levibold, a showbiz entrepreneur; he is smoking a cigar in a first-class carriage on a fine Whit Tuesday morning. He lolls in his corner, 'his eyes roaming idly over the flying landscape of canals, factory chimneys, lovely fields, higgledy-piggledy hencotes, ploughed acres, slagheaps fit for hell, towns that defile the

earth and trees and streams that glorify it'. Like many visitors to Blackpool, he has left behind him a 'begrimed city of tall, black, sometimes austere or pillared cotton warehouses, banks, exchanges and political clubs'. Mr Levibold, carrying his expensive attaché case ('oiled by him until it would withstand anything in the shape of rain'), makes a serene exit from Blackport station, but then he is used to the place, and it is not yet high season.

The approach to Central of a train full of 'Worktowners' in high season was evoked by Mass-Observation in the late 1930s, about which a word of explanation is necessary. 'Worktown' is Bolton, and Mass-Observation was a group of volunteers assembled by the charismatic Tom Harrisson, a Cambridge drop-out, writer and anthropologist (among other things), and his middle-class friends, to anonymously observe everyday British life, mainly as lived by the working classes. Their book, *Worktowners at Blackpool,* compiles their observations of the town in 1937.

Early in the book, one 'Observer' (probably Harrisson himself) notes that, while some Worktowners favour travelling to Blackpool by bus, most prefer to go by train, partly for the convenience of avoiding 'traffic snarls', and partly because 'trams and buses are part of everyday, workaday life.'[35] Here is the train approaching its destination:

Winding along the coast of the Fylde, he [the traveller] reaches the world of sand-barrens, on which the star grass grows bending away from sea and wind. The train follows the line of the dunes and the Tower comes into view, dominating the flat landscape. No longer is the mill chimney the inescapable symbol; the 'other world' has been reached.[36]

Observer notes that as Blackpool is approached, the carriages become more convivial; cigarettes are exchanged; there are bursts of song ('Female voices, pleasant and tuneful'.) At Central there would have been one of the above-mentioned Blackpool 'crushes', the crowds likely to be slow-moving because many of the people in them knew each other. So people would be talking, and – especially on Saturdays – the crowd would have been flowing both ways, into and out of the station. On the platform, a railway employee (himself perhaps on a sort of holiday, having been seconded to Blackpool from some inland station for the summer), might have been positioned atop a stepladder, barking out train times through a megaphone. On the concourse, touts would have awaited – landladies or their representatives, trying to lure the unbooked, despite a bye-law against this introduced by Blackpool Corporation in 1869.

Blackpool landladies were often strong characters, in reality as well as mythology, and Blackpool in the Wakes era was quite a feminist world, given that the mills employed many women, who were well-paid and socially confident. So the decision about what to do first might well have been taken by a woman. Under the porte cochère taxis waited to take remove the posher arrivals to the smart hotels to the north of the town, such as the Imperial, which was half an hour's walk even from Talbot Road. But those taxis moved slowly through the crowds spilling off the pavements.

In most cases, Observer writes, the priority was 'find the place they had booked weeks ago': the boarding house, to use the term that had largely displaced 'lodging house' or 'company house' after the First World War. Whereas in boarding houses the landlady supplied and cooked the food, in the company or lodging houses guests brought their own food for the landlady to cook. In these she only supplied the

Blackpool Central station, September 1937.

basics, such as potatoes or 'cruet' (salt and pepper), and the landlady who charged for cruet was a stock figure in the landlady jokes. Perhaps those destined for company houses, some of which survived into the 1930s, might have brought some of their own food on the train. Observer points out that the vast majority walked to their accommodation, however much luggage they were encumbered with.

Observer adds, however, that some visitors 'want to see and feel the sea right away', while other new arrivals, 'mostly the day trippers', head straight from the train to the Tower.[37] Some excursion 'packages' included a voucher for tea and a parkin (a Yorkshire cake) at the Tower, along with the train tickets. As for *feeling* the sea, that seems logical. A pint of beer, a tray of cockles, a cake – all can be had inland, but only at the seaside do you have beach and sea. You might want to

commune with them immediately, to prove to yourself that you have arrived.

We are at the start of the Worktowners' 'Saturnalia', the Blackpool 'Magic', as Mass-Observation had it: the arcades, freak shows, wax tableaux, over-the-top swings, dancing or roller skating until the small hours on the Central Pier, ascending the Tower, riding the Reel, the Whip or the Big Dipper at the Pleasure Beach. Or perhaps swimming in the sea; or *watching* the sea. In *Carnival at Blackport* J. L. Hodson writes that 'Crowds of holidaymakers at Blackport sit for hours watching the sea as intently as though it were a Test match between England and Australia' – and perhaps falling asleep in a deckchair while doing so, daytime sleep being a great luxury to mill workers. For the Blackpool masses, the beach would become a home from home, and there was always a free spot on the soft sand (Blackpool's saving grace), however sunny the day.

My experience of holidaying in Blackpool as a boy had something in common with that of the Worktowners. The place seemed wild, full of dizzying excitements. In the circus at the base of the Tower, the glare of the lights and the loud cymbal crash that accompanied every pratfall of the resident clown, Charlie Cairoli, once gave me a migraine and I had to be led out onto the prom to be sick.

In the absence of Central station, by the way, Blackpool Tower has become the heart of the town. It offers numerous attractions, the most elemental being a ride in the lift to the top, from where, on a clear day, you can see the Lake District. And the heart of the Tower itself is the ballroom, where, several afternoons a week, in and out of season, dancing takes place. You enter the vast, gilded space to be confronted by a Felliniesque scene. A great white and gold

organ is being played by a man whose blazered upper half is serene, but his feet are flying about the pedals. Any idea of Blackpool as a dissolute lowest-common-denominator place is dispelled by the correctness and energy of the dancers, who sweat slightly in their sparkly clothes. The food menu contains one option: a three-tiered serving of crustless sandwiches and dainty cakes.

Central was not a Beeching closure – he had wanted to retain Central and close Blackpool North – but Blackpool Council lobbied for the closure of Central, because it had plans to develop the site, by which presumably it meant that giant car park. We travelled from York direct to Blackpool North direct from York on puttering DMUs, so there was no glamour in that. The Blackpool trains I chiefly remember were at the Pleasure Beach, whose diverse thrill rides made it seem like some great transport interchange, albeit with some of the passengers flying by overhead and possibly upside-down. I preferred the rides that remained on the ground, like the Ghost Train and the 21-inch gauge Pleasure Beach Express, dating from 1905, whose carriages are hauled by sparkling Hudswell-Clarke steam-outline diesels. The train rolls sedately beneath the wilder rides, the journey punctuated by funny signs – 'First class accommodation is at the front, middle and rear' and 'Sorry to confuse readers, but there will be no delays today.'

As an adult, I knew about the death of Central. In the late 1980s you could still see the outline of the platforms in the car park. Some low walls survived, with traces of black engineering brick. I discovered that a gaunt red-brick building on the south-east corner of the car park, with shops at its base and broken windows on the three storeys above, had been overnight accommodation for railwaymen finishing late turns in Blackpool. Apparently facilities were basic, with

beds in cubicles. There was a reading room, however. The LNWR had built it, but it was also used by employees of the Lanky. All that survived of the station itself was a public lavatory, with huge stone urinals. There was a blue plaque on the wall, explaining what the conveniences had been part of; they were knocked down in 2009 even so, and replaced with some less attractive toilets. I would sometimes walk in the direction the tracks had taken, the car park giving way to the coach park and then the Yeadon Way, which connected the cars and coaches to the M55, the conduit for most Blackpool visitors today. And there are still many visitors: 20 million in 2022, that post-Covid summer, testifying to a long bottled-up need for escape and fun.

The seemingly astronomical 2022 number reflects the greater mobility of modern times. You can just jump in your car and go to Blackpool; but you can also just jump in it and drive away at the end of the day. Whereas most of that 20 million were day trippers, a high percentage of the 7 million in 1937 would have stayed a week. When it comes to proper holidays, as opposed to day trips, Blackpool (in the words of Vanessa Toulmin, an adviser on seaside regeneration) 'moved lock, stock and barrel to Benidorm'.[38] But Blackpool is trying to reclaim the overnighters: single tickets for multiple attractions, for example – more than can be enjoyed in a day. These initiatives reflect a new confidence in Blackpool, which is in the midst of a big regeneration, funded by two billion pounds of private and public investment.

At the time of writing there are direct services between Blackpool and London (which there weren't between 2003 and 2014), but not many: one a day from London and two from Blackpool. In 2018 a Virgin Pendolino unit was named *Blackpool Belle* to mark the start of Virgin's electric services to Blackpool, enabled by the electrification of the line from

Preston in that year. (*Blackpool Belle* was the name of Blackpool's first illuminated tram as well as an excursion train which, according to Visit Blackpool website, 'took people across Lancashire for a Saturday night of dancing through the 1930s to the 1960s'.)

Most railway journeys to Blackpool involve a change at Preston, whose station Simon Jenkins finds 'a building of charm' for its 'Italianate/French style … The lower floor is of five Tuscan bays, while the roof is crowned with a French mansard roof, prominent dormers, chimneys and much ornamental ironwork.'[39] The latter is festively coloured in red and two shades of green, appropriate for a holiday junction. In busy times the queues for trains extended for hundreds of yards outside the station, with buckets and spades lashed to the knapsacks and suitcases.

In early summer 2024 I awaited a Blackpool train at Preston, alongside a man who looked to be in his late seventies. He wore a suit and tie and was thin in the old-fashioned way. He kept looking at his watch to check the time, rather than a phone, and he had alongside him an old-fashioned suitcase, longer than it was high and without wheels. He might have been a figure from the 1970s, because all the evidence suggested he was heading to Blackpool not merely for a day trip but for a holiday. As we boarded the train to Blackpool North, I said, 'It's a long time since I've seen a suitcase without wheels.'

'It *does* have wheels,' he said, slightly affronted, and he pointed to two small ones in one corner, almost residual, like little toes. Across the aisle a youngish woman was crying. It became clear from her anguished conversation with her male companion, and from various phone calls, that at some point on her journey to Preston station she'd been robbed. Either

because of some nervous condition, or just because of the stress of the moment, she was shaking continually.

The train, about a third full, began rolling through the flat fields of the Fylde, which looked very green in the developing sunlight, the cows very black and white by contrast. In the 1920s and 1930s there were hoardings in the fields, paid for by the Lanky and the LNWR and promising good times in Blackpool. We called at Kirkham, Poulton, Layton; each time more people got on than got off. Clearly Blackpool was the goal. Finally the top of the Tower came into view, like the tip of a rocket taking off. The companion of the woman across the aisle tapped her shoulder, alerting her to the sight and she slowly smiled: 'Exciting,' she said. That the Tower could make her smile was a great tribute to its architects, James Maxwell and Charles Tuke, neither of whom lived to see it completed.

You can now see less of the Tower from a train approaching Blackpool North than in the past, thanks to the building of a new Holiday Inn. An underpass beneath the new hotel proclaims itself NORTH STATION TRAM STOP, because in spring 2024 Blackpool trams were reconnected to Blackpool North station for the first time since the 1960s. So Blackpool North is being re-embraced, brought back into the fold.

As for Central station, it's not being rebuilt, but the next best thing is happening: the site is earmarked for regeneration at a cost of £300 million. The plan is for restaurants and a food market, where 'fresh food' will mean more than that Blackpool staple, 'freshly fried doughnuts'. The engine men's hostel is set to to become an Aparthotel, adjacent to a Heritage Quarter. The space freed up by a new multi-storey car park will accommodate a new public square to be used for live entertainment. Hoardings about the project include this from Adrian Spawforth, master planner for redevelopment:

'We are trying to retain some of the railway heritage as part of the scheme. In particular we are trying to show the original platform and rail line positions in the new public square so that when you are up the tower, you will see the scale of the station.'

SOME RAILWAY-MADE RESORTS

Cleethorpes

Some seaside resorts were created by a local visionary work-ing in tandem with a railway company, and we will be coming on to those. In other cases, the railway itself supplied the vision. Stuart Hylton describes the 'particularly strong rela-tionship' that developed between the railway and the town of Whitehead **in** the north-east of what is now Northern Ireland. The Belfast & Northern Counties Railway

> undertook many of the functions of a local authority. They built a landing stage and a ½ mile-long promenade (made of old railway sleepers, and lit by railway-style oil lamps) and even imported sand for a beach, which they kept in place by groynes (again built of surplus sleepers).[1]

This project reflected the enthusiasm for promoting tourism of Edward John Cotton, dynamic manager of the B&NCR. He appears as 'Captain Ross' in a novel of 1935, *Delina Del-aney*, by the notoriously florid writer Amanda M. Ros, who describes him as

> the father of railway enterprise – that most undoubted

friend of railway ingenuity, whose sharp, keen eye reveals in its sly look the wonders of science; that eye that flashes with pride as the inquiring mind of the most curious is brightened by the marvellous growth of steamy enterprise ...

(The sentence goes on for the rest of the page.)

In a blog for the National Railway Museum, Lorna Hogger mentioned another very physical entanglement of resorts and railways: in 1908, the Great Eastern Railway brought barrels of seawater to Liverpool Street. Hogger quotes the *Railway Magazine* of 1908:

> Now that the seaside holiday season is over, it is valuable information to those who have enjoyed the recuperative qualities of sea bathing to know that it is possible to continue their sea water baths in their own home through an enterprising arrangement made by the Great Eastern Railway to deliver sea water in kegs daily from Lowestoft to any part of London including the Great Eastern Railway suburban stations within the ordinary railway cartage delivery radius for the small sum of 6d. for three gallons.[2]

In 1908 or so, *Dickens' Dictionary of London* (a publication started by Charles Dickens Junior) commented on the plan. The water 'was brought into London by the night mail passenger train'. Orders for it could be sent by post to the Sea-Water Office, 138 Bishopsgate St. Without, EC, or to the station manager at Lowestoft. The casks containing the water were 'well sealed and fitted with handles for ease of carrying upstairs.'[3]

A more orthodox railway promotion of the seaside was observable at Cleethorpes.

The railway came quite late to Cleethorpes, in 1863, when it was a genteel watering place and fishing village. People would drift down to it on foot or by horse-drawn bus from Grimsby, which from the late 1840s was being developed as a port by the Manchester Sheffield & Lincolnshire Railway. Cleethorpes was more attractive than Grimsby; most places are, in a conventional sense. In mid-June 1860 the *Grimsby Gazette* announced an 'IMMENSE SUNDAY SCHOOL TRIP TO GRIMSBY', scheduled for Sunday 21 June.

Not less than 8,000 children and teachers are expected to arrive at Grimsby by a special train in the morning, from Bradford and neighbourhood ... Forty-four schools will march in procession from Grimsby, by the sands, to Cleethorpe [sic], preceded by two brass and two drum and fife bands. They will be addressed, and will join in singing at Cleethorpes ...

On Monday 22 June the paper followed up on the story:

This great excursion of which we gave notice last week, came off yesterday ... the first train, consisting of about 25 carriages, arrived at Grimsby about 9 o'clock, being quickly followed by five others, consisting of from 25 to 30 carriages each; the passengers being conveyed to the docks, and proceeding along the coast to Cleethorpe [*sic*] as they arrived, bearing their many coloured banners ... The morning continued cloudy, but shortly after twelve the rain descended copiously, to the great discomfort of the mass of children who could not obtain shelter ...'

Notwithstanding which, the report continued, 'all parties appeared to enjoy themselves exceedingly' (which I don't believe).

A Cleethorpes historian has described the coming of the railway as 'the most important single event in the resort's life'.[4] Bringer of the railway was the thrusting Edward Watkin, General Manager of the Manchester Sheffield & Lincolnshire Railway from 1854, and later its chairman. (He eventually extended its network to London, under the ambitious guise of the Great Central Railway, which he also sought to connect to France, via a Channel Tunnel and two other companies of which he was chairman: the Metropolitan Railway and the South Eastern Railway.)

Watkin has a big fan club in Cleethorpes.

Cleethorpes is served primarily by TransPennine Express, but also by Northern and East Midlands Trains. Most train-borne visitors come from the Midlands and South Yorkshire, the latter especially, to the extent that tourists in the town are known as 'Yorkies'; but I approached from London.

In the 1970s there were twice-daily services to and from London, with luncheons and teas served in summer, as was only civilised, it being a four-hour trip, and some of these trains were Deltic-hauled. For anyone whose pulses were not set racing by that word Deltic, perhaps it's worth mentioning that these haughty-looking locos (otherwise known as BR Class 55s) were the most powerful single-unit diesels in the world when introduced in 1961. They hauled express trains on the East Coast Main Line, and a hundred miles an hour was a mere cruising speed for them. Rail fans worshipped the roar and the throb of the engines, and were known to favour riding in the carriage nearest the loco with all the windows closed, the better to experience this. That would

be a radical move in a train to the seaside on a hot day, but the scenario became possible when the Deltics began to be retired from express duties in the late 1970s, displaced by the HST. They were seen at Scarborough, Filey and Skegness as well as Cleethorpes, and, of course, heard. It has been said that an approaching Deltic could be heard five minutes before its arrival at a station, so anyone sitting on a beach at those spots might be aware of some strange atmospheric tremor, with no apparent cause in view.

There were direct trains from London until the 1990s, and there are plans to restore them, but for now it's necessary to change at Doncaster. The class 185 Desiro DMU from Donny (operated by TransPennine Express) had the casual comfort of a train on a French or Italian branch line in the 1980s: wide, soft seats, and not in the high-backed airline style, which blocks window views. There were capacious luggage racks, but with notices saying that suitcases should be stored at the carriage ends – not that there were any suitcases or holiday impedimenta to be seen on this bright Saturday in late May.

On the journey there was interest all the way. At first the line skirted the Aire & Calder Canal; then came the rusty steelworks and commensurately rusting freight wagons of Scunthorpe. Then to Barnetby, which nestles in a gap in the rolling Wolds. Soon after, the pale, thin chimneys of Immingham, like giant cigarettes puffing away, became visible to the north; next we were in the Victorian gothic of Grimsby Docks, some of whose buildings are derelict. For about a minute I had a view of the sea – the Humber Estuary, that is – uninterrupted by industry, then we were in Cleethorpes. That fleeting sea view must be the one evoked in the poster, 'Cleethorpes: It's Quicker by Rail'. But I can't believe Cleethorpes beach ever really manifested as that

wall of dazzling gold; the poster also implies that the beach is below the train, whereas in fact Lincolnshire is flat. But Cleethorpes station really is right on the front; the signs on the concourse bearing the word 'Seafront' with direction arrows are completely unnecessary, the sea being immediately beyond the disused Platform 4, on to which the beach sand sometimes blows.

On the station concourse is a small, nondescript brick building, part of a late-Victorian refurbishment of the station, reading 'No. 2 Pub'. It boasts many CAMRA accolades, but the effect must be to prompt some drinkers to seek out 'No. 1 Pub'. To find this, you must quit the station before doubling back on the landward side to a building resembling a row of cottages with tall chimneys. This once housed the original refreshment room and booking office, and is now No. 1 Pub. It, too, boasts CAMRA accolades; it is also an informal railway museum. Old oil lamps are displayed, along with signal arms, telegraph instruments and blue enamel signs reading 'Waiting Room', 'Tickets' etc. There are framed 'crush' photos of early-twentieth-century trippers overflowing from station to prom to beach. A framed BR notice dated 10 June 1962 lists 23 excursions arriving on that day, about one every seven minutes between 10 a.m. and 2 p.m. from spots like Doncaster, Sheffield Victoria, Rotherham Central, Wakefield Kirkgate, Penistone, Clay Cross, New Holland, Mexborough.

When word got round the pub – crowded on this Saturday lunchtime – that somebody was interested in the history, a sort of emergency education committee was quickly formed, the chief convener being Ray, who modestly described himself as 'the kitchen boy' (he looked about sixty) at No. 1 Pub. He led me to one memorabilia-packed alcove, designated 'Watkin Room'. 'Amazing fellow, Watkin,' said

Ray. 'He saw all the possibilities of Cleethorpes and he just *did* it.'

In the 1950s Cleethorpes advertised itself as having been 'Planned for Pleasure'. It was Watkin, and subsequent railway managers, who did most of the planning. At his initiative the MS&LR line was extended from Grimsby to Cleethorpes in 1863. The immediate effect was that of 'multiplying the number of trippers ten-fold' compared to the year before.[5] In 1874 the line was doubled, bringing in yet more, and the resident population of Cleethorpes doubled between 1860 and 1880.

In 1881 the MS&LR (Watkin, in effect) reinforced the sea defences of Cleethorpes by building the North Promenade, saving the station, and the town, from tumbling into the sea. I stepped onto that prom, with the intention of looking at the other gifts the railways brought to Cleethorpes, but the station does its best to detain you. Alongside No. 2 Pub, and facing the prom, is a fish and chip restaurant, housed in an elegant glass building dating from 1885 that was once another station refreshment room. Alongside it was a delicate Gothic clock tower with four faces, built in 1887 for the benefit of trippers who might not have watches, and so were in danger of 'losing' their train, as the Victorians had it.

Eventually I exchanged the smell of fish and chips for that of candy floss and waffles. A procession of donkeys with sun-faded blankets under their saddles carried children across the soft sand. Out on the Humber was another procession – of cargo ships. It was said of Cleethorpes in the late eighteenth century that you could see 'a hundred sail' on 'the German Ocean' from the bow windows of the Dolphin Hotel, which survives as the Dolphin live music venue. Behind the ships in the hazy blue, Spurn Point lighthouse (the tallest in the North of England) looked about a centimetre high.

One of the former station refreshment rooms
at Cleethorpes. Well, it still is really.

Only a stub of Cleethorpes pier remains, but the stub does
accommodate the large Pier Pavilion, built by the MS&LR,
which leased the pier from 1884 and in 1903 bought it out-
right. At a meeting in 1884 some shareholders objected to
the company's involvement with the pier, to which Watkin
replied that in 1864 the company had carried 47,030 passen-
gers to Cleethorpes, in 1881 283,022, and 'traffic of that kind
is really worth a little outlay to sustain it'.[6] I was now passing
what a local paper had called in 1885 'an imitation pile of
ruins'. Ross Castle, as it's called (after the secretary of the
MS&LR secretary, Edward Ross), was a railway-built folly,
designed to look like the leftover of a medieval castle. It, and
other amenities, including gaslights along the prom, were
opened in 1885 by Prince Albert.

In 1898 the MS&LR became the Great Central Railway,
and three years later Sir Edward Watkin died. He epito-
mised can-do Victorianism to the extent that his dates were
the same as those of Queen Victoria: 1819–1901. In 1923 the

GCR was absorbed into the LNER, and an internal LNER memo of 1926 chuntered about how the administration of a pier and pleasure gardens was scarcely a job 'for a railway company to undertake'.[7] Cleethorpes Council would buy the LNER's seafront estate in 1936. Cleethorpes was still *en fête* in the 1950s: John Trevitt, a retired academic and co-organiser of a mobile exhibition about Edward Watkin, points to 1951, when (neatly enough) fifty-one excursions arrived. 'I've no idea how they handled all the trains; I think they were backed up for half a mile outside the station.' But this was the peak.

Alan Dowling reports that 'three-quarters of the resort's estimated 1 million visitors in the mid-1960s travelled by road.' In 1964 the BR Board sold the remainder of the railway estate in Cleethorpes, and in 1970 the link to Peterborough via the East Lincolnshire Line was lost under the Beeching cuts. At least Cleethorpes retained its other line, but the closure of the East Lincs cut Mablethorpe, Sutton-on-Sea and other small resorts off the network entirely.

Cleethorpes was always a working-class resort, and there had been the usual objections from locals to rowdy excursionists. But it was never as wild as Blackpool, and an accommodation was achieved in that, the further south from the station you walk, the posher the town becomes. The accumulating salubrity – signified by the increasingly exotic character of the gardens alongside the prom – culminates in the Kingsway Hotel, which opened in 1926 and has the stately comfort of a Deco liner: all wood panelling, polished brass and thick blue carpets. Inland from the prom are pretty Victorian streets with independent shops, delis and bars, suggesting that Cleethorpes is, gently, gentrifying. Many residents commute to Grimsby, just as they did in Watkin's day, and they'd be mad not to do it by train.

Silloth

What emerged from a ferocious railway tangle at Silloth in Cumberland, Cumbria, was a sleepy seaside resort without a railway. So I drove to Silloth, which took six hours, the town being remote from London, as it is from most places.

In 1854 the Port Carlisle Dock & Railway Company opened a line along a filled-in canal running directly west from Carlisle to Port Carlisle. But Port Carlisle quickly became unviable owing to silting up, and in 1856 the Carlisle & Silloth Bay Railway & Dock Company (henceforth the C&SB) opened a branch running south off that line over the 16 or so miles to Silloth, which at the time was inhabited mainly by rabbits. The main proposers of the C&SB were William Marshall, MP for East Cumberland, the Dixon family, cotton manufacturers of Carlisle, and J. D. Carr, biscuit manufacturer, also of Carlisle, and after turning off the M6 I found myself behind a green articulated lorry belonging to Carr's Flour Mills and heading to Silloth.

It's a simple, small town built on a grid facing a large green, which in turn faces the sea – that is, the Solway Firth, with the Criffel hill beyond, which is in Scotland. I had booked into the Green View guest house, and as the proprietor, Graeme Aiken, showed me up to my room, I mentioned that I was interested in Silloth's history.

'Right,' he said, 'then I'm going to bore you to death, because so am I.'

The lounge at Graeme's place combines – incongruously, but somehow happily – a sparkly 1950s-looking cocktail bar and a small archive devoted to Silloth history, this in a house dating from the 1850s. The archive includes a print showing the first block of houses in Silloth: it includes Graeme's own and the Silloth Hotel, now called the Golf Hotel. 'The date is 1859,' said Graeme,' but these are essentially Georgian

properties.' He meant by virtue of their handsomeness, and this applied to the whole grid of Silloth streets. 'They were meant to be wide enough so you could turn a horse and carriage around in them. I don't know whether that's true, but I do know you can't quite turn a Volvo XC90 round in them.' The gracious streets attracted the gentry, just as today people come to retire to Silloth from places like Greenwich, Buxton and Bath, seeking a more economical version of the Georgian scale they've got used to.

The builders of the town were the above-mentioned Marshall, Dixon and Carr, especially the latter two, whose plan was to create a holiday resort as a back-up, in case the dock they were developing should fail. The plan was of dubious legality, because the Act of Parliament that permitted their railway made no mention of urban planning.

The opening of the line, on 28 August 1856, was celebrated with a banquet at the Silloth Hotel, and the railway route to Silloth quickly eclipsed the one to Port Carlisle, to the extent that the motive power on that line was changed in the late 1850s, from iron horse to an actual horse. Having purchased 46 acres of land, Dixon and Carr began building their town, developing their dock, and losing money, but the North British Railway looked on their project with interest.

The NBR sought a foothold in Carlisle – the territory of rival companies, especially the Caledonian Railway – which the C&SB's station there would give them. Use of the C&SB line would also give them a dock from which to export goods carried along their new Waverley Line from Edinburgh. In 1859 the NBR bought the rolling stock of the C&SB before leasing it back to the company, and Dixon and Carr used this injection of funds to acquire further land and build more houses, as well as another hotel, a gasworks, a sewerage system, public baths and a promenade. The aim was to create

a 'Torquay of the North', and 'Carlisle and back for a shilling' became the excursion train formula.

In 1862 the NBR bought the C&SB on a 999-year lease. In 1880 it absorbed the company altogether. The NBR acquired steamers to ply from Silloth pier to the Isle of Man, Liverpool, Dublin, Belfast. It named one *Waverley*, which has become famous for still being in active service. The port prospered in the late nineteenth and early twentieth centuries, with imports of grain, timber, cattle and phosphates from America and exports of coal and manure. In 1870 Mr Carr had built his large, elegant flour mill on the dock, where it still stands.

At the 1923 Grouping the LNER took over the line to Silloth, even though it was in LMS territory. It perpetuated Silloth's image as a tranquil holiday resort, rebranding it on posters Silloth-on-the-Solway. On the eve of the war Silloth became slightly more bustling when a large airfield was built on adjacent flat land. But BR, it seemed, lost interest in Silloth when the airfield closed in 1960 and railway traffic reverted to being heavily seasonal. On Whit Monday 1963 3,000 visitors arrived at Silloth station. Even so, Dr Beeching closed the line on Monday, 7 September 1964, the last day of operation having been Sunday the 6th.

A tour of the town takes about twenty minutes.

The Green was deserted except for a single dog walker, this being a chilly spring day. Once, there were tennis courts on the Green, hence the LNER slogan, 'Silloth-on-the-Solway: First Class Tennis and Golf'. Graeme had told me the Green was packed on summer weekends, with people lounging around, playing makeshift games, eating picnics. 'People come to Silloth to do nothing,' he said. Certainly they don't usually swim in the sea, and they never did – too muddy.

Instead of swimming they sit on the prom like a cinema audience, watching the waves. There's a clump of pine trees just back from the prom, and these undermine any summer scene because they have been violently bent back by incoming gales.

Looking for the site of the deceased railway station, I walked past the flour mill, which looks like a Victorian ghost, or would have done had not some of the green lorries been in attendance. It stands on the dock, which is still quite busy, although it has suffered from the Russian invasion of Ukraine, since it used to receive grain from both.

On Railway Mews, a short street just inland from the dock, stands a row of elevated terraced houses of indeterminate age – elevated because they stand on the platform of the old station, a deliberate nod to the past. They date from the late 1960s but are designed to look older. The station was the focus of a network, with goods yards, and branches into the docks and onto the pier, the remains of which fell down in 1973. There was also a branch to a great sanatorium situated south of the docks, which helped determine the peaceful nature of the resort.

In 1954 Silloth was one of the first seaside stations to be served by diesel multiple unit. A two-car Derby Lightweight DMU (a particularly elegant and light-filled class of train) that once served the town now operates on the Ecclesbourne Valley Railway in Derbyshire. But on that final Sunday steam was in charge, as it generally was on summer weekends.

The 6.55 p.m. departure of Ivatt class 4 number 43139, from Carlisle for Silloth, was watched by hundreds. When it reached Silloth a thousand protestors tried to block its entrance to the station; they dispersed on the orders of railway policemen riding on the running board of the loco. A folk group played 'The Beeching Blues'; it was a beautiful

late summer's evening. An extra four carriages were added to the train for the return trip to Carlisle, such was the demand, but while some wanted to experience the last trip, others sought to block it, and there was an invasion of the line. The communication cord was pulled several times on that last trip; a bomb hoax phone call was apprehended. 'Save the Railway' and 'We Want to Keep the Line' had been painted on lineside houses.

Most of those details come from an article by Alan Earnshaw in the September 1990 issue of *Backtrack* magazine. 'Silloth suffers the legacy from being a railway town without a railway', writes Earnshaw, but Graeme Aiken is more phlegmatic. 'People had already adapted to the loss of the line, or they soon would do.' In other words, they bought cars or took the bus to Carlisle. And Silloth is still busy on summer weekends. 'After nine a.m. on a sunny day,' Graeme said, 'you won't find a parking space.'

Not quite everyone comes to Silloth to do nothing. It's famous for its golf course, considered one of the best in Britain. It was another gift from the railway to the town, being founded in 1892 by the North British Railway, and I had brought my golf clubs to Silloth. But before we come to the bathetic tale of my engagement with the course, a digression about railways and seaside golf seems justified.

'Golf', says *The Oxford Companion to British Railway History*, 'was probably the spectator sport which has been least influenced by railways.' Being an exclusive game (in England if not Scotland), golf 'did not seek ease of rail access.' Railways were too public and 'made access too easy'. But the direct opposite could also be argued.

Golf bags were often seen on railway posters, and in the guard's vans of sea-bound trains. An Edwardian railway

cartoon, often reproduced, shows a golfer on a station plat-
form. The caption reads, 'Porter (to Golfer who is immensely
proud of his set of clubs): "Where will you 'ave your 'ockey
bats, sir?"' Golf clubs might be carried to the railway-built
hotels serving golf courses – at Cruden Bay and Gleneagles,
for instance.

And there is an entire book on railways and golf. It's
written by Ian Nalder, who speaks of 'the close connec-
tion between the railways and golf' that 'lasted through the
Edwardian era to the 1920s'.[8] He mentions some booklets
published by railways, such as *A Round of Golf on the LNER*
by Bernard Darwin; *Golf at its Best on the LMS* by Del Leigh,
and *Some Friendly Fairways*, a Southern Railway publica-
tion, written by E. P. Leigh-Bennett. (We might add to the
list some more modest publications, like the *North British
Railway Golfers' and Anglers' Guide*, published in 1921, which
included a list of golfing 'DON'TS, for instance: 'DON'T
blame your caddie when you make a bad stroke; he may
be quite a decent lad, and is, perhaps, as ashamed of your
display as you are yourself.')

Nalder describes how George Gibb, a golfer with a hand-
icap of six and General Manager of the Great Eastern,
offered discounted golfer's permits on his railway. Gibb
was a co-founder of the Aldeburgh Golf Club, and the
permits, offered between Liverpool Street and Aldeburgh,
helped make Aldeburgh fashionable. The Great Eastern was
absorbed into the LNER, which offered its own Golfer's Cer-
tificate, enabling reduced fares to 130 golf-adjacent stations,
if signed by a club secretary, and if the journey was 'for the
sole purpose of playing golf'.[9] Nalder's book has a chapter
with almost the same title as the work by Bernard Darwin:
A Round of Golf on the London & North Eastern Railway, and,
yes, Bernard Darwin was related to Charles (grandson); he

was also *The Times* golf correspondent from 1907 to 1953 and a gifted amateur player, as ubiquitous in upper-class golfing circles as his fellow Old Etonian, Arthur Balfour.

Darwin wrote up twenty-three courses on LNER territory for his book. One was Goswick, by the sea in Northumberland, which particularly interests Nalder. The course was founded in 1889, by which time the village of that name had died, but in 1885 the North Eastern Railway had speculatively built a station near the beach, and this catered mainly to golfers until it closed in 1958. The course remains a landmark of the East Coast Main Line. 'Invariably in a sunspot, regardless of what the weather may be doing elsewhere, the eye feasts upon holes readily discernible between dunes, beyond which lies Lindisfarne.'[10]

Seaside links were among the earliest, most romantic and socially smart courses, and most were eventually served by rail. Bernard Darwin suggested that all players have favourite journeys to their second golfing homes, some made more 'enthralling' by the familiar railway junction that comes on the 'threshold of paradise'. He mentions a few: 'Leuchars, change for St. Andrews, Ashford, change for Rye, Preston, change for St Annes and, best of all, Dovey Junction, change for Aberdovey, Tywyn and Barmouth way.'[11]

The train journey often gave a preview of the links to be played. When in 1946 the American Sam Snead surveyed the Old Course at St Andrew's – on which he was about to play the British Open – from an approaching railway carriage, he wasn't impressed. The course was not as manicured as those in the States, and he said he was sorry to see it had been bombed in the War (which it hadn't been).

The clubhouse of the Silloth-on-Solway Golf Club lies a minute's walk from the site of the old station, and two minutes

from the Green View Guest House. I made that walk with trepidation. I am not a good golfer. I knew that Silloth, like all links, is unforgiving of wayward shots, and it was likely there'd be even more of those than usual from me, since a strong, rain-flecked wind was getting up and the light was fading, the sunset turning the bricks of the Flour Mill russet- coloured.

On the first tee the sea was out of sight, but the roaring of the waves was loud. From the third tee, by which point I'd already lost three balls in the rugged heather offsetting the manicured fairways, the third green is invisible, but a little stepladder is provided so that you might espy the hollow in which it lies, as if in my case this made any difference. On the fourth hole, the sea came into view, shockingly dramatic and adjacent, like suddenly seeing a wild animal. By the sixth hole there was so much wind and rain that the seagulls seemed out-of-control overhead. Giving up, I trudged back to the clubhouse.

Framed photographs on the wall of the bar give some of the history. The club was founded in 1892 by the NBR and developed by two Willies, both leading professionals: Willie Fernie and Willie Park. The NBR already had a relationship with the latter, since its line to Silloth ran through his land, and he had the right to flag down any passenger train he wanted to board. Also resident in Silloth was a doctor called John Leitch. He had five daughters; three went on to be leading amateur golfers, of whom the most successful was Cecilia, known as Cecil. Ian Nalder writes that 'because of her prowess any golfer worth his salt could tell you where Silloth was!' She was known for her 'palm-under grip, and ducking right knee', and the graceful woman depicted in the LNER poster of the late 1920s, captioned 'Silloth-on-the-Solway: Finest Seaside Golf', seems to be striking the ball with just that technique.

Great Western Railway Resorts

The GWR did not physically create the resorts it served, but it put them on the map by publicising them. Of the Grouping companies, the GWR had a rival in the Southern when it came to promoting seaside destinations. But the GWR's publicity was more audacious, and it raised the profile of literally out-of-the-way places, whereas thousands of Londoners would have gone to Brighton every year even had the Southern Railway not existed, because Brighton is on London's doorstep. The GWR was also more sea-oriented and more sybaritic than the Southern, whose primary task was to ferry commuters in and out of London. You can see that today, at Paddington, where there's a great frieze showing the Dawlish sea wall above the entrance to the main public lavatories. The theme tune of the Paddington Band, which strikes up at 7 p.m. prompt every Friday, is 'Plymouth Hoe!' It was said in Edwardian days that you would be guaranteed to see 'a dash of Naval uniform' at Paddington, and that's still true.

Ex-Paddington trains all seem destined for the sea, but in the early days of railways Paddington might have approximated to King's Cross: a starting point for a journey to industrial scenes. Most of the towns in Cornwall and Devon that became holiday resorts gained railway lines in the first half of the nineteenth century, but they served mineral mines declining even then; and if Cornwall was not seen as industrial, it was seen as remote. It was the last county to be connected to the English network, and the connection was made by Brunel who, reading from west to east, engineered the West Cornwall line from Penzance to Truro (1852); the Cornwall Railway from Truro to Plymouth (1859); the South Devon Railway from Plymouth to Exeter (1846); the Great Western Main Line from Bristol to Paddington (1841).

Brunel was dying, from overwork and cigars, when he was carried recumbent across his Royal Albert Bridge. It is paradoxical that his hard work created the 'Holiday Line', which is what the GWR called itself in 1908, at the suggestion of the Welsh artist Archibald Edwards. In *The Cornish Riviera* (one of many books with that title), Sidney Heath wrote, 'It is not too much to say that Cornwall owes its present favourable position as a health resort almost entirely to the genius of Brunel and the enterprise of the Great Western Railway.'[12]

What the GWR frankly called its 'propaganda' took imaginatively diverse forms before and after the Grouping. Series of slides for lantern lectures were available free to clubs and societies, and the GWR was the first company to publicly exhibit a film about itself ('animated pictures' of the North Wales coast, shown in 1904 at the Empire Theatre, London). More films followed, and on 20 May 1914 the GWR held its own 'Cinematographic Matinee' at the London Coliseum. There were fifty or so jigsaws (as against the LNER's two), with a children's board game, Race to the Ocean Coast, made by the jigsaw supplier Chad Valley. Perhaps it was also an *adults'* board game: 'Take one home for the kiddies to-night and have a game yourself,' suggested the advertisements. A map of the whole GWR system was 'the racecourse', and the winner was the first person to surmount 'novel handicaps' – such as 'communication cord pulled' or 'line under reconstruction' – and reach Penzance, Birkenhead or Fishguard. The latter two seem uninspiring targets, and the game did not sell well: it was withdrawn in 1932, two years after its launch.

The most regularly occurring tag was 'Cornish Rivera', to the extent that the company didn't feel the need to include its own name on a poster of 1913 showing a woman in a gauzy dress alongside the sparse information: 'The Cornish

Riviera ... On the sunny shores of the Atlantic'. The original poster of 1907 showing the Cornwall peninsula apparently mirrored by a map of southern Italy was described even by so mild-mannered a man as Michael Palin as 'dubious'. Others have called it an outright lie. But its brilliance lay in the suggestion that this was a seaside location welcoming and temperate all year round, the real Riviera – the one on the Med (which did not return the compliment of comparing itself to Cornwall) – being a winter destination for wealthy British travellers. Hence the GWR's outrageous poster of the early 1920s, headlined 'Bathing in February in the Cornish Riviera', featuring half-tone photos of flapper girls smiling bravely, but obviously shivering in their fashionable swimsuits.

The company's main holiday projectile was the *Cornish Riviera Express*, from Paddington to Penzance, or vice versa. It made its first run on 1 July 1904. A competition had been staged in the *Railway Magazine* to find a name for it. The two joint winners suggested the *Riviera Limited*, which was sycophantic of them, since the GWR had already launched the 'Cornish Riviera' concept with a book of that name published earlier in the year. The company inserted 'Cornwall' into the title of the train, which was also known as 'the 10.30 Limited', that being its departure time from Paddington for many years. When from 1958 the train became diesel-hauled, the quaint boast 'Limited', meaning a service with a limited number of stops, was dropped, and the official title became the *Cornish Riviera Express*.

Initially the train really did make limited stops, its first being at Plymouth. So 225 miles of the total 305 were accomplished in one great leap. Its next stops were at Truro, Gwinear Road and St Erth, railhead for St Ives, before arrival at Penzance. The train gradually took note of Devon, and

the number of stops increased. The initial leap was foreshort-
ened to Exeter in the 1930s, Taunton in the 1950s; today it's
Reading. (Modern trains, being faster, can afford to stop more
often than they once did.) But 'the Riv' was always a feeder for
the wider West Country, scattering tourists, and their money,
over the whole territory, by shedding, or 'slipping', coaches
on the way to Penzance, like so many blessings bestowed.

At Westbury two coaches were slipped for Weymouth; at
Taunton, two more for Ilfracombe and Minehead; another
two for Torquay at Exeter. The GWR was a slip-coach special-
ist, and before the war its *Torbay Express* featured the virtuoso
refinement of a slip portion for Ilfracombe that included a
dining car. In Cornwall further coaches were more sedately
detached (not slipped) at Par for Newquay, at Truro for Fal-
mouth, at St Erth for St Ives. As your slipped or detached
carriage, suddenly abandoned by the roaring express, rolled
to a halt and you waited for the tank engine that would carry
you along the branch, you might worry about whether your
destination would live up to the GWR propaganda. Would
Torquay really look like St Tropez, as the posters implied?
Would Falmouth really be 'only less majestic than Plymouth
Sound, and far more lovely'?

As for CRE haulage, the most glamorous double act,
from 1927, was a King class (the most powerful British 4-6-0
engine) which, being too heavy for the Royal Albert Bridge,
gave way at Plymouth to a Castle, Hall or Manor – nimbler
4-6-0s, but still with the elegantly tapering boilers and the
predominant greenness offset by the brass boiler caps, seem-
ingly designed to catch the sun's rays. And since the Halls
and Manors resembled smaller versions of the Kings, they
had something of the cuteness of model engines. The GWR
celebrated the elegance of its rolling stock in many books,
usually written by A. J. L. White Green, intimidatingly styled

the 'mechanised accountant' at the company's Swindon Works. The engines were often named after attractive locations on the network. Only one Manor was named after a coastal mansion (*Torquay Manor*), but the Castle class namechecked several seaside spots, such as *Dartmouth Castle, Powderham Castle* and *Tregenna Castle* – and the GWR would have missed a trick by not mentioning *that*, since it owned Tregenna Castle and ran it as a hotel for visitors to St Ives.

The GWR was always writing about its most famous train. In 1929 a booklet called *A Silver Anniversary* marked its twenty-fifth year and the introduction of new rolling stock. Among its boasts was the following:

> An innovation which demonstrates the desire of the GWR Company to ensure the well-being of its patrons is the glazing of the coaches of the new trains with Vita glass, which admits those health-giving ultra-violet rays from the sun which ordinary window glass excludes.[13]

Which prompts the thought that any train heading to the real Riviera would not seek to boost the sun's rays, but rather block them with window blinds.

That book of 1904, *The Cornish Riviera*, written anonymously by A. M. Broadley, sold a quarter of a million copies and was republished and revised half a dozen times up to 1926. In 1928, a book of the same title was written by and credited to S. P. B. Mais, who in the same year produced a parallel volume, *Glorious Devon*. The GWR had become a sort of railway Faber, reflecting its middle-class clientele and mythologising its destinations and services. In *Go Great Western*, Roger Burdett Wilson writes that 'no other railway achieved anything near the output or quality of the Great Western's publications.'[14]

They were high-minded, literary and lyrical, with bibliographies at the end that included novels. There's some heavyweight (or heavy-going) art appreciation by Mais in *The Cornish Riviera*. Of the school of painters based at the fishing village of Newlyn outside Penzance he writes,

> They have fought an amazingly successful fight against the pretty-pretty and the conventionally beautiful. Their Madonnas are sturdy Cornish girls whose dignity of bearing and stillness arouse in the beholder an emotion only compatible to that felt on hearing the most majestic music.[15]

Mais was not so crass as to say that the GWR transported them and their paints and easels, but it did. Foremost among the Cornish art colonies was St Ives, base of Barbara Hepworth and her husband, collaborator and rival, Ben Nicholson. 'Artists as well as tourists puffed down from London on the steam trains,' writes Hepworth's biographer, Sally Festing, 'congregating, at different times, in Penzance, Newlyn and Lamorna on the south coast, St Ives and Zennor on the north.'[16] With logistical efficiency Hepworth – star of the St Ives scene – made the Great Western Hotel at Paddington her London base.

From 1906 the GWR also produced a more practical series of paperbound directories called *Holiday Haunts*. They were lists of places to stay, with commendations of hotels and guest houses in telegraphese ('facing sea', 'good cooking and homely'), with a few poetic embellishments by Broadley. The word 'haunts' was telling, designed to suggest the mystical uniqueness of GWR's patch – this land of strange legend, mermaids, giants, mists and myths. 'You may go there with the idea that you are in for a normal English holiday,'

S. P. B. Mais writes in his introduction to *The Cornish Rivera*, 'and find yourself in an atmosphere of warlocks and pixies'. In other words, you'll have a classier holiday on the GWR network than you will on that of the suburban Southern Railway, whose accommodation guides were more prosaically called *Holiday Hints*. A few sentences later, Mais takes the gloves off. 'The soft prettiness of our Southern Shires, she neither has nor pretends to have, her beauty is bracing and austere, rugged and fine. Let lovers of chocolate-box covers take warning.' But this sneering at the south is undermined by his own sign-off: 'S. P. B. M. THE HALL, SOUTHWICK, SUSSEX.'[17]

The distinctive tone, and vigour, of GWR publicity reflected its rivalry with the LSWR before the Grouping, and with the Southern afterwards. The LSWR developed a string of resorts in North Devon and North Cornwall. In the map at the back of Mais' book, the railways serving these are shown more faintly than the GWR's and described vaguely as 'other lines'. The ghost of the GWR won the battle with the ghost of the LSWR when Beeching closed most of these 'other lines', while only giving the GWR's old empire a severe pruning.

By then the West Country was the domain of the holidaying motorist, hence a Motorail (car-carrying) service running from Surbiton to Okehampton. The narrow Devon and Cornwall lanes, particularly unsuitable for cars, nonetheless became the natural habitat of the 'motorist', as against the mere 'driver', and you do wonder whether the Great Western didn't pave the way for this by its romanticisation of its territory. In 1961 the Tamar Road Bridge was opened alongside the Royal Albert Bridge; in that same year, the British Travel Association produced a film called *Westward Ho!*, fruitily narrated by Paul Rogers 'by arrangement with

the Old Vic Trust'. In its strangulated lyricism, it could almost
have been written by an updated S. P. B. Mais. 'Here,' Rogers
brazenly avers, as happy couples tootle through the techni-
colour lanes in Minis and Wolseleys, 'is the world as nature
intended, without any meddling by man'; and a great virtue
of Cornish bays is that they are 'all joined by twenty-minute
lengths of motor-road.' There are never more than two cars
in any shot. One of the motorists is shown, in a break from
motoring, doing an oil painting of Mousehole fishing village.
We are shown his depiction; there are no cars in it, which
underlines the disingenuousness of the commentary.

In his history of Penzance, Michael Sagar-Fenton argues
that, while the arrival of the railway brought the town into
'the mainstream of British commercial life', it 'maintained
a certain Victorian dignity', while other Cornish towns
touched by the GWR, like St Ives, Newquay, Looe, Fal-
mouth and Perranporth, 'went over to the tourist trade 100
per cent'.[18] But Penzance couldn't transcend the effects of
the motor car. Traffic became 'a curse of monumental pro-
portions'.[19] In 1937 the GWR had reclaimed land from the
sea to enlarge Penzance station. But in 1968 the council filled
half the harbour to create a large car park, and that's what
you notice if you arrive at Penzance on a rainy day, especially
if your train terminates at the platform outside the station
roof, where the block of granite inscribed with a welcome
to Penzance looks very grey indeed.

In 2001 the Tamar Road Bridge became the first sus-
pension bridge to be widened, whereas the railway bridge
remains single track. The current GWR still fights the good
fight against the car. In 'Five Get There First', a short, ani-
mated film that's part of their boldly retro 'Famous Five'
adverts (in which their Hitachi Intercity Express Trains co-ex-
ist with a rural 1940s world), the five head west to the seaside

on a train, while caddish Uncle Quentin, voiced by Richard E. Grant, attempts to get there first in his sports car. As the Five enjoy a peaceful journey playing cards (rather than looking at TikTok on their phones), Quentin fumes in traffic jams.

When considering the fate of a GWR-created resort in the era of the car and the plane, it is instructive to look at Newquay.

Newquay was put on the map by J. T. Treffry, who in the 1840s connected its harbour to his network of china clay lines on the moors above. In 1879 this network was taken over by the GWR, which had joined Newquay to Bude on the Cornish main line in 1876. At this point

> The village swelled into a little town; by 1901 it had a resident population of 3,000. Its industrial character had then gone, the china clay being handled at Par and Fowey on the South Coast. With its magnificent sandy beaches, the way was open for it to become the most frequented resort in Cornwall.[20]

In *The Cornish Riviera* S. P. B. Mais had assisted the town's ascent: 'If you arrive at Newquay by train, your first impression is one of surprise and delight at the number of jingles and governess carts that do duty for taxis, and your second, one of surprise and disappointment at your failure to see the sea' (it being below the clifftop town). But after that slight faltering, Mais is soon back up to speed: 'acres of sands with their huge rocky coves ... emerald-green waves ... first-class surf-riding'.[21] The surfing craze took off at Newquay in the 1930s, and in 1937 the GWR featured a Newquay surfer on a poster ('Safe Surf Bathing'), but something about Mais' prose suggests he was never a surfer himself. He'd rather talk about clifftop walks between medieval churches, and he

stresses that Newquay is no more 'new' than New College, Oxford.

When I arrived at Newquay by train one overcast morning in July 2024, my first impression was of neither surprise nor delight. The station was denuded in the familiar seaside way. Some of its former territory had been taken over by a large car park, which was entirely full throughout my stay. Some of the cars had surfboards on roof racks, or carried upright in customised trailers, so this might – with a different-coloured sky – have been a Californian scene. The station had two platforms, only one in use. On this stood a small brick shelter, capped incongruously by a wooden valanced canopy, of no practical use, but a nod to railway heritage. The disused platform was occupied by some ill-looking palm trees.

This was not my first railway arrival at Newquay. Our family went there by train for a week's holiday in the 1970s. We had a car but were not 'motorists' in the *Westward Ho!* sense. Possibly we travelled direct from Paddington, behind one of the of BR Western Region's stylish Warship or Western class diesel-hydraulics. The station had already undergone shrinkage, initiated by Beeching's closure of the branch from Truro, but a substantial canopy still sheltered the concourse. I remember that we stood beneath it, cowering from a summer downpour as we planned a dash for a taxi.

That canopy has gone, replaced by a skimpy, artistic wave-like one. In place of the old head-building is a 1960s block incorporating a shuttered café. The station exit is via a bleak walkway, where a Portaloo is guarded by two traffic cones. You emerge next to a Burger King, whose façade seems in keeping with the area around the station, and at odds with the Newquay I remembered. Our hotel was on the edge of the town. There was a steep, flower-decked climb up to it from the beach. It was in that hotel that I was first served a

Newquay station, summer 2024. The disused
platform has since been revived for the Mid-
Cornwall Metro and the palm trees re-homed.

minute glass of fruit juice before meals ('Sip it,' my father
counselled. 'It's a cocktail'), and where I first had Parmesan
cheese sprinkled on vegetable soup. In an article for *Rail*
magazine of September 2009, Chris Leigh wrote, 'I doubt
whether anywhere in the west has changed quite as much in
the past half-century as Newquay.' He continued,

> In the aftermath of the surfing craze, it has sought a new
> money-spinner and settled upon becoming the 'party
> capital' of the west. Amusement arcades, nightclubs and
> cheap drinks have brought the young uninhibited and
> driven away the traditional family holidaymakers.

Over the road from the station stands a venue surely
not catering to the young uninhibited: the Art Deco Great

Western Hotel. But was it ever a Great Western *Railway* hotel? In the slightly faded lobby, members of the hotel staff said neither the hotel nor the Great Western Beach it over-looks had ever belonged to the railway company. 'A lot of people used to think it did, though,' one of them conceded – and no doubt that was the whole point of the name. A display case in the lobby contains a 1930s brochure that speaks of a 'First-Class Residential Hotel, proprietor C. V. Hooper', not 'the Great Western Railway'. Ominously for that concern, another document on display showed that the hotel had been a member of the RAC.

The average age of the people in the hotel dining room that overlooks the Great Western Beach was about sixty; that of the people on the beach was about twenty-five. In their wet suits, they surfed or paddle-boarded or canoed; nobody just swam, and it all looked very effortful. They wielded the surfboards like shields. People seemed to be battling the waves rather than enjoying them. Fixed to the railings on the path down to the sand were notices advertising clubs, discos, cocktails and 'happy hours' for later in the day.

Back at the station a train was in – an Intercity Express Train, which is what GWR calls its version of the annoy-ingly omnipresent Hitachi A-Train template. The IETs have received a bad press since they were introduced in 2017, mainly because they have hard seats that numb your bum as you head towards Cornwall. Somebody commented on a railway forum: 'Hitachi techs came over from Japan and they expressed their surprise that the UK was using these on long-distance, intercity services! They are a short hop com-muter unit and nothing more. So sad when you remember what went before them!'

Are some of the IET services still named? Not an easy question to answer. The one waiting at Newquay was about

to form the 11.20 to Paddington, and this was footnoted 'AC' on the station timetable. 'AC' is short for *Atlantic Coast Express*, formerly the name of the Southern's famous West Country service, which lapsed in 1964, and which GWR cheekily appropriated for its summer-only Paddington–Newquay trains in 2008. The guard was standing on the platform ushering people aboard. 'Is this the *Atlantic Coast Express*?' I asked him.

'No idea, mate,' he said.

On returning to London, I twice emailed the GWR press office to ask about their named trains. No reply. The September 2024 edition of *Rail* magazine stated that GWR has dropped the name of the *Cornish Riviera Express* in its marketing. Where that leaves the Paddington–Penzance *Golden Hind*, the Paddington–Paignton *Torbay Express* and the *Atlantic Coast Express*, I don't know, and I wonder if GWR does?

I rode the IET – sparsely occupied – to the start of the branch at Par, where I alighted, and the train continued to Paddington. It was not a very sorrowful goodbye. It's more satisfying to ride the Newquay branch on the other trains that serve it: the ancient class 150s, better known as Sprinters. The Sprinters look more at home in the Cornish countryside than the brash IETs; they have softer seats and bigger windows – and they stop by request at the intermediate five stations, which the IETs ignore. The one that took me back to Newquay was very countrified, with a muddy floor, almost as many dogs on board as people, and tree branches probing and poking through the opened windows.

Despite its grandiose name, you don't see the sea from the Atlantic Coast Line, and it's not the most attractive of the surviving West Country branches. That accolade goes to the St Ives branch, which curves gently around the western side of St Ives Bay from St Erth, whose main purpose in life was once to be a railway junction for St Ives; it is now the

'park and ride' place as well. Riding that branch on a very hot day a few years ago, I began to wonder whether the rays of the sun coming through the window might be worsening the sunburn I'd picked up in Penzance. To the right-hand side, the whiteness of the beach was dazzling to the point of headache-inducing, and a kind of blue electricity made the sea hard to look at as well; on the other side, the bright pink flowers (thrift, I think) amid the greenery seemed to keep flaring and flaming in a not very restful way. It was the sort of experience that's beautiful in retrospect. In St Ives I needed a bottle of water, Nurofen and sun cream. I was then able to notice that the town still looks as quaint as it does in the GWR posters, hence the problem that could never have been brought about by trains alone: over-tourism.

The most interesting sights on the Atlantic Coast Line include the St Blazey freight yard, just after Par, where once was much activity connected with the carrying of china clay to Fowey. A few white-dusted hopper wagons are still hanging about. The line then enters the woodland of the Luxulyan Valley, and you see more of the wood than the valley from the train. Bland fields and white bungalows take over on the run-in to Newquay.

During the early afternoon in Newquay, the usual thing happened: the sun came out and the place began to align with the old GWR propaganda. The golden letters announcing the Great Western Hotel gleamed, as though with increasing confidence that it had once belonged to that illustrious company and not just C. V. Hooper. The surfing on the beach below looked exuberant rather than perverse. Bank Street, whose attractive Victorian facades once fronted banks, was bustling with people of all ages buying holiday goods amid aromas of sun cream. On my return to the station I noticed,

scrawled in chalk on the façade of the shuttered café, 'Closed, but back soon.'

What's also coming, in 2026, is the Mid-Cornwall Metro. This seeks to address social and environmental problems in Cornwall, which include seventeen neighbourhoods in the top ten most deprived areas in England and a high dependency on cars combined with low car ownership (22 per cent of households in Cornwall have no car). The scheme will increase the connections between Newquay on the north coast and Falmouth on the south coast of Cornwall, via Par, St Austell and Truro. New passing places will allow local trains to coexist with the IETs, which currently displace some local services to Newquay, and the second platform at Newquay will be brought back to life, with the palm trees humanely rehomed.

The old GWR had a mixed effect on the economy of Cornwall. It promoted some parts of its fishing industry, while killing off others. Certainly it created Cornish tourism, providing luxurious first-class services for visitors, but its third-class services for the locals were less good. It is a testament to the success of the old Great Western's propaganda that we might think of all West Country trains as holiday trains; they are not, and nor should they be.

SOME MIDDLEMEN

Pease in Saltburn

Here we consider some men (always men, unfortunately) who were either intermediaries between a railway company and a town or, as in the case of Henry Pease, prompted a railway company they were associated with to do something it might not otherwise have done: visionaries, perhaps, in whom altruism or sentimentality might be discerned, alongside the usual profit motive.

In 1861 the coal-oriented Stockton & Darlington Railway branched out into fun by opening a line from Redcar to Saltburn. This was to fulfil the vision of Henry Pease, a director of the S&D and a member of the Quaker family that had built Middlesbrough up from nothing into the 'Ironopolis', after the discovery of ironstone in the Cleveland Hills. While walking along the coast about 8 miles south of Redcar, Pease had another vision of a new place, but this would be an antidote to infernal Middlesbrough. Extrapolating from the Ship Inn and half a dozen cottages of what would come to be called Old Saltburn (all of which still stand), he envisaged a seaside resort for the upper echelon of the Ironopolis. The town, with streets named after jewels, a pier, assembly rooms, hotel and park, was built, as though from a seaside

kit, by the S&D in tandem with a local landowner, Lord Zetland.

In 1865 a guide to Saltburn-by-the-Sea recommended its climate for 'Unstrung men, languid women and weakly children', and let's hope these never occurred in the same family. It prospered gently before the First World War, reaching a population of over 3,000 in 1911. Thereafter it stagnated. In their *Yorkshire Tour* of 1939, Ella Pontefract and Maria Hartley suggested that the place 'seems to require another genius to rise up and finish its planning'.[1] The beachfront still looks a work in progress. There's a café and a small row of beach huts facing a tentative pier that reaches only as far as the end of the beach – an ensemble that hardly seems to justify the funicular taking people down to it.

Saltburn station, designed by the S&D's architect, William Peachey, retains its handsome portico in buff brick, surmounted by a sign reading 'Railway Station' in the tangerine shade denoting BR's North Eastern Region. The offices to either side have been converted to retail, and the train shed that once stood behind has entirely gone, so the two remaining platforms look naked. Also gone (in the 1970s) is the adjacent Excursion station.

When I was last in Saltburn you could see, to the north, the tangled form of the last remaining blast furnace of the dying Teesside Steelworks. It was demolished in 2022. The steelworks would have glowed dirty orange throughout the night, like a sunset that has got stuck, and the sight would have reminded people how lucky they were to be in Saltburn, where the Middlesbrough fires seemed to be parodied by night lights in glass bowls glowing gently in the park. The giant wind turbines standing in the sea off Redcar don't have the same salutary effect, since they are gentle themselves.

In his history of British Railway hotels, Oliver Carter

quotes a *Yorkshire Post* article from July 1863, describing the train ride from Middlesbrough to Saltburn. The journalist recorded the 'miles of gigantic blast furnaces and extensive iron shipbuilding yards, long trains of ore and countless heaps of pigs [pig iron]', and how these eventually gave way to 'pleasant countryside' and Saltburn itself, 'this Brighton of the North-East coast.'[2] Carter does not give the date of the article, but it was presumably occasioned by the opening of the Zetland Hotel, located immediately south of Saltburn station, on 27 July 1863. Henry Pease had a hand in its design, together with Peachey and that distinguished architect of the Gothic Revival, Alfred Waterhouse.

The Zetland was a classic railway hotel, in that it was intimate with its station. A siding projected towards its back door, with a glass canopy above, to shield travellers from the lashing wind and rain occurring more often in Saltburn than the builders of the town would like to admit. On sunny days the sound of the engine might have given way to happy cries of 'Love thirty!', because immediately to the right of this siding stood a hedge with a lawn tennis court beyond. But the frequent accompaniment of summer tennis, glasses of Pimm's Fruit Cup, probably weren't in evidence, Henry Pease having been a Quaker. So the Zetland was not a very boozy establishment, and in 1882 a certain John Richardson was fined 5 shillings for drinking a glass of beer on the terrace.

For the benefit of guests a telescope was kept in the circular room at the top of the central turret. From here the viewer would have been able to watch trains – or the steam and smoke arising from them – as they progressed south along the cliffs towards Whitby, having reversed out of Saltburn. The line, built by the Whitby Redcar & Middlesbrough Union Railway, and later taken over by the NER, visited the sleepy resorts of Staithes (approached from the air, in

effect, via a vertiginous viaduct), Hinderwell, Kettleness and Sandsend, all denied their chance of becoming less sleepy by the closure of their stations in 1958. The terminus was at Whitby West Cliff station, as opposed to Whitby Town, which survives.

One night in the late 1960s Malcolm Barker, author of *The Golden Age of the Yorkshire Seaside*, had 'the eerie experience' of being the only guest in the Zetland Hotel; it was converted to flats in the 1980s.

Shortly after writing this, I met a couple who'd stayed in the room that formerly housed the telescope. They'd rented it as an Airbnb. 'We looked out of the windows all the time,' one of them said. 'If it had been for sale, we'd have bought it like a shot.'

Peto in Lowestoft (and not in Yarmouth)

Of Lowestoft, *Bradshaw's Descriptive Railway Handbook of Great Britain and Ireland* (1863) observed, in snobbish telegraphese: 'Admirals, Sir T. Allen and Sir Thomas Leake, Nash the author and Gillingwater the historian, were natives. Harbour of Refuge, Tram Way, Promenade, Pier, Light Houses, Warehouses and Sea Wall were erected in 1848, by Sir S. M. Pete, Bart.'[3]

Inaccurate as well as snobbish, 'Pete' being a typo for 'Peto' – Sir Samuel Morton Peto, that is, widely known as 'the maker of Lowestoft'.[4] As such, he stands alongside those other patrons of East Anglian coastal towns: Colonel George Tomline at Felixstowe (which is today more port than resort) and Henry Styleman Le Strange at Hunstanton. It might be that such dynamic, and rich, characters were required to develop seaside towns in this remote territory, with its meandering country branches and a main line, the

Great Eastern, hardly worth the name. It had developed by piecemeal extensions in the mid-nineteenth century, with metropolitan termini at Shoreditch and Bishopsgate before Liverpool Street was settled on. 'Like the Great Western in Devon and Cornwall, the GER was part of the landscape,' writes Stanley C. Jenkins, 'and its dark blue engines with their polished brasswork and vermillion lining seemed to enhance the green fields, blue skies and flint villages of Norfolk.' There was another similarity with the GWR, since both were '"Holiday Lines", relying to a very great extent on summer leisure traffic to make up for a lack of heavy industry in their respective areas.'[5]

In *Howard's End*, E. M. Forster perpetuated the comparison. Just as in Paddington 'all Cornwall is latent and the remoter west', so 'down the inclines of Liverpool Street lie fenlands and the illimitable Broads'. The former seems truer than the latter. The partly subterranean Liverpool Street of 1910 – when *Howard's End* was published – was 'a place of endless shadows and corners'.[6] There was something of Gothic horror about its smoky platforms, with blockhouse-style station offices that looked like tombs and a giant dangling clock resembling a small church. (When it was lowered to the ground in 1941, in case it should crash down in bombing raid, it was hollowed out and used as an enquiry office with the clock face serving as a round window.) Posters advertising holiday destinations on Liverpool Street platforms were probably hard to read in the miasma.

Samuel Morton Peto was the largest shareholder and chief promoter of the Lowestoft Railway & Harbour Company, which in 1847 connected the town to the Yarmouth & Norwich Railway at a junction near Reedham. So began the railway entanglement of those two great rivals for tourists and North Sea herring, Lowestoft and Great Yarmouth. Ten

years later a second line, magnetised by Peto's improvements, approached from the south (today's East Suffolk Line), connecting Lowestoft to London via Ipswich.

Peto was born in Woking and he operated on a world scale – as well as building Nelson's Column and the new Houses of Parliament, he was the man behind the Grand Crimean Central Railway – yet he chose to live in Lowestoft, or nearby, in Somerleyton Hall, where I once warmed myself beside the largest November 5th bonfire I have ever seen, and which seemed to grow progressively hotter despite steadily falling rain. Peto's vision was of Lowestoft as a port for Norwich and a holiday town. In 1844, he and his architect, John Louth Clemence, built the Outer Harbour. They also developed a masterplan for a resort along the town's South Beach, where the tall, elegant houses of Wellington Esplanade arose in the early 1850s. Soon afterwards Peto was embroiled in the bankruptcy of the London Chatham & Dover Railway, which ended his involvement with Lowestoft, a town he had essentially created. In *East Anglia*, Paul Fincham writes that Great Yarmouth – which developed without a sugar daddy – was 'jealous' of Peto's benefactions.[7]

While Lowestoft and Yarmouth would compete for the mass market in holidaymakers, Peto put Lowestoft on a higher level. Yarmouth was, and is, brasher, with more amusements, two piers (to Lowestoft's one) and, like Blackpool, a Golden Mile, although it lacks the intensity of Blackpool. In Clement Scott's bestselling travel book of 1886, *Poppy-Land Papers*, the chapter on Yarmouth is headed 'A Playground by The Sea', whereas Lowestoft is 'Lazy Lowestoft':

> I shall always look upon Lowestoft as the very pink of propriety. It is certainly the cleanest, neatest, and most orderly seaside spot at which I have ever cast anchor.

Lowestoft station, with endearingly out-of-date sign.

There is an air of respectability at the very railway station, no confusion, no touting, no harassing and no fuss.[8]

The double identity of Lowestoft – port and resort – would have been immediately obvious to those arriving by train, the station being in sensory range of the harbour and fish market. The latter featured on postcards and might become part of any visitors' holiday, once the attractions of beach and pier had worn off. It was open to the public, rather than barricaded by high fences as it is today, and trippers could arrange for boxes of fish to be sent by train to friends back home. Many freight lines ran through the town, connecting the station to the harbour and other enterprises, including the 'Sleeper Depot' – not a refuge for night trains, but a quayside manufactory of railway sleepers established in 1914. The end products were stacked high like wooden skyscrapers for distribution around the country by three trains

every day. Also amid the freight lines was Coke Ovens Junction (which presumably did *not* feature on holiday postcards), from where a coastal line to Yarmouth sprouted in 1903, enabling holidaymakers to visit both, or for locals to see how the other half lived. In *Little Englanders* Alwyn Turner quotes a newspaper article of 1909 concerning the introduction of the state pension: 'A recently married couple in Yarmouth announced that they'd be spending their first week's pension on a honeymoon in Lowestoft.'[9]

By 1903 plenty of trippers *were* arriving. Early expresses from London for Yarmouth and Lowestoft had bifurcated at Beccles, but from 1904 there were through services to both. Holiday traffic peaked in the 1950s, when the *Easterling* ran from Liverpool Street to Lowestoft and Yarmouth, the train's name borrowed from *The Lord of the Rings*.

That Lowestoft–Yarmouth coastal line had been constructed jointly by the Great Eastern and the eccentric Midland & Great Northern Joint Railway, which rambled over East Anglia perpetuating romantic and doomed ventures. To build the line, the two companies operated as the Norfolk & Suffolk Joint Railway, so this was, so to speak, a double-jointed railway. The line connected a North Lowestoft station and Yarmouth South Town station, one of three that would arise in Great Yarmouth, of which only one remains.

Of the half dozen stops, only Gorleston-on-Sea was roused from slumber, and in the 1950s it had its own holiday special from London. The line survived Beeching and was still receiving *Holiday Camp Expresses* from Liverpool Street in the 1960s, but it closed in 1970. *Gorleston*, a novel by Henry Sutton, is a haunting depiction of the town in the mid-1990s and the romantic entanglements of its aged residents. The novel – presumably an accurate picture, since Sutton grew up in Gorleston – suggests that the railway must have been

largely forgotten by the citizenry, since no character mentions it, whereas cars play an important part in the plot.

There is no longer a straight-line connection between Lowestoft and Great Yarmouth, even though they're only 10 miles apart. They are linked indirectly by the Wherry Lines, which triangulate Norwich, Lowestoft and Yarmouth. The lack of a connection is lamented by both towns, neither of which is served any longer by direct trains from London. Lowestoft and Yarmouth are like two pensioners who, having been rivals in their thrusting youth, find themselves in the same retirement home.

The surviving Yarmouth station is a boring bunker, a 1960s rebuild of the station once known as Yarmouth Vauxhall. Lowestoft station is much more interesting. A plaque on the exterior wall reads, 'Britain's most easterly station. The Reedham to Lowestoft line was commissioned by Sir Morton Peto and opened on 3 May 1847. The present station was built in 1855 by Lucas Bros.' Also on the exterior is one of the last BR enamel signs – the largest one remaining. The sign (dark blue, signifying BR's Eastern Region) proclaims 'Lowestoft Central', which was what the station was called between 1903 and 1970, to distinguish it from Lowestoft North on the line to Yarmouth.

Lowestoft station is reminiscent of Saltburn in having the enamel sign, the Italianate facade and having lost its roof. Lowestoft's went in a brutal 'improvement' of 1992, the result rationalised as an 'open-air concourse', as if that were desirable in a spot so subject to sea gales. A Suffolk railway history shows colour photographs of the interior when it was still cosily protected by a roof, enabling a wooden bookstall with a long table alongside for the sorting of newspapers, a wooden clock, a Christmas tree.[10] But the next best thing to

the restoration of the roof has occurred at the station: it has been taken in hand by the Wherry Lines Community Rail partnership. There is a well-stocked railway bookshop (by which I mean that it includes some of my own titles), a café and a lovingly detailed timeline on the south wall. Here are some highlights from it:

1929: Gas lighting at Lowestoft station is replaced by electricity.

1962: Steam services in the area end.

1963: Management of Lowestoft Harbour passes from the railway to the British Transport Docks Board.

1973: Transportation of fish by rail from Lowestoft ends.

2024: First freight service from the new sidings at Lowestoft commences with aggregates conveyed to Staffordshire.

I know Lowestoft a bit, having once rented a house in nearby Southwold, and I like the town, but it never seems to flow. There is the desolate industrial area around the station, overlooked by rundown Commercial Road, surely the most seagull-blighted street in Britain, with whole abandoned houses turned into cliffs of guano. To the north are the sort of large, dignified houses you see in North Oxford; to the south, beyond the dock and the marina, is Peto's resort, with its ornamental gardens and tall Victorian guest houses, about equally divided in summer between 'Vacancies' and 'No Vacancies', although in winter this part of town is so quiet that one of my sons learned to drive there.

I would come to Lowestoft by train from London, before taking a bus to Southwold, which has not had a station since 1929. In the absence of a direct train to Lowestoft, the least indirect is from Liverpool Street with a change at

Ipswich. Here I not only changed trains but went back in time, boarding a Sprinter that ambled through sunny fields, and for these pleasant interludes I had Gerald Francis Gisborne Twisleton-Wykeham-Fiennes to thank. 'Gerry' (to his many friends) brought an aristocratic confidence and flair to being a senior rail executive. As Chairman of the Eastern Region from 1965–7, he saved the East Suffolk line from the closure Beeching had proposed by operating it as a 'Basic Railway', with simplified signalling and tickets sold on trains, but he could not prevent the ending of passenger services on the Aldeburgh branch off the East Suffolk. Fiennes lived in Aldeburgh, and he became mayor of the town having been sacked from BR for the entertaining and indiscreet memoir, *I Tried to Run a Railway*.

Today the East Suffolk Line, like the Wherry Lines, is under the protective wing of the Community Rail Partnership. Both are served by Greater Anglia's class 755 bi-modes, which are smooth-riding, with wide windows for the wide landscapes, attractive, warm-hued moquettes and plenty of bike space. The highlight of the Norwich–Lowestoft run is the crossing of the river by the swing-bridge at Reedham, where the trains always seem to fascinate the drinkers in the nearby pub garden. But the whole trip is a treat, with flower-decked stations full of butterflies and broken windmills appearing like tiny crosses on the horizon, a scene hardly changed from those evoked by the Norwich School of painters, whose works are displayed in Norwich Castle Museum.

Le Strange in Hunstanton

In Hunstanton, originally a coastal village on the tip of the south side of the Wash, Henry Styleman Le Strange part-funded the Lynn & Hunstanton Railway, of which he

became Deputy Chairman, and which ran north from King's Lynn. Where the practical-looking Samuel Morton Peto was a builder, the dandified, long-haired Le Strange was an artist, as exotic a flower as his name suggests. His work decorates the roof of the nave in Ely Cathedral – much of which he painted himself, lying on high planks – and parts of St Alban's Church in Holborn, London.

Le Strange – Lord of the Manor of Hunstanton and Lord High Admiral of the Wash – lived at Hunstanton Hall, where he supervised his 10,000 acres with a paternalistic eye. He was planning a holiday annex to the village of Hunstanton from the mid-1840s, while also restoring the village itself, which came to be known as Old Hunstanton. He built in a Gothic style that aligned with his Anglo-Catholic theology, which had also prompted his paternalism. The centrepiece of his new resort was the Royal Hotel (now the Golden Lion), overlooking the wide green that gives Hunstanton its appealing, open feeling. You can see it in the background of many shots in the Ealing Comedy of 1957, *Barnacle Bill*, which was filmed largely on Hunstanton Pier and is described by *Halliwell's Film Guide* as 'quite an amusing comedy' (which is putting it a *bit* strongly). Alec Guinness plays the descendent of a long line of mariners who is afflicted by seasickness, so he becomes the 'captain' of a seaside pier. In the film Hunstanton is called Sandcastle, and at one point Guinness, at a low ebb, says, 'It's always like Sunday in Sandcastle.'

Le Strange began building the station in 1861, using labourers who'd just gathered in the harvest. It was of vernacular appearance, with small cottage windows and gothic detailing. Le Strange died in July 1862, in the same week the station opened, so he did not live to see the change he had wrought. The population of Hunstanton was 500 in 1862; it doubled in the next ten years. The line to Hunstanton, unlike

the line branching off it to Wells, proved to have been a good idea, and was highly profitable when it was acquired by the GER in 1890. Hunstanton gained a pier in 1870, a theatre in 1896. The station was separated from the sea only by the Jacobean-style Sandringham Hotel, opened in 1876, and so well patronised that it was extended in 1905. In 1909 W. A. Dutt described Hunstanton as a 'popular and growing watering place', commending its clean sea and bracing winds, and it was promoted as genteel, even if 'shabby-genteel' came to be nearer the mark.[11] A picture of the town in an Edwardian September is given by L. P. Hartley's novel of 1944, *The Shrimp and the Anemone*, the first in his trilogy about the siblings Eustace and Hilda:

> Eustace turned round to look at the two promenades, stretching away with their burden of shops, swingboats and shabby buildings dedicated vaguely to amusement; next came the pier striding out into the sea, and beyond it the smoke-stained sky above the railway station.

This is Hunstanton all right, a town Hartley had often visited as a child, albeit renamed 'Anchorstone', and the 'smoke-stained sky' reminds us that the station had no overall roof, but merely platform canopies.

Hunstanton never looks crowded in railway posters. An Edwardian one shows the Sandringham Hotel, describing it as 'the cosiest nook of the beautiful Norfolk Coast', adding, for connoisseurs of sunsets, that it 'faces west', in which Hunstanton is unique among the Norfolk resorts. In the grounds are a few white-clad ladies with parasols escorted by blazered gents, and one red motor car. Hunstanton probably was a cut above its Norfolk rivals. How could it be otherwise, given that it was only 5 miles and four stations from Wolferton,

where the Royal Family alighted for Sandringham – a station never sullied by posters and whose platform lamps were surmounted by crowns? It was no doubt the nearness of Wolferton that prompted the BR poster of the 1950s describing Hunstanton as 'the Queen of the Norfolk Coast'.

The town's supposed refinement was reflected in its train services. It attracted half-day Sunday school specials and was well-connected to London. Stanley C. Jenkins describes how, in 1905, the GER included a restaurant car on its Sunday 9.50 excursion from Liverpool Street to Hunstanton, and on the 6.20 p.m. return working, hoping 'golfers and other high-class customers would be tempted to spend an occasional Sunday beside the sea'. But these sorts 'preferred long week-ends rather than simple day trips'.[12]

The day-trippers did come, though, summer Sunday excursions rising to a dozen or more in the 1930s. The several goods sidings were not enough to accommodate the excursion trains, so these were stabled at Heacham Junction on the sleepy Wells branch, which had no Sunday services. By the late-fifties holiday traffic was tailing off, and Hunstanton was indeed becoming permanently Sunday-ish, as 'Barnacle Bill' had said of the imaginary town of Sandcastle. The closure of the Midland & Great Northern network in 1959 removed direct connections from the Midlands, and by 1966 there was only one train from Liverpool Street on weekdays, two on summer Saturdays. Hunstanton was mainly served by DMUs from King's Lynn.

John Betjeman boarded one of these for a short film of 1962, *Betjeman Goes by Train: King's Lynn to Hunstanton*. 'Flat on all sides,' he muses as the train leaves King's Lynn. After royal Wolferton station ('no expense spared') the land, dotted with 'red farms and flint churches', becomes hillier, and it was those modest hills that had persuaded Le Strange that

people would never come to Hunstanton in large numbers except by train. In the background, as Betjeman approaches Hunstanton, are caravans and prefab holiday bungalows, which he doesn't mention and doesn't seem willing even to look at.

As the train nears Hunstanton, JB speculates: 'If the diesel goes too fast, we'll go right through the barrier, out through the hotel and into the sea.' He emerges alongside the large green in the heart of Hunstanton, doing his best to approve of the setting, apart from noting one ugly concrete lamppost. As he takes a lungful of sea air, he says, 'I'm glad there were children on the train; that was *right*.'

He probably knew the line was doomed: Dr Beeching had become chairman of British Railways in the year the film was made. In another railway film of 1963, Betjeman takes another DMU, this time to Burnham-on-Sea, urging the townsfolk to take pride in their line (already all but closed) and counselling: 'Don't let Dr Beeching take it away from you.' Hunstanton was not on Beeching's kill list, possibly because of the royals using Wolferton. I do hope so, because then we could add snobbish sycophancy to his main character defect: lack of foresight. In 1966 the Hunstanton branch became the first 'basic railway' under the Gerry Fiennes template but, as Stanley C. Jenkins writes, Hunstanton's 4,000-strong population in 1966 was not enough 'to sustain a railway in the age of mass motoring'.[13] The station closed on 3 May 1967, the entire branch two days later, the Queen having graciously agreed to use King's Lynn instead of Wolferton as the railhead for Sandringham.

In 1945, most of the Sandringham Hotel had become council offices. Its Casino Ballroom became the 'Sunset Rooms' in 1965 – well named, since the entire building was demolished in 1970. Today, the site is a car park that also

encompasses the site of the station. The population of Hunstanton remains at about 4,000, but perhaps galvanisation awaits: the King's Lynn–Hunstanton Railway Campaign aims to reopen the line.

The story of that troubled young man, George Harvey Bone, anti-hero of Patrick Hamilton's novel of 1941, *Hangover Square*, begins in Hunstanton. Bone has been staying there with his aunt for Christmas, and hasn't fitted in at all, since he 'bore the stamp of Great Portland Street' (that is, London pubs). On Boxing Day he departs for London, entertaining thoughts of murder. Having found an empty compartment,

> he could hear two people talking to each other through the wooden walls of the train, two compartments away; and if he listened he could hear, through the open window, the rhythmic purring of a mud-coloured sea, which he could see from here a hundred yards or so beyond the concrete front which was so near the station as to seem to be almost part of it. Not a soul on the front. Cold and quiet. And the sea purred gently. Dismal, dismal, dismal.

The train then moves off, 'rattling in gentle unison ... over the cold, flat, Boxing-Day bungalow-land of this portion of the coast'.

Joseph Armytage Wade in Hornsea

My late uncle George lived in Hornsea, towards the southern end of the Yorkshire coast. I never asked him direct, but I don't think – given the speed and relish with which he drove a succession of Alfa Romeos – it would have bothered

him that Hornsea lost its railway station in 1964 under the Beeching cuts. Hornsea, an attractive, bustling town, seems always to be doing fine without its railway, and it could be argued that it never really wanted one in the first place, hence the title of David Dunning's book, *Hornsea: A Reluctant Resort*.[14]

The Hull & Hornsea Railway was promoted by Joseph Armytage Wade, who became the company's chairman. Wade, known as 'the King of Hornsea', had made his first fortune as the owner of a timber-importing business in Hull. He founded the Hornsea Brick and Tile Company, the Hornsea Gas, Light and Coke Company, and was the chairman of the Hornsea Local Board of Health for 25 years. But his ambitions for the town – and the profitability of his holdings within it – were not necessarily shared by the populace.

Hornsea Town station opened in 1864, a hundred years before it closed. At the time, Hornsea was a small market town, not a holiday destination, and its beach was chiefly significant because nine men made a living extracting gravel from it. The station, set just back from the front, was a handsome red-brick building with a colonnaded façade. It had first-, second- and third-class waiting rooms, a single glass-covered platform and an exposed excursion platform. Its opening, on Monday 28 March, was met with scepticism:

> The shopkeepers of Hornsea had refused the request to decorate the town and, indeed, most of them declined to open. The feeling of the people of Hornsea was that the railway would encourage 'day trippers', not the upmarket visitors who stayed for a week. This attitude has changed little over the subsequent 150 years.[15]

The coming of the railway did energise the town. Some smart new streets were built to accommodate Hull merchants who could now commute to work from the seaside. The population of Hornsea increased by 60 per cent between 1861 and 1871 – below Wade's expectations – and in 1865 the Hull & Hornsea Railway (and its debts) were taken over by the North Eastern Railway. But the railway had been successful enough to justify the locals' fears: it did indeed bring excursionists 'flooding into the town in their thousands during the newly mandated public holidays'.[16] To serve them and the more desirable overnight visitors, the town eventually gained gardens on the Promenade, a Floral Hall and in 1880, courtesy of Wade, a pier – a rickety thing with modest attractions. It was demolished in 1898, two years after Wade's death, at which point an assessment of his career might have concluded that, rather than having been the making of Hornsea, he had blocked its progress towards rivalling Scarborough or Bridlington.

In 1875 a Sheffield businessman, Pierre Henri Martin Du Gillon, had promoted a grander pier, as part of a new promenade and a large estate immediately south of the town. His plan depended on having a road connection to the railway station. Wade, perhaps suspecting that here was a rival to his Hornsea crown, would not sell Du Gillon the piece of land required. But Wade was an enigmatic figure, and perhaps altruism and good taste were considerations. Dunning suggests that he remained convinced he had saved Hornsea from 'an unsavoury character whose greed would have destroyed the town'.[17]

There is an accurate model of Hornsea Town station in Hornsea's excellent museum, where mocked-up newspapers tell the town's story. One of these, headlined, 'Farewell to the Trains', deals with the station's closure. It speaks of tourism

having lately taken a 'downturn', with most visitors being day-trippers, and even these in declining numbers, of whom half arrive by car, those who do stay favouring caravans over hotels and lodging houses:

> It is argued that day trippers don't want Hornsea and Hornsea doesn't want day trippers. Many locals are dismayed, but closure of line seems to be the first step in returning Hornsea to being a rural bridge on a beautiful coastline. This comes as part of a movement by residents and commuters against the commercial development of the seafront.

When I was growing up in York in the 1970s, we often went to Hornsea, and I think we would have driven there, even if the railway were still open. The purpose of our visit was to go to Hornsea Pottery, the factory and visitor centre established in the town in 1954 (somewhat eccentrically, since there was no local source of clay), by two artistic brothers, Desmond and Colin Rawson, and the theoretical purpose of any such trip was to buy a tea set, which could not easily have been carried on a train. Besides, Hornsea Pottery tableware, with its un-dainty, mud-coloured rustic styling, designed to be displayed in an easy-going, open-plan 'farmhouse kitchen', was as much part of the modern world as a Ford Capri; it just didn't *belong* on a train. The pottery lay inland, so we never saw the sea on our visits. It became the largest employer in the town in the early 1980s, with 700 staff, but the business overreached itself and the site is now a shopping village.

Hornsea doesn't try hard to attract visitors. A shop on the front selling beach requisites doubles as an off-licence. There are no donkeys or deckchairs for hire on the beach. Fish and

A church wall in phlegmatic Hornsea.

chips are easy enough to come by, but ice creams are elusive and there is no amusement arcade. On a visit to Hornsea in late summer, 2024, I sought out the old station. It wasn't hard to find: it looks like a Victorian mansion with smaller, more modern houses in its back garden. These were built in the 1980s, on the site of the old excursion platform, and the builder was required to restore the main station building as a quid pro quo. A man came up to me as I was taking some notes; he lived in the main building, in a property formed of the ticket hall and one of the three waiting rooms. It was an attractive home, looking out onto what had been the station forecourt, now a neatly trimmed lawn. The man told me that his previous home had also been a former station. All

around the walls were pictures of Hornsea railway scenes. 'I like trains,' he said, unnecessarily. On emerging, I spoke to a woman who was sweeping up the driveway of one of the 1980s houses. 'It'd be nice to have the convenience of a train again,' she said, ' ... but I'd like to keep Hornsea as it is.'

And what *is* Hornsea? A retirement town, and even though the railway line could be restored, since much of it is now the Pennine Trail footpath, that's unlikely, since Hornsea's appeal to its retirees is, as David Dunning puts it, 'the peace and quiet, the natural charm, the lack of tourists'.[18]

The Duke of Devonshire in Eastbourne

William Cavendish, Seventh Duke of Devonshire (1808–91), was the lord of the manor in Eastbourne. In contrast to his father, the Sixth Duke, he was ambitious on behalf of the town, and his vision was refined: 'a resort built by gentlemen for gentlemen'. Since he did not see this as being incompatible with having a railway, he sought an Act of Parliament authorising the LBSCR to construct a southbound branch from the East Coastway Line main line at Polegate to Eastbourne. It arrived on 14 May 1849, only three years after pioneering Brighton got its railway, and it does not seem to have lowered the tone of the town. In 1865 the snooty *Bradshaw's Handbook* described Eastbourne as 'fashionable', code for 'select'.

A friend of mine used to go to Eastbourne on holiday with his grandmother in the 1970s 'because it was safe'; they would always watch its pre-Wimbledon tennis tournament. Lewis Carroll went there for twenty-one summers in a row from 1871, always staying at a guest house on Lushington Road, accommodation characterised by one visitor as 'worn', but 'respectable', and it was the respectable aspect that drew Carroll.[19] He liked to chat up all the little Alices on

the beach, where he found the right sort of girls for his taste: not 'common'.

When my wife and I took the train to Eastbourne on the first May Bank Holiday of 2024, I thought I might go first class, because it would be all of a piece with the town itself: we'd have a posh day out. But in the end meanness prevailed. The train was packed with people and suitcases until Gatwick, but no suitcases remained after we diverged from the Brighton Main Line after Wivelsfield. On a bright day, Eastbourne station has a holiday atmosphere nonetheless, with its two long platforms covered by valanced canopies, and a third canopy magnanimously covering a car park created on an abandoned platform. But passengers travelling on to Hastings are probably sick of the sight of those canopies, since all trains from Victoria to Hastings call in at Eastbourne and hang around for five minutes while Eastbourners smugly detrain and the driver plods from one end of the train to the other, to take it out again.

The present station, of 1886, is the third at Eastbourne. In *Britain from the Rails,* Benedict le Vay writes that it was built in an 'elegant not to say bonkers French style'.[20] For Simon Jenkins it has the 'careless messiness you get on an Indian Railway', which is a compliment, and a reminder that many of the children educated in the town's numerous private schools were the children of colonial administrators.[21]

Eastbourne was 'cradled by the railway', writes John Surtees in *Eastbourne's Story.*[22] Its arrival marked the start of an investment plan carried out by the duke and his highly competent agent, George Ambrose Wallis (who would have a 0-4-2 tank engine named after him by the LBSCR). A sea wall, a gas works, an electricity station flowed from the railway's arrival, all served by a network of lines. A freight line was opened to the great shingle bank on the duke's estate,

and this would provide track ballast for the entire LBSCR. The population of the town doubled every ten years after the railway came, and by 1900 it was the largest town in Sussex after Brighton. But it didn't embrace the railway to quite the same extent: in 1901 a proposal to establish a LBSCR locomotive and carriage works was rejected by the council on the grounds of its 'dangerous social implications'.[23]

Eastbourne was happy to receive railway-borne travellers, though, and after electric services began in 1935 an increasing number of the town's residents commuted to London. Eastbourne is commutable (Hastings isn't, really) and, to emphasise the fact, the canopy on the station's main façade carried the words 'Southern Electric' scored though diagonally with a lightning flash motif. It persisted until the 1960s, by which time presumably everyone had got the point. Between 1948 and 1957 the relaxing-sounding *Eastbourne Sunday Pullman* ran from London using the spare *Brighton Belle* set. Eastbourne was also a magnet for long-distance holiday services. The *Sunny South Special* was inaugurated by the LNWR and the LBSCR jointly in 1905. This, despite its name, was a year-round service to Brighton and Eastbourne from Liverpool and Manchester, via Crewe and Willesden Junction. It faded away in 1939. But excursions, and a sleeper train from Glasgow, continued to come down, and in August 1958 five people died after the steam-hauled sleeper collided with an electric train at Eastbourne.

The glazed station concourse is full of light, with a good independent café and plenty of helpful staff strolling about. A walk along Terminus Road, which connects the station to the front, must once have perpetuated the excitement generated by the station, but today the word 'Terminus' rings rather balefully.

'Oh, good,' said my wife, as she stepped onto the road.

'Charity shops!' Of course, what's good for her is not necessarily good for a town. Lewis Carroll's biographer, Donald Thomas, writes that in the 1870,

> tree-lined Terminus Road which ran from the railway station to the sea front already offered bookshops and circulating libraries, confectioners and homeopathic chemists, a photographer and artist, banks and billiard rooms. For the summer visitor there were shops which sold swimming corsets and vests, skating rink boots for Devonshire Park, and opera glasses whose only probable use was on the seafront.[24]

In the 1930s Terminus Road was known for its large, genteel department stores with wicker chairs in palm courts for morning coffee and afternoon tea dances. The grandest was Bobby's, one of a chain whose presence signified the salubrity of a southern town, just as Waitrose does today. Diners in Bobby's restaurant were serenaded by Afredo's Gypsy Quartet: 'Their lilting Gypsy melodies and dashing Italian tangos will thrill you.'[25] Bobby's later became a branch of Debenhams. Today it's a white ghost, standing derelict. 'Eastbourne's former Debenhams building used for "drugs and under-age sex" as police work to secure site,' reported *Sussex World* in April 2014, but perhaps Eastbourne was never quite as posh as it liked to think.

This is the view of Donald Thomas, who writes that Terminus Road 'divided two communities'. To the west lay the hotels of the Grand Parade, and the villas of the select suburb, the Meads, a 'seaside Belgravia', as it was known. To the east lay 'another world' – more modest streets, where instances of poverty and crime belied Eastbourne's claim to be 'the Empress of the South'. And the crime might be imported.

Thomas mentions a 'near riot' on the seafront among excursionists in 1896.[26] The year before, the *Eastbourne Gazette* had fretted, 'The upper middle class used to frequent the place more than they do now. Can it be that the excursions have anything to do with the change?'[27] 'In the early decades of the railway', write the authors of a pamphlet about the railway in Eastbourne, 'the gentlemen of the Vestry and the Board, who ran the town, had mixed feelings about the "artisan excursionists", especially the Sunday arrivals.' But towards the end of the century, 'a general recognition of the economic value of this new market began to spread.'[28]

By way of conclusion to *Eastbourne's Story*, John Surtees writes that the town 'keeps its suntrap image, holds its reputation for safe sea bathing, and maintains its welcoming tradition', a careful, diplomatic formula.[29] But many visitors to Eastbourne are presumably comparing the modern town with its upmarket reputation.

There are no shops along the seafront, because of restrictive covenants imposed by the Dukes of Devonshire. There was a food market there during my last visit, but this didn't detract from the civilised atmosphere. The band was playing, the musicians mainly schoolkids. 'Private school,' said my wife (an educational consultant). 'You can tell because they're Asians.' As we walked past, they struck up with the theme from *Thunderbirds*, beautifully played, but only three people occupied the canvas seats in the paid enclosure. Everyone else listened while standing on the prom. The Burlington Hotel still looks the part from outside, but it's only a three-star these days. On the Western Lawns, where the Sunday promenades or 'snoot parades' were once held, there was a display of classic cars. On the way back to the station we wandered along the front to the east of Terminus Road. Instead of large white hotels, there were thin guest houses, a slightly sulky air.

Some Middlemen

The train back to London was packed, and the guard announced loudly over the PA, 'I am declassifying First to make more seats available.' How I would have hated to hear that, had I bought a first-class ticket. It would have been a punishment for snobbery, and perhaps it was mere snobbery that had slightly taken the edge off a largely enjoyable day. Or was it simply that I was looking at Eastbourne through the lens of the past?

THE PASSENGER EXPERIENCE

Luggage

In *The Middle Classes 1900–1950*, Alan A. Jackson writes:

> As the departure date approached, one or more cabin
> trunks would be taken down from loft or attic or landing,
> to be filled with the family's newly washed and ironed
> summer clothes, all carefully packed between layers
> of tissue paper. Placed around the edges were walking
> shoes and beach sandals, books and bathing costumes.
> Remembering wet holidays past, umbrellas and rain-
> wear would not be overlooked, whilst a parasol might be
> thrown in too, with an optimistic smile. Were servants
> employed in the household, much of this work would
> fall upon them, but as they also had something to look
> forward to, it would be done with a light heart.[1]

The Victorians and Edwardians took more luggage to the
seaside than people do today: trunks, hampers, Gladstone
bags full of books and stationery, blankets, rugs, bathing
dresses (far bulkier than the later bikinis, which, as we know
from Brian Hyland's song of 1960, are 'Itsy-Bitsy-Teeny-
Weeny'), folding cots, tin baths. (For all those thirty-one

years, Lewis Carroll always took a tin bath on the train with him to Eastbourne.)

Great agglomerations of luggage formed on station platforms during summer Saturdays, and 'Allowances of ten minutes or more had to be inserted into summer timetables for loading and unloading the trunks and other impedimenta at principal intermediate stations,' Jackson writes, 'allowances that in practice were often exceeded by as much again.'[2]

Luggage sprawls were attended by debate about what could be taken as hand luggage into the carriage and what was 'for the van' (the guard's van). It was considered bad form to lug, say, a golf bag into a compartment, just as would be to take a golf bag into a restaurant. Some luggage racks were labelled 'Light Articles Only', and to reinforce the message, they might be made of string. There was – and is – a limit on the amount of luggage that could be carried per ticket holder with no extra charge, whether it was destined for carriage or van. The rates of free carriage accepted by most companies were 150lb in first class, 120lb in second, 100lb in third, a more liberal arrangement than in many other countries.[3] The general rule today is three items of luggage.

In *Travelling by Train in the Edwardian Age*, Philip Unwin writes that any holiday journey began with the arrival of an outside porter: 'a tough individual who led a slightly shadowy existence in a corner of the station yard'. He was 'half porter, half carter', and came with a smell of 'stale sweat almost inevitable for those who did hard physical work in days before their houses had bathrooms'.[4]

The outside porter might take your luggage on the same day as your departure and put it into the guard's van of the same train, which you would be able to watch him do. This is the case with the Stevens family, whose departure for their

Luggage label for Bognor, kindly given to
the author by Mr Robert Sharp.

annual holiday in Bognor is beautifully evoked (along with
the holiday itself) in R. C. Sherriff's *The Fortnight in September*. The Stevens live at 22 Corunna Road, Dulwich, and the
first leg of their journey is a train from Dulwich to Clapham
Junction. Every aspect of the holiday is conducted ritualistically, trammelled by repetition over the years. The Stevens
know their outside porter, and his name makes him sound
like a railway station: Ruislip. He is a placid, plodding man,
who wheels his trolley at his own pace even as Mr Stevens,
walking beside him with the family on tow, begins to sweat
at the thought that they are running late.

At Dulwich station (a 'faded, little place'), the Stevens
cluster around Ruislip as he pastes on the luggage labels:
'The trunk looked well with its new white label stuck
crossways over the faded one of last year, for Mr Stevens
took care to preserve the old travel stains of the past.' The
train comes in and the family find an empty compartment,
but Mr Stevens lingers on the platform, one foot on the
running board beneath the open compartment door, to
make sure the trunk has been loaded into the guard's van.
Then Ruislip comes up to him and, touching his cap, says,
'All right, sir.'

'Good,' Mr Stevens replies. 'Five o'clock on Saturday fortnight' – this being when Ruislip will take their luggage back
to Corunna Road.

'Very good, sir,' responds Ruislip, and Stevens – reflecting

that it is satisfying to be called 'sir' in front of his wife and three children – hands Ruislip two shillings.

At Clapham Junction Mr Stevens watches the trunk being unloaded and verifies with the porter that the Bognor train will leave from Platform 8. 'You'll take it across?' he asks the porter, who nods. The Stevens make their own way to Platform 8, via the ticket office, because it's not Mr Stevens' habit to buy the tickets in advance (surprising, since he is such a methodical character). On Platform 8 they see their trunk amid a large collection of luggage, so it looks smaller than before. The Stevens then scramble to find a free, or half-free, compartment. They pile in, with their hand luggage, trusting that the trunk will be loaded onto the train.

Things are more leisurely on arrival at Bognor. The train 'can go no further than Bognor', so there's no hurry to get out, and the Stevens join the crowd milling around the guard's van. The Stevens are embarrassed to see their own trunk upstaged by a larger one unloaded just before and 'covered all over with romantic, highly coloured labels from hotels in very corner of the world', some half torn off, 'as if they did not matter'.

One-upmanship about luggage labels is described from the opposite perspective by Max Beerbohm in an essay from his collection of 1909, *Yet Again*: 'Travelling in a compartment, with my hat box beside me, I enjoyed the silent interest which my labels aroused in fellow-passengers.' The game was to try and see if the owner lived up, or down, to the labels on their luggage. When the prestige of the British seaside holiday began to decline, that of a foreign luggage label (one reading 'Train Bleu', for example) began to increase, and whether British or foreign, labels might seem more interesting for their ferocious specificity: the name of a modest guest house, say, or 'North British Railway: Rothesay, Via Craigendoran

Pier'. Or perhaps they gave away too much. In *The British Seaside Holiday*, Kathryn Ferry suggests that 'middle-class visitors heading for Margate hid their luggage labels … because of the resort's reputation for rowdy day trippers.'[5]

Mr Stevens is maliciously pleased to see that the man collecting the romantically labelled trunk at Bognor is elderly and ill-looking. There are 'plenty' of porters standing by at the station; Mr Stevens selects one, who wheels the trunk along the platform to the barrier. Presumably Mr Stevens tips him, but this is not stated. Beyond the barrier, a number of 'baggers', or unofficial outside porters, await, two of them looking so uncouth – sunburnt 'to the colour of oak' – that they scare the Stevens, who finally entrust their trunk to a lanky youth who, flatteringly, knows the location of 'Seaview', the guest house they have visited every September for almost twenty years.

They go on quickly through the sunny streets, ahead of the lanky youth, anxious to change out of their London clothes and get into the swing of the holiday. Their landlady, Mrs Huggett, greets them warmly, and just as she asks, 'Is the luggage coming along?', they all see the lanky youth turning the corner into the street. Mrs Huggett ushers the Stevens in, saying that she will deal with the luggage, so presumably she is the one who tips him.

The Stevens don't seem to have had the option of entrusting their bag to an official outside porter at Bognor. At Shanklin station on the Isle of Wight there is a memorial to an official outside porter called George Hawksworth and known to all as 'Jarge'. Jarge's dates are not given, but the plaque suggests that he was a figure of the Southern Railway rather than the BR era. On his brown trilby he wore a brass badge proclaiming him to be 'licensed by the railway company as an outside porter'. He would petition people

with, 'Carry your bag, sir?', often adding, peculiarly, 'Got hobnail boots but can't I run dirreckly minnet, sir.' He would be distracted and enraged by local lads who would pirate his customers. When he handed in his badge, according to the plaque, 'a national newspaper proclaimed him the longest serving Outside Porter in the entire country.'

Alternatively, luggage might be collected in advance of the holiday, a facility offered by the railway companies to avoid the pile-ups on the platforms. An account of luggage collected in advance of a seaside holiday in East Anglia is given by Michael Palin in *Happy Holidays*: 'The excitement began three or four days before we left, for our buckets, spades, water-wings and athlete's foot powder had to be packed early, in heavy leather suitcases stamped with the magic letters PLA – passenger luggage in advance.' The luggage is collected by a 'snub-nosed articulated vehicle'. The young Palin's cry of 'Pickford's are here!' signifies, in a sense, the beginning of the holiday even though it is still some days away. (This was in the 1950s, when Pickford's ran a luggage cartage business allied to BR.) Despite the luggage having gone on ahead, Palin's father is not free of the need to keep an eye on the goods van during the journey, since he has installed his bike there, and Palin has vague 'memories of father having to race up to the guard's van at every change, to make sure his bike hadn't been offloaded for Hunstanton or Mablethorpe.'[6]

Outbound, passenger luggage sent in advance could be delivered direct to your hotel or to the nearest station; inbound, to your *home* or the nearest station. And if you paid for the cheaper 'nearest station' option you collected the luggage yourself, usually from the parcels office.

The question of luggage-in-advance etiquette was addressed in a bizarre British Transport Film of 1958, *A*

Desperate Case. The eponymous suitcase is anthropomorphised by being joggled by off-screen hands; 'his' squeaky voice is supplied by the pixie-ish character actor, Maurice Denham; his facial features are suggested by bits of left-over luggage labels. He is the designated 'luggage-in-advance' case, the one to be sent home apart from the family and their personal baggage and, from his vantage point atop a wardrobe in a seaside boarding house, he frets about the amount of stuff he is going to have to convey. Dad has won a cuddly toy at the Bingo; his daughter has bought a table lamp at a jumble sale, etc. Will the family attempt to tie down DC's lid with string? Will they make sure to write a legible label for the railway carter to read?

A lot of luggage is shown in the film, but I don't think any trunks appear. They began to be displaced by suitcases – or 'suit-cases' – in the early twentieth century, signifying a new, more democratic era of travel, in that you didn't necessarily have to pay someone else to carry them.

In *Worktowners at Blackpool*, Mass-Observation observed the following being carried through the barrier at 'Worktown' (Bolton) one summer Saturday evening in 1937:

83 heavy cases
48 light cases
39 paper shopping bags
10 rucksacks, and canvas bags
9 fish rods, baskets
6 bunches of flowers
2 dogs
2 golf bags
1 china bowl
1 camera[7]

No trunks are listed.

When our family holidayed in the 1970s, we carried our suitcases with us, by which I mean my father carried them. The philosopher Nassim Taleb asked why the wheeled suitcase seemed to have been invented after we had landed a man on the moon. Well, back in the 1970s no man would have been seen dead propelling a wheeled suitcase. I recall Dad walking along Ryde Pier to the train that would take us to Shanklin. He stops halfway there and flexes his arms like a weightlifter, refusing my offer of help before resuming.

I had a strong affection for our family suitcases, which were made of leatherette, with cosy compartments inside. They slumbered in the loft for fifty weeks of the year and I'd pay them a midwinter visit occasionally. A kind of briny waft came off them when you unzipped the tops, and the internal pockets always retained some small tokens of pleasure: little rivulets of sand, a Blackpool tram ticket, the stub of a tube of Polo mints.

Anticipation

Aside from packing, what might precede a seaside holiday by rail? 'If the absence was to last more than a fortnight or so', Alan A. Jackson writes, 'pre-holiday tasks included placing dust covers over the furniture and depositing the family silver and other valuables in the vaults of the local bank.'[8]

That sounds like a grand household. The one evoked by Molly Hughes's memoir, *A London Child of the 1870s*, was slightly less grand. Here is an early phase in her description of the family's annual trips to stay with relatives in Cornwall:

> We used to go to bed earlier the day before, not so much to please mother as to bring tomorrow a bit sooner.

We got up long before it was necessary, impeding all the sandwich-making and hard-boiling of eggs that was going on. But eat a good breakfast we could not, being 'journey-proud', as our old cook used to express our excitable state.[9]

The Stevens of *The Fortnight in September* were a notch lower again on the social scale. The evening before the journey to Bognor, they had a supper of boiled beef, 'because it made good sandwiches for the train journey'. This night before departure is one of family celebration, rising sacrilegiously 'almost to the height of Christmas Eve: a night, voted sometimes as the best of all the holiday, although it was spent at home and the sea was still sixty miles away.'

Lower again on the scale were the Wakes Week travellers from northern towns to the coast. Researching a novel about Edwardian Wakes Weeks in Halifax, I learnt that the Halifax pubs were quiet in the run-up, as people economised, saving for the holiday. The local paper, the *Halifax Courier*, ran an anticipatory column, 'The Wakes Outlook', which stirred excitement to an almost irresponsible degree. Most of the Wakes trips from Halifax were to Blackpool, but not all. At Rhyl 'bowling, yachting and golfing were in full swing.' At Penzance 'the outlook was good for holidays; glass steady, wind from the north.' At Yarmouth 'the Winter Gardens stood ready to accommodate people if it rained.'

After all this build-up, to be at the departure station was akin to being finally on stage for an actor who's been rehearsing in some dingy back room. Philip Unwin writes,

To stand upon a railway station platform early in this century, waiting for an express train to bear you away

John Hassall's much parodied poster of 1908 was first issued along with timetables of excursions from King's Cross. Perhaps Hassall didn't read this, because when, in 1936, he was invited to Skegness to receive the freedom of the town, he attempted to go there from Liverpool Street.

GWR poster of 1907 that underpinned the fairly
outrageous 'Cornish Riviera' conceit.

Laura Knight's delicate and sophisticated women seem to belong
in Bloomsbury not Bridlington. The name of such a prosaic thing
as a railway company at the bottom seems incongruous.

Poppies were first associated with Cromer by Clement Scott in 1883. In this poster of 1937 they are still being invoked, albeit with an admixture of sex.

One of a sun-dazed series by Tom Purvis. Today, these images often stand in for actual sunshine in the cafes and guest houses of the Yorkshire coast.

Another Purvis image for the LNER, in which the weather is even hotter, almost apocalyptically so, it seems.

Brighton: as racy as the trains that went there.

Sunny South Sam was the mascot of the Southern Railway's weather boasting. His facial features were based on those of an actual railwayman, a guard on the Hayling Island Branch.

The athleticism depicted here by Bromfield (a one-name artist) might arouse sniggers today, when Herne Bay is satirically referred to as 'Hernia Bay'.

Bridlington inspired other excellent posters besides this
one by Tom Eckersley, the artists perhaps motivated by a
desire to bring 'Brid' out of Scarborough's shadow.

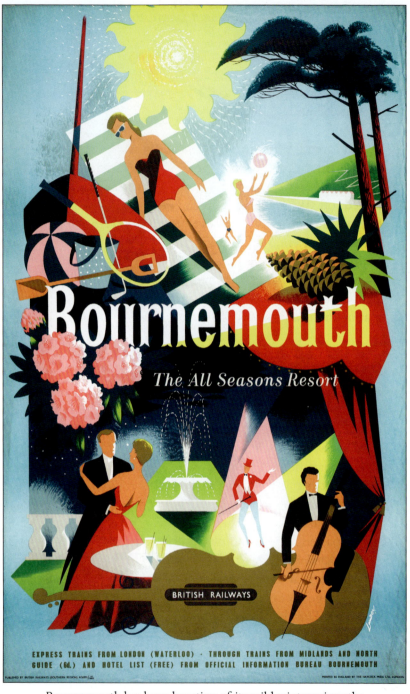

Bournemouth has been boasting of its mild winters since the 1840s. It seems fitting that the most famous holiday train to go there, the Pines Express, was named after an evergreen.

for a holiday was, for a child, a very close approach to heaven. There was anticipation so delicious as to be all but incomprehensible to the very young of today, who travel almost exclusively by car.

The arrival of the momentous train would be preceded by the 'titter-titter' of the signal wires below the platform edge as the signalman in his box – a way off but in sight – pulled 'off' the signals. Then came the ring of the electric bell on the outside wall of the waiting room to signal that the train had 'entered section'.[10]

In *The Fortnight in September*, the Stevens family 'could always sense the train's approach a little before it came in sight around the bend. There was a kind of tightening anticipation in the atmosphere of the platform.'

On the Train

For most of the twentieth century British railway carriages might be 'open' or compartmentalised. An early pioneer of open-ness was the LMS, seeking to fit more people into third class, whereas the traditionalist GWR was notably pro-compartment. A prosperous family might have reserved a compartment for themselves, or they might just bribe a guard or porter at the last minute to find them an empty one; in either case it would then be marked with an 'Engaged' sticker pasted to the windows.

In *A London Child of the 1870s*, Molly Hughes recalls that, on their regular trips to Cornwall, they always shared their broad-gauge compartment – six seats on either side – with strangers. The children (Molly and her three older brothers) were well-schooled in compartment etiquette. For example, sweets were not permitted before Reading. There would

have been no side corridor in that compartment, so the Hughes were effectively trapped in it. Corridors, pioneered by the GWR, didn't come in until the 1890s. The older the train, the more likely it was to be corridor-less, and much seaside summer stock *was* old. It was better, of course, to have a corridor: it gave access to the lavatory and the dining car or was a place to stretch one's legs and look out of the window, especially if the sea was on the opposite side to the compartment window (although railway companies tried to align their carriages so that the sea would appear on the compartment-window side). John Elliot recalls that the Southern always tried to supply corridor coaches and restaurant cars on its trains to the 'best resorts'.[11]

Perhaps Bognor was not considered among the best, because the Stevens family travel there in one of the Southern's corridor-less thirds, in a compartment with six seats each side, so the five Stevens share with seven strangers. Mrs Stevens assesses their travelling companions. 'The only doubtful one was opposite her ... a puffy woman with a baby. On the whole quite a lucky carriageful, if the baby was all right.' The Stevens exchange smiles with the strangers but no words. The compartment gradually empties out until, at Horsham, they find they have it to themselves, except for a 'pleasant' naval man – a real stroke of luck, Horsham being only halfway to Bognor.

A conversation might be as likely to occur in the corridor as the compartment, perhaps among people who share the characteristic of being slightly at odds with their families or friends, hence their being in the corridor. In Margaret Kennedy's novel of 1950, *The Feast*, two sets of children, the Coves and the Giffords, get talking in a train corridor on their way to the Cornish coast:

'Are you going for a holiday?' Michael wanted to know.
'Yeth,' said Blanche, who lisped a little.
'Where?'
'Pendizack Manor Hotel.'
'Oh!' said the three Giffords.

They are going to the same place, where something terrible, albeit darkly amusing, is going to happen.

In the absence of conversation there was reading, of course. In Victorian and Edwardian times, station bookstalls were notorious for peddling lurid, downmarket fiction. As Gwendolyn says in *The Importance of Being Earnest*, 'One should always have something sensational to read in the train.' Penguin Books were seaside railway fiction, in that Allen Lane had the idea for sixpenny paperbacks when, returning from a visit to Agatha Christie in Torquay, he found himself at Exeter station with nothing to read. In *The Fortnight in September*, Mr Stevens equips the family for the journey at the Clapham Junction bookstall. He buys *The Times* for himself (a paper he doesn't usually read because it's hard to open on the bus, but which he feels befits the spaciousness of a holiday). His eldest son, Dick, gets the *Captain* magazine (adventure stories); his daughter Mary, *The Red Magazine* (inoffensive fiction for young women). For his wife he buys 'a little domestic journal' (she's not a big reader), and his youngest son, Ernie, gets two comics, *Chips* and the *Scout*. Thirty years later Ernie might have got an *I-SPY* book, ideally *I-SPY On a Train Journey*, rather than *I-SPY Cars*, both designed to postpone the dreaded 'Are we nearly there yet?' phase of the journey. No doubt they were often used on trains to the seaside, and indeed Big Chief I-Spy, aka Charles Warrell, a former headmaster who'd created the concept, *lived* at the seaside, having retired to Budleigh Salterton, Devon.

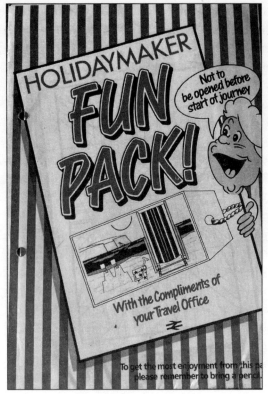

Life before the smartphone.

I own a 1980s approximation of *I-Spy*, a 'Fun Pack', tied in with BR's 1980s 'Holidaymaker' excursion brand. There is 'Holidaysearch', a word-search grid where you must find '14 items you might expect to find on a holiday'. The words include some you would expect to find today, e.g. 'Sandcastle', and some you wouldn't, like 'Postcard'. In the 'Window Points' section there are 5 points for spotting 'car with caravan' or a church, but only one sight merits 30 points: 'The FIRST Person to See the SEA'.

Since the windows would be open, the smell of the sea

might come first, or the 'sea air', often called 'ozone' in Victorian times, and still in LMS literature of the 1920s: 'The healthiest Holiday places in Autumn are on the West Coast of Britain. THE PREVAILING WINDS THERE ARE FROM THE WEST, and holidays spent on the West Coast mean ozone-laden breezes direct from the open sea, unblemished by city dust or smoke.'

When, after Horsham, the Stevens have the compartment to themselves, they open the window, enjoying the breeze, which would have been considered a draught at home. Shockingly (to me), Mr Stevens throws a sandwich paper out of the window at Pulborough. Since the Stevens are travelling to Bognor a few years before the electrification of that line, their train is steam-hauled, and they would have been receiving through the window little bulletins from the engine: the tang of its coal smell, an occasional inflow of warm steam, a stray spark, perhaps.

Of course, you can't open the windows today on the air-conditioned Electrostars of Southern, and when the train to Bognor is rolling through the South Downs on a sunny day or stopped next to the flower baskets of Arundel station, I always wish I could.

The excitement of arrival at a beautiful coastal spot would have been increased had it been prefaced by scenes of heavy industry, as it commonly was. Let our witness here be the naturalist Henry Gosse, who was frequently bound for the coast, usually that of Devon, his specialism being marine biology. In *Tenby: A Seaside Holiday*, he took his microscope to South Wales and he comes across as a witty and empathetic observer of life, contrary to his depiction as a religious zealot and tyrant by his son, Edmund, in his recriminatory memoir, *Father and Son*.

Between Neath and Swansea, he sees what look like rain

clouds, but a fellow passenger informs him that they are clouds of copper smoke. 'And presently we saw it – pouring forth in thick yellow masses from the shafts of the smelting furnaces, and spreading in wide horizontal layers, like a huge pall, over the earth. The pall of death indeed!' Then come 'Whole hills of black coaly-looking material', before the 'beautiful Bay of Caermarthen' appears.

Let's stick with the entertaining Mr Gosse for a moment. On arrival at Narberth and Tenby station eager coachmen

> leaning over, and now and then bursting through, the slender station wicket, vociferated, gesticulated, and were fain to take the bewildered passengers by storm, as they called out the names of their conveyances. 'Coburg, sir?' 'White Lion, sir?' 'This is the coach for Tenby, sir; the Coburg, sir!' 'Here you are, sir! For Tenby, sir! The White Lion, sir!'[12]

Gosse chose the Coburg, despite reflecting that 'as a naturalist' he ought to have favoured 'so unique a zoological curiosity as the White Lion'. As the Coburg dashed away from the station on 'a brilliant summer evening', he found it a 'pleasant change from the railway carriage'.

As a rule of thumb, the longer the journey, the greater the desire to arrive. As the comedian Mark Steel said on his Radio 4 programme, *Mark Steel's in Town*, 'The first thing you notice about Penzance is that it's miles away,' and however pleasant the journey, it's always a relief to see St Michael's Mount looming to the left as you close in on Penzance. On one occasion I and my son walked directly from Penzance station to the nearby Deco lido for a cooling swim. In 1989, I interviewed the novelist Leslie Thomas on a train going from London to Edinburgh, and he told me he'd travelled

to Penzance on the *Cornish Riviera Express* with a painfully throbbing toe, which he was desperate to dip into the sea at one of the Penzance beaches, and that is what he did. The sea is immediately visible on stepping out of Penzance station, but the Stevens appreciated the deferred gratification of an arrival at Bognor station, from where the sea is some way off. It would be 'poor showmanship on the part of Bognor' to reveal it immediately.

BESIDE THE SEASIDE

Skirting the Sea in South Devon

We have had an overview of the Cornish Riviera Express journey from Paddington to Penzance, albeit glossing over the most scenic stretch, that between Exeter and Newton Abbot, known as the South Devon sea wall and described by Michael H. C. Baker as 'the most famous piece of seaside railway in the land'.[1] In *A London Child of the 1870s* M. V. Hughes goes further: 'I have travelled in many show places of Europe and America but have never been along a piece of line to equal the run from Exeter to Teignmouth.'[2]

In travelling over that stretch we will be following in the swaggering footsteps of Isambard Kingdom Brunel, and how could you not swagger with a name like that? He built the line from Exeter to Plymouth for the South Devon Railway (which would be acquired by the GWR in 1876), running it close to the sea's edge where it touched the coast, and he decreed that the locomotive-hauled trains that first served the line should give way to the new-fangled atmospheric system – which they did, between Exeter and Newton for six months in 1848.

Those six months were the spring and summer of that year, and what would vacationers have made of Brunel's

railway? They would have seen, adjacent to the beaches – and supposedly protected from the waves by the defences known as the 'sea wall' – tracks of Brunel's trademark 7-foot gauge, with a black iron pipe running down the middle. Along the route (including at Starcross, Dawlish and Teignmouth) were pantile-roofed buildings resembling Tuscan churches, but what appeared to be the belfries were chimneys, because these were pumping houses to evacuate the pipe. While smoke emerged from these, the trains must have looked weird by virtue of having no such emissions – indeed no locomotive at all, but just a series of carriages, one of which was connected by a piston to a groove in the pipe. The groove was supposedly kept sealed in between trains by overlapping leather flaps, and it was the leakiness of these that caused the abandonment of the system in September 1848 and a reversion to locomotives.

Many other railway entertainments, or calamities, have been observable by visitors to South Devon. The sea wall was first damaged in 1846 just months after the line's opening, and parts of it would be washed away in 1855, 1859, 1869, 1872, 1873, 1929, 1930, 1965, 1986, 2006, and 2014. In 1939 the GWR, tired of playing Canute, began work on an avoiding line; fortunately for the next generation of trainspotters and railway photographers, the project was killed off by the war.

My wife and I began our trip to the sea wall at Exeter St David's. In the booking hall I bought a ticket to Teignmouth, and asked a cheerful ticket seller whether I would be able to break the journey at Dawlish on the way. 'Of course!' he said. 'It's a lovely day. Break it anywhere you like!' Exeter St David's, remodelled in the 1860s for the joint use of the LSWR and GWR, is an architectural jumble inside and out, but a colourful and cheerful one. My wife liked it; she found the risers on the staircase leading to the footbridge 'very elegant'. I

pointed out that the balustrades are wittily shaped like steam locomotive driving rods. The station boasts a refreshment room, a staffed customer lounge and a police station with old-fashioned blue police lamp outside and railway police-men inside. There's a set of retro 'Classic' scales for weighing yourself, and attractive benches with wrought-iron bases incorporating GWR logos. It's easy to get into the holiday mood at Exeter St David's, and part of the pre-Beeching fun for the young railwayist was to observe how the BR Western Region trains from Paddington en route to Plymouth left the station from the opposite direction to the Southern Region trains from Waterloo en route to Plymouth (which travelled over the route Beeching closed, now known as the 'Withered Arm'). Our train rolled in: not one of the GWR's short-hop units, but one of its IETs, bound for the end of the line at Penzance. My wife liked the carriages, an unusual opinion. 'Why?' I asked her, as we sat down.

'I like the grey and green.'

'Don't you find the seats a bit hard?'

'I suppose so, but then the seat I sit on all day in my office is hard,' which seemed an odd comparison to me, but our attention now turned to the view from the windows.

The wide Exe estuary came shimmering into view shortly before Starcross. M. V. Hughes recalls being hypnotised by waders 'carrying on some mysterious hunt in the water' – she means wading *birds*, presumably. Starcross is today a perfunc-tory station, like a small grey dock, and you can take a ferry from here across to Exmouth. The station lost its roof in 1906, and you can get a soaking here just from badly behaved waves, or the general miasma. Inland from the station, the majority of a Brunel atmospheric pumping station survives, as a water sports centre. The estuary becomes the English Channel when the train reaches Dawlish Warren station.

'Then', writes M. V. Hughes, 'with a magnificent gesture, the Great Western swept us to the sea-side, indeed almost into the sea. Mother remembered a day when the waves had washed into the carriage. The bare possibility of such a thing made this part of the run something of an adventure, and we almost hoped it would happen again.'[3] Inland of Dawlish Warren stands a collection of old carriages in BR maroon. This is Brunel Holiday Park, which began life in 1935 as holiday accommodation for GWR staff, presumably with that company's chocolate and cream coaches providing the accommodation. It is currently for sale. An advert in the *Railway Magazine* of December 2023 noted that offers in the region £550,000 were being solicited for the site, which 'includes five recently refurbished Mark 1s and two-bedroom chalet for owner / manager.'

After Dawlish Warren the sea wall proper begins, and it accompanies the line into Dawlish itself, where it becomes something more like a modern concrete dam. In February 2014 a storm cut a 100-metre-long hole in the wall where it runs parallel to Riviera Terrace on Marine Parade, leaving the tracks swinging like a hammock. In July 2023 Network Rail unveiled a new half-mile of sea wall, part of the South West Rail Resilience Programme to shore up the defences all the way to Newton Abbot. The new wall at Dawlish is wider and higher than the old one, which had been kept relatively low in the 1840s for the sake of the sea views, at the insistence of a local landowner. Those views are now slightly interrupted. Then again, there is a proper promenade along the new wall, as opposed to the mere footpath along the old one.

On a sunny day, with a few saunterers on the sea wall, a few more on the beach and a couple of swimmers in the sea, the defences seemed unjustified. To see Dawlish besieged,

watch a BFI film clip from winter 1980, showing a filthy, snow-dusted Brush 4 hauling four Mark 2s warily along the wall, with the waves bouncing up three times higher than the train.

Most of Dawlish station dates from 1875. Its predecessor, amazingly enough given the watery situation, burned down. On the seaward side, the station looks like a fortress or prison, whereas, viewed from the town, the pale blue exterior of the ticket hall looks delicately classical. On this afternoon of milky sunshine, Dawlish seemed to be largely ignoring the sea, the entertainments and attractions being arranged at right angles to it, fronting the ornamented stream of Dawlish Water, with its famous black swans. There was Union Jack bunting, many dog walkers, games of crown green bowls underway; a piano tinkled from a church hall outside which a sign read, 'Special Guest Speaker Dan Letchford, With Tales of his Guide Dogs'.

I was not very surprised to learn that in 1918 a railway convalescent home had been established at Dawlish, with rest room, writing room, games room, billiards room and veranda. It was in Bridge House, built in 1793, and available to rent for much of the nineteenth century. It is believed Charles Dickens wrote some of *Nicholas Nickleby* there. The Railway Convalescent Homes movement had been started in 1899, a voluntary insurance scheme, funded by deductions from pay and providing one or two weeks of restful accommodation after accident or illness. The first was at Herne Bay from 1901. Other coastal ones besides Dawlish included Ascog Manor near Rothesay (1924), Shottendane at Margate (1927) and the Old Abbey at Llandudno (1950), the latter two for women. A BR leaflet of 1952 speaks of ten homes 'all situated in delightful surroundings ... they are models of cleanliness; the beds are really comfortable, and the food is the best that can be provided.' Among the distractions available, dominoes,

draughts and smoking were singled out. The last to close was Bridge House, in 2020.

After afternoon tea (more or less obligatory in Dawlish) my wife and I walked back to the station, where she boarded a train back to Exeter to look at the cathedral, and I went up to speak to a man I'd seen on the platform when we arrived. He obviously had no intention of catching a train, and this was because he was *watching* trains and taking down their numbers. He said he was a retired electrician and he'd been coming to Dawlish 'for the trains' ever since boyhood holidays from Manchester. I queried his policy of standing in the station, whose fortified wall blocks off a view of the sea. 'If you stood outside, you could have the trains *and* the sea.'

'I can get that from my hotel,' he said. This was the Marine Tavern on Marine Parade. He referred me to its website, where I read, 'If you're interested in trains, the Marine Tavern is for you,' and to prove the point there was a film clip of two trains going along the sea wall. The first, not deemed worthy of a caption, was a CrossCountry Class 220 Voyager, but the other was lovingly described: 'A BR Standard Class 7 No. 70000 *Britannia* powering the return Kingswear-to-Bristol Temple Meads *Torbay Express* on 8 July 2012.'

There are many old photos, paintings and posters of children watching trains at Dawlish in the era of steam, their parents perhaps fretting, 'What's wrong with this kid? He ought to be facing the sea.' It usually was a 'he', of course, and many of those former kids are watching trains still.

I quit the station, and walked southwards along the sea wall to the reddish beach, overlooked by the reddish cliffs of Coryton Cove. Every ten minutes a train emerged from Phillot Tunnel to the south or Coryton Tunnel to the north and skirted the beach. But the trains were ignored by the swimmers and sunbathers here, just as they ignored the

A CrossCountry Class 220, nearly on the beach at Teignmouth.

railway engineers suspended by ropes on the cliff face. The cove, served by a red, white and blue tea hut billed as 'The Only Beachside Café in Dawlish', seems determined to be a normal beach.

I took the train from Dawlish through the two above mentioned tunnels, and two more, to Teignmouth. The experience was much as M. V. Hughes described it:

> The sun was always shining at Dawlish, and there was the sea all spread out in dazzling blue. And as if the train knew how to enhance the effect, it would roll in and out of the short tunnels in the 'rouge' or red sandstone of Devon. Each time it emerged the sea looked bluer and the rocks more fantastic in shape. However beautiful the inland scenery might be, it seemed dull after this, and after Teignmouth we usually fell asleep.

By Train and Steamer to Rothesay

As a *Guardian* columnist the late Ian Jack was, in an informal and poetic sense, the paper's industrial correspondent. He wrote unsentimentally from an Old Labour angle: about traditional working-class life, men and machines. He had a strong interest in railways, but steam boats and ships were his first love.

On 29 July 2011 Jack reminisced in the *Guardian* about how, as a boy standing on a beach at Dunoon one blazing summer's afternoon of 1955, he saw a two-funnelled steamer come around the headland, 'gliding towards us like a small liner'. 'That'll be the wee *Queen Mary*,' his uncle said, 'going home to Glasgow from the isles of Bute.' Jack became an adherent of the cult of the Clyde steamer, 'once as fierce as Britain's better-known devotion to steam locomotives'.

In the piece Jack described the 'rituals of summer', which might involve steaming all the way down the Clyde from the grand quays of the Broomielaw in Glasgow to the chosen resort, or first taking a train before boarding a steamer at one of the Clyde railheads. Either way this was called going 'doon the watter'. 'Smells were exchanged,' he recalled – 'the stale tobacco smoke of the railway compartment for the fresh sea air – on the opening of the carriage doors.' On the long-haul steamers 'coffee would be brewing in a dining saloon which later served roast lunches and fish teas … You might go below and watch the engine cranks turning mesmerically or stay on deck to see a succession of Victorian resorts, some no more than a line of villas along the shore, come and go.' And there is today an Ian Jack Fund, in support of the last surviving sea-going paddle steamer, *Waverley*, which can be seen, and boarded, every summer on the Clyde, the Bristol Channel, the Solent and the Thames.

The first successful paddle steamer, *Comet*, was built by

Henry Bell in 1811. Oddly enough, Bell's thoughts had been leisure-oriented – he wanted to get people from Glasgow to Helensburgh, where his wife ran a hotel – but he had inadvertently revolutionised the speed of shipping. *Comet* has come to symbolise the modern age of Clyde shipbuilding, and Glaswegian industry in general, which spawned the countervailing business of Clyde holidays, concentrated in the July week of the Glasgow Fair, when the factories closed down.

In Ian Jack's golden summer of 1955 there were still 'eight or nine' steamships on the Clyde, whether driven by paddles or turbine-powered propellors, but in 1900 there'd been 300, plying the fractured landscape of the Clyde in a complicated network of ferry services and cruises, often in conjunction with connecting trains. Millport, Rothesay, Dunoon, Helensburgh, Arrochar, Ayr, Campbeltown and Inverary were among the 'Doon the Watter' destinations. By the 1860s three large companies operated the boats and trains: the Glasgow & South Western, the North British and the Caledonian Railway, giving way to the LNER and the LMS post-Grouping. The automobile has largely killed the network of diesel boats that took over from the steamers, and today the 'Doon the Water' options are limited. The classic surviving trip is from Glasgow Central to Wemyss Bay, there to board a ferry to Rothesay, the largest settlement on the Isle of Bute and known as 'Glasgow-on-Sea'.

It's a pleasure to start any journey at Glasgow Central, which has a somehow American bustle and grandeur, and which, owing to the largest glass roof in the world, always sparkles with light, even on a rainy day, and where the ticket offices and shops are smoothly curvaceous so that the crowds seem to flow naturally around them like water. Whatever station

you are heading towards from Glasgow Central will usually not live up to Glasgow Central, but that is not the case with Wemyss Bay.

First, however, there is the penance of the journey between those two stations.

It began well enough. A friendly driver came up to me as I was havering between two electric units on the high-level part of Glasgow Central. 'Are you for the Bay?' he said, by which I seemed to be co-opted into the 'summer ritual', albeit this was towards the end of September. He indicated the correct train, which was sparsely occupied with only a couple of minutes to go before departure time. 'This train would be packed out in high summer, right?' I suggested. He pulled an equivocal face, as though unwilling to give an outright 'no'. 'Not so much these days,' he said.

There are a dozen stops on the Inverclyde Line between GC and Wemyss Bay. It's a trip into Glasgow suburbia, through anonymous small stations (except for stately, stone-built Paisley Gilmour Street), then into mild countryside. On the BR Class 303 or 311 units that served the line in the 1960s and 1970s, passengers could have watched the landscape hypnotically unrolling directly ahead, thanks to the glass bulkheads behind the drivers' cabs and the wide panoramic windscreens that were the characteristic features of those trains. Today the line is served by ScotRail trains (ours was a Hitachi Class 385) that don't have any characteristic features except, it seems, a loud and distorted voice on the automated PA.

The voice speaks for about half the duration of the ride – a moronic, brain-numbing tape loop:

This train is for Wemyss Bay … We will shortly be arriving at … Take care of the gap between the train and the platform as you leave the train … Don't forget to take

all your belongings with you before you leave the train
… This train is for … We will shortly be arriving at …
Take care of the gap between the train and the platform
before you leave the train …

It's the frequency of the stops and the short distance between
them that makes this so painful.

I asked the guard if he could do anything about it and he
laughed. 'The driver might have a fighting chance, but me?
No way!' He walked off, then quickly returned, still tickled:
'It's no consolation to you, I know, but at least it's telling us
the right information. It could be saying we're at Glasgow
Central; that's actually happened!' I began to be jealous of
those nineteenth-century holidaymakers who'd gone all the
way 'Doon the Watter' by boat, a practice that gradually fell
out of favour, the Upper Clyde being heavily polluted. But at
least the sound of the wind and the waves and the churning
paddle would have given you a 'fighting chance' of avoiding
the tyranny of any annoying voice.

The widening Clyde lay to the right, empty of boats.
Instead, a great rainbow had formed over the water, signify-
ing rapidly improving weather. Here, from Alasdair Gray's
science-fictional, or magic realist, novel *Lanark* is a descrip-
tion of a flight over a Clyde-like 'wide and widening firth' in
industrial days:

> On both shores he saw summer resorts with shops,
> church spires and crowded esplanades, and clanging
> ports with harbours full of shipping. Tankers moved
> on the water, and freighters and white-sailed yachts. A
> long, curving feather of smoke pointed up at him from a
> paddle steamer, churning with audible chunking sounds
> toward an island big enough to hold a grouse moor, two

woods, three farms, a golf course and a town fringing a bay.

Wemyss Bay, like Glasgow Central, receives five stars from Simon Jenkins, and both were redesigned in the early twentieth century by the same team of architect James Miller and engineer Donald Matheson. Their work at Wemyss Bay, which was opened in 1865 as a branch from Port Glasgow, was completed in 1903 to handle the huge increase in holiday traffic. The station roof is like a glass flower extending over the sandstone walls and out from the central hub of the ticket office. Like Glasgow Central it has an organic quality, and the curved, covered ramp that leads down from the circular concourse towards the ferry dock seems to occur as spontaneously as a river flowing down a hill. Edwardian photographs show the crowds coming down the walkway ten abreast, everybody smiling. The holiday mood is captured by a bronze sculpture at the top of the ramp. It depicts a generic Glaswegian lad, 'Bobby', heading purposefully towards the boats, clutching his own model yacht.

On my visit, Bobby and I had the ramp to ourselves, so it was apparent that, despite the glass roof, its floor planks were as liberally splattered with seagull droppings as any pier. Even though the station was quiet, it was not depressing, because Wemyss Bay is populated by its own staff. There was a ticket clerk in the ticket office, and three women in the ferry terminal office at the base of the ramp, one of whom smiled indulgently when, as she issued my ferry ticket, I said I was going 'Doon the Watter'. (She did not attempt to correct my pronunciation.) I had half an hour to kill before embarkation, so I looked in on the small station bar, where five customers were sipping afternoon beers and watching an appropriately retrograde TV channel, '70s Now', on which, in blurry

colour, Tony Orlando was singing 'What Are You Doing Sunday?' On the door of the bar is a sign reading 'Welcome to the Station Bar, serving the Public since 1903', and it must have seen a lot of action over the years. The phrase 'steaming drunk' arose from observation of crowds going 'Doon the Watter'. In *Summer in Scotland*, Ivor Brown writes:

Perhaps not all Scots and certainly not all English know the story of the Glasgow man who set out in Fair time to see the Kyles. He settled himself below decks in the well-filled and socially clamorous bar which had developed a fine frowst of friendship, tobacco and beer fumes. When his wife, more hygienically braving the air on deck, realised that their goal was won and shouted at him, 'Hey, Wullie, the Kyles of Bute! Come up and see the Kyles!' he roared from the cosy depths, 'Och, to hell with the Kyles! Do you nae ken I'm on holiday?'[4]

Adjacent to the Wemyss station bar is the station café. There is also a second-hand bookshop, operated by the Friends of Wemyss Bay Station, who are responsible for the station flower arrangements and the parade of bay trees on the ramp. The bookshop is in the 'old' waiting room, but you can still wait there, in the living-room-like space, with its large mantelpiece and a table covered with photo albums of Glaswegian holiday history.

Today the only boats from Wemyss are car ferries to Rothesay, the Clyde cruises from Wemyss having stopped in 1977, but roughly half the passengers of any sailing are foot passengers. Two almost identical craft ply the route, *Argyll* and *Bute*, and the one awaiting me was *Argyll* (or possibly *Bute*). They're operated by Caledonian MacBrayne which, neatly abbreviated to CalMac, has been an institution on the

Clyde seaways and beyond since 1973, and with still deeper roots if one digs into the complex history of the company's predecessors.

There was a bar on the boat, but the main attraction was the large TV screen showing one of those sleepy afternoon programmes about property buying. I sat on the small open deck next to two women, probably in their seventies; they were comparing notes about their cockapoos. One half-drunk glass of red wine, perched on an unoccupied seat, was a reminder of more raucous days. Its contents sparkled in the sun, as did the Clyde water. There was no longer any danger of being soaked; rather, of sunburn. Over the water, the white villas of Rothesay slowly expanded.

The current ferry terminal, with its retro clocktower, looks vaguely Victorian but dates from 1992, when it replaced something more modern-looking. During the Glasgow Fair policemen might have awaited arrivals from Glasgow, because there was tension between gentility and rowdyism in the town's heyday, reflected in the presence of at least one temperance hotel amid the many pubs; there was also a temperance steamer.

Heading east along the promenade, I passed two parties of elderly Scottish women taking tea on their front lawns with blankets on their knees. I was heading for the epitome of Rothesay gentility: the baronial Glenburn Hotel, whose terraced front garden was obviously designed with Edwardian lounging in mind. It gave beautiful views to the hills across the water, which seemed as unreal and idealised as a theatrical backdrop. After checking in, I walked back to the middle of town: that is, to the vicinity of the ferry terminal. I ought to have brought my golf clubs, since there are three courses on Bute (and two putting greens on the front at Rothesay). Instead, I went into the Golfer's Bar, which features detailed

maps around the walls of one of the Bute courses. David Bowie was being played too loudly on the sound system, but the barman was friendly, and a large glass of white wine was only £3.75.

Dinner was fish and chips, eaten while sitting on a wall on the front, during the time it took to watch a ferry arrive and depart. Back at the Glenburn, I had a nightcap in the lounge overlooking the dark water. It was a big room, but with only half a dozen other customers, and those who were talking did so in low voices. Eventually, most people went to bed.

'Quiet night?' I ventured to the barman.

'It's always quiet after the Highland Games,' he said. (The Games are held on Bute in mid-August).

'But things pick up again towards Christmas, I suppose?'

'Not really,' he said. 'We're closed in December and January.'

It does seem that 'Doon the Watter' by train and boat has been eclipsed by 'Over the sea in an aeroplane.'

The Cambrian Line to Pwllheli

The Railway Magazine Encyclopaedia of Titled Trains calls the *Cambrian Coast Express*, which served the resorts of Cardigan Bay between 1927 and 1967, a 'delightful exception' to the idea that the term 'Express' suggested high speed.

The first part of my journey to the Cambrian Coast Line involved taking a train from Euston to Birmingham, never a very cheering prospect. The 'new' Euston, opened in 1968, was conceived as a refutation of its rambling Victorian predecessor. There would be one big room, in which passengers could buy tickets, look at train times, eat and circulate, free of the presence of embarrassingly old-fashioned things like trains. But the clean, modernist vision has been undermined

by the barnacling of fast-food outlets that radiate a blurry glow in the otherwise crepuscular interior. It's always like night-time inside the Euston concourse.

The platforms are even darker. You might think they're subterranean, an impression created by the ramps you descend to reach them, but they're on a level with adjacent Eversholt Street, a hideous thoroughfare in itself, but it does at least have a sky above it. What's above the Euston platforms is a 'parcel deck', a space for handling parcels and mail, conceived in the days when the railways did handle parcels and mail. It is now used for storage and offices. In other words, the platforms are dark for a reason no longer valid.

There are some white metal benches down there of the kind you might expect to find in prisons, but nobody ever sits on them, because passengers are only admitted to the platforms from the concourse at the last minute, so waiting for a train at Euston is like waiting to see a doctor at A&E, in that you're in thrall to some illuminated signal, in a space that is the environmental embodiment of a headache.

Admittedly, the business of separated waiting was pioneered in the old Euston station, or in one of them. Not the original of 1837, constructed by the London & Birmingham Railway as the terminus of the first main line into London, with the monumental arch plonked in front, in a fit of self-congratulation, but in the rebuild of 1849, when the Great Hall was opened, with the largest ceiling span of any building in the world, supported by 20-foot-high Ionic columns. This was the grandest waiting room ever built, so you probably wouldn't have minded hanging around there until a bell signifying your train was tinkled, or until its designation was cranked into a view on a sort of canvas blind worked by a porter. Old photos show clusters of white-globe gas lights,

supplemented by daylight streaming in from high windows; there was also daylight coming through the iron and glass roofs of the train sheds lying either side of the Great Hall.

It was a whimsical arrangement, though. The Great Hall was out of alignment with the Arch, and the platforms flanking the Great Hall kept accumulating. The loading and unloading of letter and parcels on those platforms supposedly incommoded passengers, hence the way those functions were kicked upstairs in the replacement station – as if it wasn't fun to watch porters chucking parcels and mail bags about.

It might be said that any seashore, when you finally reach it from Euston, must look the more attractive in comparison to your starting point. But when our aristocratic golfer Bernard Darwin travelled to the Cambrian coast from old Euston, he found it all of a piece with seaside jollity. The 'most dear and romantic of stations', he called it in 1911. Darwin would travel from Euston to reach his favourite course, Aberdovey, on the mid-Wales coast, and we will be checking in with him as we make our own way to Aberdovey and beyond.

In Darwin's day the West Coast Main Line was in the hands of the London & North Western Railway, and this company was the main English ally of the Cambrian Railways, which sounds like a generic term but was the name of a single company that ran a network of 230 miles of railway in mid-Wales, including the Cambrian Coast Line. The LNWR offered daily through services to the Cambrian Coast from Euston via Stafford and Shrewsbury – that is, via the West Coast Main Line, but not the loop on which the LNWR's Birmingham station, New Street, was built. (At the Grouping, Cambrian Railways was absorbed into the GWR, so Paddington became the chief starting point from London.)

My train departed twenty minutes late, and when I told

the guard, who was sitting in his little compartment, that I was heading for Pwllheli and was worried about the connection, he said, 'It's nice isn't it, Pwllheli? We go up there quite a bit. We stay at the Haven place,' he added, meaning the former Butlin's. 'Let's see if your train from Birmingham's running on time.' After browsing on his phone for a while, he said, 'Typical, isn't it? When you want a train to be late, it's not.' He said he'd give me an update beyond Coventry, so I returned to my 'Quiet Carriage' seat in a state of anxiety not lessened when the man across the aisle initiated a phone call with the words, 'Hi gang, can you hear me?'

After Coventry the guard came up. We agreed that I'd have a better chance of catching my Wales-bound train if I intercepted it at Birmingham New Street rather than connecting at Birmingham International, as per my ticket. 'You might make it,' he said. 'You'll have about a minute. The platform you want is the next one over, but you have to go up some stairs and down again,' This was because Birmingham New Street, being built in the same benighted railway decade as Euston, also relegated its trains to the sub-surface level.

I didn't make it, and the next train to Pwllheli was two hours later.

Two hours in Birmingham New Street. It could be worse. Or could it? In 2003, the station was voted the second biggest eyesore in Britain by readers of *Country Life*. (In first place were wind farms.) In 2015 the station was slightly brightened. A new concourse was created, with a domed atrium to let in some artificial light. Shiny steel cladding was applied to the exterior, so that, if the station does not add to the grandeur of central Birmingham, it does at least reflect it. The station remains an underground maze, though.

There has been some attempt to rationalise the maze by colour coding the platforms, but in a couple of hours of

wandering about I kept getting lost. I had a cup of coffee in a WH Smiths; then I went through a couple of ticket barriers and bought a magazine in what was either another WHSmiths or the same one again. I asked an Avanti man at a barrier about the station 'improvements'.

'I wouldn't call them that,' he said.

'What about the steel cladding?'

'We call that the dustbin.'

He seemed quite cheerful, though, and all the station staff seemed friendly and helpful; a kind of Blitz spirit, perhaps, making the best of a bad job.

Despite the New Street confusion, I could have located my train by the smell alone: a four-car Transport for Wales Sprinter, whose diesel fumes, and engine growl, were magnified by this subterranean station premised on electric traction. The platform indicator said the train was for Aberystwyth, but most people on board knew it would divide, with one half going to Aberystwyth, the other half for Pwllheli – but which half was which? This would be a subject of constant perplexity, in spite of the guard's regular announcements that the front two coaches were for Pwllheli. It was a busy, jolly train, with an attractive red and black seat moquette, signs in Welsh and English, suitcases on the luggage racks, a couple of vintage touring bikes in the sizeable bike storage area.

At Shrewsbury, considered the start of the Cambrian Main Line (as opposed to the Cambrian Coast Line), the sun was shining brightly, increasing the attraction of this antiquated junction, seemingly surrounded by churches. We came out of Shrewsbury the same way as we'd come in, prompting discussion as to whether those of us bound for Pwllheli were still in the 'front' two coaches. I was sitting opposite two trim, retirement-age people – I'll call them Ian and Sarah – who

looked as though they might be a couple but weren't. Both lived on the Pwllheli branch of the Coast Line, Ian (a Welshman) in Tywyn, Sarah (English) in Harlech. They assured me I was still in the right portion for Pwllheli.

At Shrewsbury in 1911 Bernard Darwin was usually joined in his compartment by other golfers. 'I should not be surprised if we even attempted to waggle each other's clubs in the extremely confined space at our disposal.'[5] Darwin's train continued over the route we now began to follow, towards Welshpool on the Welsh border, the difference being that the intermediate stations are now closed. Darwin writes that the stations passed in a 'leisurely' manner: 'Welshpool, Abermule, Montgomery, Newtown – I forget their order but love to write down their names.' (He does forget their order: Abermule comes after Montgomery, or it did: both were closed by Beeching in 1965.) He continues:

> The train comes into a country of mountains and jolly, foaming mountain streams; it pants up a steep hill to a solitary little station called Talerddig ... Near Talerddig is a certain mysterious natural arch in the rock, and it is a point of honour with us to look for it out of the window. However, since we never can remember exactly where it is, and the twilight is deepening, we never see it.[6]

I never saw it either. There is no modern reference point for the natural arch among the surrounding rocky hills, Beeching having closed Talerddig in 1965, with no trace remaining.

'Nice scenery,' I said to Ian and Sarah.

'You haven't seen anything yet,' said Sarah. 'Just you wait.'

We had entered the valley of the River Dovey. We came to Machynlleth station, where Darwin's train experienced a

'pause', so he and his fellow golfers had tea and listened to the people on the platform talking Welsh. There used to be a café at Machynlleth; there is no longer, but the station is still attractive, the main building resembling a long, granite cottage: you can see how it would have been cosy at twilight. Perhaps the 'pause' was caused by Darwin's train awaiting a connection from the narrow-gauge Corris Railway that used to run into Machynlleth, carrying mainly slate but also adventurous tourists. It closed in 1948 but has since been partly reopened. At Machynlleth our train divided into Pwll-heli and Aberystwyth halves: a painless surgical procedure, attended by some good-humoured shouting from the train staff on the platform. Belatedly the word 'Pwllheli' appeared on the carriage indicator as the last of many stops, prefaced by the elegantly formulated but misspelt message, 'We will be calling at the following principle stations ...' There would be others besides – all the small request stops in between.

Sarah pointed out a high mountain to the right. 'Cader Idris', she said, 'on the southern edge of Snowdonia.' We came to Dovey Junction, where the line, as opposed to the train, splits. No roads lead to Dovey Junction; it is described by R. W. Kidner in *The Cambrian Railways* as 'purely an inter-change point, perched wetly and windily on the very edge of the water'.[7] By 'water' he meant not the sea proper, but the ever-widening River Dovey.

Darwin again: 'Then on again through the darkness till we stop once more. There is a wild rush of small boys outside our carriage, fighting and clamouring for the privilege of car-rying our clubs. *Nunc dimittis* – we have arrived at Aberdovey.'[8]

We too had arrived at Aberdovey. 'Aberdovey means the mouth of the River Dovey,' said Ian, and by this point it was beginning to look like the sea. We rolled on past the velvety green undulations of the golf course, which lies between the

line and the sea; the players were beginning to be attended by their shadows. It is said that in Darwin's time a player hooked his drive on the 16th, which is directly adjacent to the tracks. He broke a carriage window; the train guard pulled the communication cord, stopping the train to remonstrate with the golfer, who said, 'You're running late. If you had been on time, I'd have missed you.'

The course was succeeded by a long sandy beach, the first of many. 'A lovely sunny day', said Sarah, 'and still plenty of room on the beach.'

'People tend to drive here,' Ian said, 'but then they use the train to shuttle between the beaches.' Our train was old enough to have openable windows, and they *were* open, and one small boy was standing on a seat, as though to inhale the ozone.

We came to Tywyn, where Ian disembarked. Adjacent to the station stands the terminus of the narrow-gauge Talyllyn Railway, considered the first preserved railway in Britain. One of its engines gleamed in the late afternoon sun. The Cambrian Coast Line owes its survival to the Community Rail Partnership that helps maintain it, and the fact that it serves both the Talyllyn Railway and the preserved lines based at Porthmadog, principally the Ffestiniog.

'This is the best bit,' Sarah said as we set off again – 'between here and Harlech.'

We continued to track beaches and the sparkling sea, but the view inland alone – white villas on hills, granite chapels and the occasional castle – would have made this one of the most scenic routes in Britain. The train was always packed, but with a high turnover of people, boarding in swimming trunks, trailing sand, carrying surf boards or lilos, and the new guard we had acquired at Machynlleth might also have just stepped off a beach: she wore shorts, a pink bandana, sunglasses on her forehead.

Barmouth Viaduct, which the author photographed
from the train – not a very original thing to do.

We approached the famous Barmouth Viaduct. It trav-
erses the Mawddach Estuary, which resembled a tinted
postcard, being an implausibly deep blue against the vivid
green of the hills and mountains. The viaduct is half a mile
long, and the curvature of the track means you have a good
view of it beforehand. How many parents have pointed it
out to how many children, saying, 'On the other side of
that, our holiday begins'? The whole route was threatened
in the early 1980s when the viaduct had to be closed. Being
old (1867), the Barmouth viaduct is made of wood, and had
been attacked by shipworm – not the same as woodworm,
but both bore into it. As Benedict le Vay writes, this 'gave
the unlikely headline: "Shipworms stop trains."'[9] As repaired,
the viaduct remains a timber structure, with some assistance
from reinforced concrete.

Barmouth station was in the heart of the holiday action. The view of the sea from the carriage window was blocked by a small funfair. Sarah pointed inland to the long queue outside the Mermaid Fish Bar. 'That's always being written up in the national papers.' A silvery haze was developing amid the goldenness of the sun, but Barmouth beach was still quite crowded.

Barmouth is the most important station on the 50-mile stretch from Dovey Junction to Pwllheli. It was formerly the terminus of the Ruabon to Barmouth Line, which carried tourists to Barmouth beach and goods to Barmouth port through the beautiful Vale of Llangollen. It fell victim to Beeching in 1965.

The old GWR promoted the Cambrian Coast heavily as a holiday destination. One particularly memorable poster, dating from the early 1930s, showed a woman in a green swimsuit writhing ecstatically in the shallows of the sea: 'The Cambrian Coast: Miles of Glorious Sands'. In 1927 the GWR initiated the *Cambrian Coast Express*, hauled by a King or a Castle as far as Wolverhampton, where more modest motive power took over: a Manor, or a pair of Dukedogs, antiquated-looking engines cobbled together from two older classes: Dukes and Bulldogs. Antiquated, but clean and well-maintained in GWR days. The poor condition of these engines under their inheritor, BR, has often been lamented by steam fans. Latterly, BR Standard Class engines took over the *Cambrian Coast Express*, making the train one of the last steam-hauled services outside the Southern Region of BR, but the Pwllheli portion was a DMU in the last year, 1967. Our own DMU had now arrived at Penychain, which once served the nearby Butlin's, and was now a holiday camp operated by Haven. Two people alighted: a blind man, led by his sighted companion, who carried an old-fashioned suitcase.

We arrived at Pwllheli bang on time at 19.21 – impressive, given all the request stops. Pwllheli has the sparse look of many seaside stations, the one remaining platform being glowered over by an adjacent superstore ('Home Bargains'). At least the concourse retained its glass roof. As I walked towards my hotel, located half a mile from the characterful town, and one street away from the sandy beach, two men were discussing the weather. 'Something funny's happening to that sky now,' one of them said, as the silvery sheen over the sea was turning grey and misty. As I overtook the men, they continued their conversation in muttered Welsh, as though to conceal their dark prognosis from a naive visitor. About two hours later, as I was eating dinner in a wine bar full of suntanned, hearty sailors, a storm blew up. It raged all night, battering against the windows of my hotel room with such force that I hardly slept, and this noise was compounded by a man-made reverberation, revealed, in the bleary morning, to have been the flapping of a sodden Welsh flag.

The DMU back to Birmingham was a two-car; the windows were all shut, which made it stuffy; then again, the storm was still flying in from the sea. I had found a seat with a table, but it turned out there was chewing gum stuck to its underneath, which marked my trousers. All the magic of the previous day – deriving entirely from the train journey – had fled, but it has persisted, and even grown, in my mind in the weeks and months since.

To Llandudno

We are not finished with Wales yet. This is a book about trains to the sea, and Wales has 746 miles of coastline. Most of the hundred miles of the North Wales Main Line from

Crewe to Holyhead are coastal, hence its alternative title: the North Wales Coast Line. On it lies 'the Queen of the Welsh Watering Places', Llandudno.

Before Beeching, Llandudno was reachable in a couple of hours from Pwllheli: a matter of heading back along the Cambrian Coast to Afon-Wen, then north along the Carnarvonshire Railway, intersecting with the North Wales Coast Line at Bangor. The Carnarvonshire was fading away from the 1930s, but summer specials survived until Beeching swung his axe. Trainline offered the following not very tempting journey from Pwllheli to Llandudno: retrace my steps all the way along the Cambrian Coast, then back east to Shrewsbury, then north to intersect with the Coast Line at Chester: a six-hour, forty-stop trip.

Instead, I started all over again from Euston, which was no prettier than before, but at least my train for Crewe was on time. It's a nostalgic pleasure to arrive at Crewe, a depleted and rusty-looking but still vibrant six-way junction. Here I boarded the Transport for Wales DMU that would take me to Llandudno. Its passengers were a much happier lot than those aboard the electric unit from Euston and, this being the last week of the school holidays, it was packed. Two extended families boarded at the same time as me. One of the grandfathers was an authoritative figure. 'We want the right-hand side, for the sea views,' he announced. Both families had light Merseyside accents. 'Are you off to Rhyl or Llandudno?' one mother asked the other.

'Llandudno,' came the reply. It was the likeliest bet, with Rhyl and Colwyn Bay close behind.

In the summers of the early 1930s the LMS offered a *Golden Sands Express* connecting those three resorts, for holidaymakers who wanted to try a different beach for a day.

'We're just off for the day,' the first mother said. 'You?'

''Til Saturday,' said the other (this was a Tuesday), indicating a couple of suitcases on the luggage rack.

'Oh, nice,' said the first, in defiance of the fact that the sky was grey, and it was starting to rain.

The impulse behind the North Wales Coast Line was strategic: to keep Dublin close to London, specifically Westminster. The line, built by the Chester & Holyhead Railway (absorbed into the LNWR in 1859) and opened in 1848, was almost literally an arm of government. It immediately became the route of the *Irish Mail*, arguably the oldest named train in UK, but not formally named until 1927. So pressing was communication with Dublin considered to be that the first water troughs were introduced between Colwyn Bay and Llandudno Junction to facilitate the non-stopping of this service. The name was dropped in 2002, when Virgin Trains had the West Coast franchise. What's 154 years of history, compared to the importance of foregrounding the brand Virgin? But then again, the North Wales Coast Line was itself a brash newcomer.

The line cut through the Chester city walls on its way west, and it seems symbolically significant that the keep of the castle at Flint – currently the first Welsh town served by the line – collapsed in the year of the line's opening, as though affronted by its proximity. The line came much closer to Conwy Castle, however. After sending the tracks over the Conwy Estuary in an elevated iron tube, its engineer, Robert Stephenson, outrageously threaded it through one of the castle's external walls. It's a dreamlike scenario, as seen in a short BFI film dating from 1898, *Conway Castle – panoramic view of Conway on the London & North Western Railway*. The footage – which seems weirdly disembodied, the camera having been attached to the front of the locomotive – is hand-tinted. A signal arm is a delicate pink, the tracks

silvery, the castle walls orange, the adjacent fields khaki. In the station beyond the castle is a single, stooped man in a long coat, his hands in pockets.

In its Edwardian holiday heyday the North Wales Coast Line was quadrupled, but taken back to two lines in the retrenchment of the 1960s. It hasn't been all downhill since, though: in 2023 Rishi Sunak announced that the line would be electrified, as one of the projects using money saved from the scrapping of HS2 beyond Birmingham, and perhaps this will actually happen.

After a countrified interlude alongside the Shropshire Union Canal, we began to run alongside the Dee Estuary.

'The beach!' exclaimed one of the younger kids, albeit with a note of doubt, since we were passing an expanse of mud and scrap metal, but his older sister, who'd probably been this way before, corrected him. 'Not yet, Ricky!'

Even so, the holiday mood was making the carriage cacophonous.

'Shotton Steelworks!' the authoritative man was pointing out. 'Look at all the railway sidings.'

The small boy (the one who'd shouted 'Beach!') poked his head through a gap in the seats and addressed me. 'I'm going to school tomorrow!'

'You are not, lovey,' said his mother. 'You'll be on holiday tomorrow. You're not going to school for a couple of years.'

We called at Flint. The remains of the above-mentioned castle were visible beyond modest red brick houses. Not long after we'd pulled away, one of the older children called out, 'The ship!' and this was obviously a familiar landmark, beached high and dry above the water. TSS *Duke of Lancaster* (I later read) was cemented into the coast at right angles to the railway line, having run aground in 1980. She was once – before her

misadventures under a subsequent owner – a British Railways ferry, operating between Heysham and Ireland from 1956.

The Dee Estuary was becoming slightly more attractive: less industry, cleaner mud, more seabirds. On the other hand, there were beginning to be many fixed caravans, their relentless whiteness offset in every case by the red of their life-support systems: the gas tanks. In typically reflective prose, Michael H. C. Baker acknowledges that these are not a pretty sight,

> but it is little use the railway complaining, for the LNWR made a fortune in opening up the North Wales coast, and if today most holidaymakers come by car or coach, their great grandparents would never have discovered the delights of the golden sands if the railway had not introduced the two parties.'[10]

Bill Bryson was less charitable: 'From the train Wales looked like holiday hell – endless ranks of prison-camp caravan parks standing in fields in the middle of a lonely, wind-beaten nowhere.'[11]

Young Ricky had poked his head through the seat gap again, and was now singing over and over the words, 'It's the end of a lovely day!' confirming his talent for mendacity, since it was the late morning of a very grey day. This didn't dampen the enthusiasm of a more widespread shout of 'Beach!' that now went up – because we had hit the North Wales Coast proper, and were running alongside a sandy beach, sand dunes, a golf links.

We came to Prestatyn: a quiet station for a quiet resort, but 'the scene of many a punch-up during the miners' strike', said the knowledgeable man. Next stop was Rhyl, where quite a few got off. It's the most commercialised

resort in Wales – the Welsh Blackpool, with some of the same problems, but also the same promising regeneration schemes. Rhyl is a rangy station, but not as big as it was: 'There was another island platform over there,' the knowledgeable man was saying, 'and a great big engine shed beyond it.' The platform fixtures are painted cream, red and green, an attractive, Christmassy colour scheme commonly occurring in north-west Britain (it's at Preston, for instance), but with mysterious origins. Those were never LNWR colours.

We were passing the Rhyl Marine Lake. Of the Rhyl Miniature Railway that has encircled it since 1911 I could see the track through the gloom, but no train.

The boy was addressing me again. 'We're getting off soon,' he said. 'I've already packed up all my stuff.'

Again his mother intervened. 'Ricky, you have *not*, love!'

Ignoring this reproof, Ricky told me, 'I've got Everton shoes!'

This was probably true, since his mother didn't correct him.

We passed a lonely funfair, forlorn in the rain, its lights all lit.

Inland, a sprawling castle loomed, looking suspiciously well preserved. The knowledgeable man was explaining all about it. Gwrych Castle is a folly, built in 1819 for Lloyd Hesketh Bamford-Hesketh, and is now possibly on the verge of becoming a five-star hotel.

We were tracking the sands of Colwyn Bay, their famous goldenness tarnished by rain. Between 1884 and the 1960s Colwyn Bay station was preceded by a station called Old Colwyn, a function of the town's success as a resort, and where people often alighted by mistake. As Simon Bradley writes, '"Bay" in a place name usually indicates that a

settlement is not very old. Colwyn Bay is a case in point, being entirely a creation of the railway era.'[12] It ought to be no surprise that Colwyn had two stations: it's the biggest town west of Liverpool. The surviving station – bang on the seafront – has an attractive covered footbridge and the mysterious Christmassy colours.

The sky was dove-grey, the sea the colour of washing-up water that needs to be changed. Nobody was swimming in it. The knowledgeable man was telling a story about a man from Colwyn Bay who'd married a Cuban woman; they'd lived together in Cuba for many years, then he brought her back to Colwyn one summer. The woman, a keen sea-swimmer in Cuba, insisted on taking to the waters in Colwyn. 'Her husband couldn't talk her out of it,' said the knowledgeable man. 'She put on her costume and ran straight into the sea. She ran out again straight away, screaming.'

We were coming up to Llandudno Junction, where the 3-mile branch to Llandudno begins. It also serves the Conwy Valley Line, which heads south towards Blaenau, terminus of the Ffestiniog Railway. (The line is eloquently evoked by Benedict le Vay, who notes how, after Betws-y-Coed, it ceases to be merely beautiful and becomes 'majestic … I have always been utterly amazed at the transformation from green sheep pastures at the north end to the bleak slate heaps and industrial moonscape at the Blaenau Ffestiniog end.'[13])

'This is Llandudno Junction,' said the knowledgeable man. 'If you didn't know, you'd think it was Llandudno,' and he began correcting people who, having made just that mistake, were proposing to disembark.

A few minutes later, at Llandudno, everyone did disembark, amid a strong wind and flying rain, from which only the very front part of the train was protected by the station's glass canopy. This projects a quarter as far as when the station

was expanded in 1892, a development reflecting the town's success as a genteel resort: any leakage of smoke and steam would have lowered the tone. On the south horizon, the Snowdonia mountains glowered in shades of grey and black as the two families were saying goodbye on the platform.

'Enjoy it!'

'We will!'

Considering this cheerfulness, I felt guilty about going straight up to the ticket office window in hopes of being able to take an earlier train back than provided for by my ticket.

'It's a Super Advance Single,' said the ticket clerk. 'You'd have to buy a new ticket.'

'OK,' I said. 'I might do that later this afternoon.'

'I won't be here after three,' she said. 'But you can buy a ticket on the train.'

No such recourse was necessary, because I liked Llandudno. Its fans speak of its 'Victorian elegance'. In *The Card*, by Arnold Bennett, the heroine, Ruth, finds it 'more stylish than either Rhyl or Blackpool, and not cheaper'. It's reminiscent of Harrogate or Bath, in that its shops and many tea rooms tend to have glass canopies supported by slender iron columns. Many shops sell holiday goods: treats and trinkets like sweets, wallets, jewellery. There's an endearing old-fashioned modesty about the place: a women's clothes shop is called the About You Boutique; a charity shop is 'Helping locally'. The miraculously intact pier is jolly without being raucous, although it is hauntingly preceded by the skeleton of the Pier Pavilion Theatre (burnt down in 1994), where Malcolm Sargent and Adrian Boult once conducted the orchestra. From the pier I surveyed the perfection of the promenade, with not a single modern eyesore (except the cars) to mar the scene. In the other direction lay the Great Orme, the massive

outcrop of rough pasture and limestone that looms almost vulgarly over Llandudno. A funicular tram has run up and down the Orme since 1903, and I took the ride myself, sitting in the very same cars that would have accommodated people who'd arrived in the town by the steam trains of the LNWR. Did they think of the tram as interestingly modern, it being electric? But there was nothing modern about the windswept Great Orme, with the wind and the rain, which had relented for a while, getting up again.

I was back at the station for about six o'clock. The ticket office woman had said she knocked off at three. She didn't mention that everybody else would be knocking off as well, so that the whole station would appear shuttered and in-accessible – until a local lad who'd been circulating in front of the station on an electric bike jabbed his thumb at me, indicating the side gate.

As the train rolled back along the coast, the rain and the interesting light of dusk gave the passing scene a melancholic appeal. The rides of the lonely funfair still twirled, still deserted, but with lights blazing bravely. Consulting the weather forecast for tomorrow at Llandudno on my phone, I saw a cheerful yellow blob: good news for the family who'd travelled up with suitcases.

6

CLASS ISSUES

Bournemouth

'The seaside', writes John K. Walton, 'puts the "civilising process" temporarily into reverse ... and conjures up the spirit of carnival, in the sense of upturning the social order and celebrating the rude, the excessive, the anarchic'.[1] It does this, he adds, 'in ways which generate tension and put respectability on the defensive.' In other words, one person's good time is another person's headache. Walton sees these themes played out in music hall songs, risqué postcards, knockabout comedy sketches featuring holidaying drunks, seaside landladies and spooning couples. They are also played out in reality: in a million culture clashes on beaches, piers and trains. Gradually the middle classes developed their refuges from the excursionists.

'By 1901 Southend had its Westcliff,' writes Alan A. Jackson, 'Brighton its Hove, Hastings its Bexhill, Margate its Westgate and Birchington, Whitby its Sandsend, Cromer its Sheringham, Blackpool its St Anne's, Weston-Super-Mare its Clevedon, Ilfracombe its Woolacombe.' He adds that an octogenarian friend of his, recalling train journeys to the Sussex coast in the 1910s and 1920s, remembers his parents claiming they could forecast which passengers would alight

at Bexhill and which would go on to Hastings, simply by listening to their accents.[2]

In *The Railway in Town and Country (1830–1914)*, Jack Simmons listed the resorts that tried to remain 'select': Bournemouth, Eastbourne, Folkestone, Torquay and Worthing.[3] Bournemouth did not get its railway until 1870, later than the others on Simmons's list, but this was down to the slowness of its growth rather than snobbishness.

In 1831 the coastal village of Bournemouth boasted three bathing machines for hire. In 1841 Dr A. B. Granville, author of *The Spas of England*, visited the town and, in a sycophantic after-dinner address, spoke of the 'balsamic and almost medical emanations from fir plantations'. Granville, who specialised in the 'almost medical', was the first person to propound the idea that Bournemouth was beneficial year-round to invalids, owing to its mild climate. Sanatoria were established in this 'winter garden of England', catering especially to retired colonial administrators seeking to re-acclimatise to the homeland.[4] But it would take the arrival of the railway for Bournemouth to transcend this valetudinarian scene.

When in 1847 the LSWR extended from Southampton to Dorchester (important as the county town of Dorset) and Weymouth (a faster-rising resort than Bournemouth), it saw Bournemouth as a low priority. So, after reaching Brockenhurst in the New Forest, it by-passed it, sending its main line via Ringwood and the beautiful town of Wimborne before dropping south to the sea at Poole.

Bournemouth got its connection twenty-three years later, courtesy of the Ringwood, Christchurch & Bournemouth Railway, but only as a branch line from Ringwood. This ran into a station that came to be called Bournemouth East, opened in 1870 half a mile from the centre of Bournemouth,

at the insistence of the town Commissioners. In his *A–Z of Bournemouth,* W. A. Hoodless quotes the following locally composed doggerel, written shortly after the arrival of the railway:

'Tis well from far to hear the railway scream;
And watch the curling lingering clouds of steam;
But let not Bournemouth-health's approved abode
Court the near presence of the Iron road.[5]

The railway triggered a rapid expansion of the town. The population, 6,000 in 1871, was nearly three times that ten years later, and the slow branch from Ringwood was inadequate. In 1874 the RC&B was purchased by the LSWR, which in that year extended its own line from Poole (discreetly and often in cuttings at the behest of the Commissioners), to what became known as Bournemouth West station. Bournemouth East closed in 1885, and a new, bigger station of that name opened over the road from the original, so no nearer the middle of town. This station received the new, faster routing of the South West Main Line (the one currently in use), running direct from Brockenhurst via Sway, leaving Ringwood and Wimborne out in the cold on the 'Old Main'. In 1886 Bournemouth East was connected to Bournemouth West.

Bournemouth East became known as Bournemouth Central from 1899 to 1967, even though it was not central. The station became just 'Bournemouth' in 1967, when the South West Main Line was electrified; Bournemouth West had closed two years before.

Excursionists came, but the Commissioners waged a culture war against them, attempting to control risqué bathing, for example: 'It is recommended in all cases of

bathing [that] suitable bathing drawers be insisted upon,' ran a decree of 1883. Sunday trains were banned until 1914, and Bournemouth was known for prestigious trains rather than cheap excursions. The *Bournemouth Limited* was hauled by the Southern's Schools class locomotives, named after public schools – *Eton*, *Winchester*, *Rugby*, etc. – which snooty Bournemouth must have liked, even if one of the engines was named after Brighton College. The all-Pullman *Bournemouth Belle* (1931–67) became year-round in 1936, fittingly enough, given the town's reputed mild winters. An LSWR booklet of 1920, *Winter Holidays in the Path of the Sun*, had observed, 'The fashionable winter season at Bournemouth seems to be more popular than ever.' Clearly mindful of the types of people likely to be attracted by this, the booklet adds reassuringly, 'The carriages of most long-distance trains are fitted with the steam-heating apparatus, under passengers' control, thus ensuring warmth en route.'

It is telling that the most famous express to serve Bournemouth was named after an evergreen: the *Pines Express*, a service from Manchester via Birmingham and Bath associated with the romantic and picturesque Somerset & Dorset Joint Railway, over whose metals its southern leg ran. The train was a testament to the attraction of Bournemouth, since the journey from Manchester took six hours and there was no buffet or restaurant car. As Michael Williams writes, 'The northern resorts tended to remain regional, whereas resorts such as Bournemouth had a more national appeal.'[6]

Bournemouth station has a high Victorian grandeur. (A previous design was rejected by the town Commissioners as 'looking too much like a station'.[7]) Its main feature is a great glass and iron roof and a pink-brick front wall that seems remarkably prolonged, almost like a stretch of city wall. The

town has grown to encompass the once remote station, but it is not an attractive embrace. The walk from the station to the front took me past 1970s shopping parades, busy roads, through a dark underpass. Palm trees in pots appeared at regular intervals, as if to reassure visitors that this was indeed famously exotic and temperate Bournemouth.

The middle of town looked more battered than the last time I had visited, in 2015. A friend who lives in Bournemouth had said it was 'never quite the same since Marks & Spencer's on Commercial Road closed in 2018'. I had not arrived in optimal circumstances – a grey Monday afternoon in late May, sufficiently quiet for me to hear the bickering of the street drinkers as I descended towards the municipal gardens that characterise Bournemouth, together with the long sandy beach.

A couple of signs indicated 'Winter Gardens', or the remains thereof. 'Winter Gardens' once denoted a great glass conservatory and performance venue and then, from 1938, a theatre of national significance. The Beatles played there a dozen times in 1963 and 1964. They didn't go by train. News footage shows them emerging at Bournemouth from the double doors at the back of a van, like old-fashioned convicts, but in their case the police were holding back loving, rather than vengeful, crowds. Today, 'Winter Gardens' denotes a car park and a rotting crazy golf course, the venue having been demolished in 2006. That garden has gone, but the Lower Gardens and the Upper Gardens remain, somehow excitingly overlooked by the white back walls of the seafront hotels. The whitewash was being renewed on one of these, as the flower beds were being planted out, from wide trailers loaded with blooms. Returning to the middle of town, I asked an assistant in the Waterstone's bookshop if she ever detected signs of the old, exclusive Bournemouth. 'There are

flickers,' she said. 'You see it at the Russell-Cotes Museum. But it's closed on Mondays.'

The Russell-Cotes Gallery and Museum is housed in an eccentric Art Nouveau house built in 1901 by Merton Russell-Cotes, a great benefactor to Bournemouth and sometime mayor. It overlooks the East Beach. As the sun was setting, I walked on the West Beach, from which rise some of Bournemouth's famous chines, or wooded valleys. My fellow strollers were quiet, civilised, friendly people.

An hour later, in the largely empty, echoing station, I sat on a bench alongside a prim-looking woman to await the train for Waterloo. As I peeled back the cellophane on a Sainsbury's sandwich, she moved smartly away. This was gratifying, in a sense, as it was to see her boarding first class when the train came in: another flicker of the old Bournemouth.

Trains to Holiday Camps

In its apparently whimsical way, the Midland & Great Northern Joint Railway built a line from Yarmouth Beach (formerly a large station, now a large car park) to North Walsham. The line closed in 1959, along with most of the M&GNJ network. Before heading inland, it called at the seaside town of Caister, where the pioneering Caister Socialist Holiday Camp had been established by John Fletcher Dodd in 1906. It was in the tradition of 'communal camping' – camps created not to make a profit but to promote community. Perhaps the first was run by Joseph and Elizabeth Cunningham, who set up a camp for underprivileged boys at Liverpool. Accommodation was in bell tents, as it was at Caister.

Drinking was not allowed in Dodd's camp; neither were children under two. There was no talking in tents after 11 p.m. But the camp evolved into something more relaxed,

with chalets and a dance floor, and from 1933 it was served by railcars (early units) and holiday camp summer 'specials' from Liverpool Street. The station was called Caister Camp Halt, one of half a dozen on the line serving holiday camps, for example Scratby and California. A reminiscence in the *Great Yarmouth Mercury* of 22 April 2018 implies that traffic to Scratby was so seasonal that it had a bench only in the summer months. Holiday camps drew most of their customers from the East End of London or the Midlands, so it's logical that coastal Suffolk and Norfolk should be holiday-camp-land. Today, it's more liked fixed-caravan land, but there are still holiday camps, even if the c-word (too reminiscent of 'prison camp') has been banished from official use.

There's still a camp at Caister, operated by Haven Holidays. I was told it was possible to discern the site of the old Caister Camp Halt within it, so I drove to Caister, an attractive seaside town sprinkled with shingle cottages. Its station, Caister-on-Sea, closed in 1959, had stood somewhere on the sand dunes behind the modern lifeboat station. Caister Camp Halt had lain further north, so I headed off that way, skirting the sandy beach. I came to some streets of 1960s semis; they included Great Close, Northern Close, Joint Close, so this was obviously the territory of the old railway.

A little way further north lay the modern Haven camp, resembling, with its white chalet-like buildings, a sprawling suburb of Los Angeles. The staff in the reception office were very helpful, and when I asked if they knew where the old Caister Camp Halt station was, they threw the question open to the people waiting to be accommodated in their chalets. One man, evidently a Haven regular, had heard of it. 'It was where the indoor swimming pool is,' he said. After walking for five minutes past people trampolining, piloting mini scooters, riding three-abreast bikes and auto-ordering from

Burger King, I came to the indoor swimming pool. It was right next to the beach, the prime spot in the whole camp. Happy screams came from within the building. It was good to know that the site of Dodd's camp was still consecrated to pleasure.

Trade union and Civil Service camps evolved from the philanthropic or ideological ones. The Derbyshire Miners' Camp at Skegness, opened in 1939, was one of the biggest 'occupational' camps, and it signified the trend towards fun. For example, there was a competition to see who could sit on a stage longest without laughing.

The king of the purely recreational camp providers was Billy Butlin, who opened his first camp in 1936, at Skegness. Butlin was born in South Africa; he came to England aged six, with his mother, after his parents had separated. As a child he worked in travelling fairs with his mother and grandmother. In the early 1920s, when Butlin himself was in his early twenties, he stayed at a small boarding house at Barry Island, and here the seed was planted for his holiday camps. 'We had to leave the premises after breakfast,' he recalls in his autobiography, 'and were not encouraged to return until lunchtime. After lunch we were again not made welcome until dinner in the evening.' He saw 'families trudging around in the rain with nowhere to go'.[8]

A few years later, Butlin was scouting locations for a funfair. He heard of Skegness from a man he met in London, who told him it was a promising site for fairgrounds, since it was flat, growing fast and convenient for the working-class populations of the Midlands and the North. (Butlin had initially thought it was in Scotland.) He took an LNER train to Skegness one bleak day in February 1927.

The view from the window as we steamed north through the London suburbs and on to Peterborough and Grantham revealed scenes vastly different from those I had known in the west of England. There was more industry; there were more people – and the countryside itself was not as beautiful. Whilst I realised this was not the industrial north, it gave me an inkling of why people wanted to get away from their homes and factories to the seaside.[9]

On arrival, he found the town was 'so small you could stand outside the station and see cows grazing in the fields'. He picked out a place on the seafront. Enquiries revealed that the land belonged to the Earl of Scarbrough. This was Roger Lumley, 11th Earl of Scarbrough (not 'Scarborough'), whose predecessor, the 9th Earl, had lured the Wainfleet & Thursby Railway to Skegness in 1873, and who commissioned James Whitton, an architect from Lincoln, to lay out Skegness on a grid plan around the station. Skegness became a magnet for excursionists from Nottingham and the Midlands, but Londoners were also lured there by John Hassall's jolly poster.

The Earl agreed to lease the land to Butlin, who opened his fair during Easter 1927, with four hoopla stalls, a tower slide, 'a home-made haunted house' and 'a batch of dodgems', a new attraction from the States. Butlin became the sole European agent for dodgems, and they brought him his first 'really big money'. In his book Butlin says he 'played a part' in the 'spectacular development of Skegness over the next ten years', but he also credits 'a lively bunch of councillors' and John Hassall, whom he met in a London club in 1936, the year in which Butlin opened his Skegness camp. On discovering, to his amazement, that Hassall had never *been*

to Skegness, Butlin said, 'You'd better come and have a look at the place.'[10] Hassall travelled to Skegness later in the year, and he was late for the reception that had been arranged for him by the Skegness Advancement Association because he'd tried to catch his train there from Liverpool Street, rather than King's Cross, thereby proving that he hadn't read, or remembered, the excursion timetable that had been issued with his original 'SO Bracing' poster.[11] He was given the freedom of the town, and was amused to discover that this meant he didn't have to pay to use a deckchair on the beach.[12]

Billy Butlin was a rail enthusiast, and his camps were train-oriented. He had a particularly strong relationship with the LNER. In *Goodnight Campers!* Ward and Hardy write that the LNER 'agreed to meet half the cost of Butlin's advertising for the Skegness camp', and Butlin's next two camps would be on that company's network.[13] Butlin's Clacton opened in 1938, and Butlin's Filey was completed in 1939, but immediately given over to the military, as were Skegness and Clacton. The three camps re-opened as soon as possible after the war.

Eventually there would be ten Butlin's camps, whose essential catalyst was the Holidays with Pay Act of 1939. Butlin provided 'A week's holiday for a week's pay' or, as he liked to put it, 'Holidays with pay, holidays with play'. Kathryn Ferry writes that 'In the 1930s, holiday camps were modern and egalitarian,' untainted with the stigma that would later attach to them. 'Once the weekly fee was paid, no-one could spend more than anyone else; those wealthy enough to arrive in their own car were no different to people who came by train to the camp station.'[14] 'Later tarred with a reputation for dishing up low-brow "shiniest bald head" contests and "glamorous granny" competitions', Travis Elborough writes in *Wish You Were Here*, 'in their infancy and in the immediate

post-World War Two years, the camps strove to exude class.' He cites the subdivision of camps into houses with 'regal names' like Gloucester and Kent, and the quotation from *A Midsummer Night's Dream* adorning every camp clocktower: 'Our one true intent is all for your delight.'[15]

But they were always slightly ghettoised. *The Golden Age of the Yorkshire Seaside,* by Malcolm Barker, shows a snapshot of Filey Bay, with a hand-drawn arrow pointing to a vague smudge of a far cliff labelled 'Butlin's Camp'. Butlin's Filey – home to 'the greatest concentration of Yorkshire holiday-makers' – had its own railway station, and the photograph shows why this was necessary.[16]

Filey Camp station opened in 1947. There was an embankment beyond the buffer stops, and visitors were shuttled to and from the camp by a miniature railway that ran through a tunnel in the embankment. The station was served by a through express with restaurant car from King's Cross, and direct trains from Manchester. Use of the line declined in the late 1960s, as people began taking advantage of the free car parking laid on at the camp. BR wanted to close the branch in 1972, but it was maintained at Butlin's own expense until 1977. The camp closed in 1983, although some of it survives as Primrose Park and Holiday Village, operated by Haven.

Butlin's Pwllheli also had its own station, Penychain, on the Cambrian Coast Line. We have been there. Most visitors to the Pwllheli Butlin's were not Welsh, and they called it 'Penny-chain', which is not the correct pronunciation. As at Filey, arrivals were met and taken to the camp by a road train. Penychain was served by summer expresses from Manchester Exchange, Liverpool Lime Street, Birmingham New Street and Euston. Butlin's Skegness and Butlin's Clacton were also served by expresses from King's Cross and Liverpool Street respectively. *The Railway Magazine Encyclopaedia*

of Titled Trains distinguishes between the former, which 'had curved headboards stating "Butlins Express"', and the latter, which 'had circular headboards spelt "Butlin Express"'.

Many Butlin's camps had miniature railways. The one at Clacton was shown in the closing credits of the sitcom *Hi-De-Hi*, whose cheesy depiction of holiday camp life Butlin's was anxious to dissociate itself from. In the 1960s, as though in tribute to the railways, Billy Butlin arranged for steam locomotives to be put on static display at the Pwllheli, Skegness, Minehead and Ayr camps. But locomotives are meant to come and go from the seaside, not be kept there motionless. Before they became totally corroded, the engines were distributed around various heritage railways and museums.

Another snapshot of Billy Butlin and trains. In 1963 he was travelling to Minehead when he saw 'a distinguished, military-looking figure' knitting in the corner of a first-class compartment.[17] This was Colonel Michael Ansell, who'd been blinded in the war and found knitting a relaxing way of passing the time on a long journey. He was also a keen horseman. Ansell and Butlin got talking – about show jumping, which Ansell promoted, evidently successfully, because Butlin then began holding show jumping events in his camps.

Butlin's camps flourished until the early 1980s, but they belonged to the holiday-by-rail era. The aspiration after freedom that the motor car embodied also militated against the notion of spending a week in a camp one was discouraged from leaving. Three camps remain under the Butlin's brand: Bognor Regis, Minehead and Skegness. The website for Minehead advertises itself as being only ten minutes from 'Minehead Station', without mentioning that this is a station on a heritage railway, it having closed in 1971 and been reopened by the West Somerset Railway in 1976.

Nor does the website mention that, to join the West Somerset Railway, you must take a fifteen-minute bus ride from Taunton, on the national network, to Bishops Lydeard. But the reward for people undertaking this adventure is that they can then travel to Butlin's by steam train, as they probably would have done when the camp opened in 1962, and Minehead is a cheerful recreation of a 1950s seaside station, complete with a station announcer who speaks fluent RP. The West Somerset Railway has no idea how many people it takes to Butlin's – 'We don't really know where people go when they get off our trains' – and Butlin's Minehead does not know how many of its clients arrive by train.

In late summer 2023, I went to Bognor by train. After Barnham – last stop before Bognor – the only other people left aboard were three Asian families (about twenty people) and half a dozen young white women, all with large, wheeled suitcases. As one of the young women waited for the train doors to open at Bognor, she said to one of the Asian women, 'Are you off to Butlin's?'

The answer was in the affirmative.

'Thought so,' said the woman. 'I bet everyone left on this train is going to Butlin's,' whereon she, and all the others, looked at me, in my crumpled linen jacket, and the conversation faltered, doubts about that last statement obviously setting in. But the original speaker got the ball rolling again with, 'The weather's great, and it's going to be like this all week, apparently!'

I was *not* going to Butlin's, and the episode was a little vignette of the English class system. But the social mismatch between Butlin's and me is not as big as that between Butlin's and Billy Bunter – 'the Fat Owl of the Remove', as he is described in the now politically incorrect language of Frank

Surely one of the strangest literary tie-ins
... a public schoolboy at Butlin's?

Richards, who wrote hundreds of Bunter books and stories from 1915.

Frank Richards was the pen name of Charles Hamilton, who died in 1961, in which year the last Bunter book, *Billy Bunter at Butlin's,* appeared. The cover shows a picture of Billy eating cakes superimposed on one of Butlin's Skegness. There is also the insignia of the Butlin Beaver Club, with the following explanation on the back cover: 'A junior fellowship of children under 12 years of age. New members are welcome and initiated weekly throughout the summer at all the Butlin Holiday Camps and Hotels.' It's surely one of the strangest ever literary tie-ins. Bunter and his pals at Greyfriars School belong to the inter-war upper middle classes, so the culture clash is considerable when they go to Butlin's Skegness, not that this is ever acknowledged; the boys are

all completely familiar with Butlin's and delighted to be off there.

They do go by train, and an episode important to the story occurs on a train, but the journey is very vaguely described. The one station named apart from Skegness is the imaginary and generic Greenfield, where a change of trains is made. When the boys get to the Skegness camp, verité does intrude slightly. 'Butlin Radio ... filled the air with melody. Cafés and milk bars were crowded.' The book is basically an advert for Butlin's – 'always something to do, something to see' – and Billy Butlin himself is a character in the story: 'a portly, well-dressed gentleman with so pleasant and kindly a face'. ('Portly,' note, not 'fat', an epithet reserved for Bunter.) In the story, Mr Butlin has arranged for the Greyfriars chaps to visit his Skegness camp as a reward for the noblest of them, Bob Cherry, having saved him from a beating by a footpad. The footpad returns, though, and seizes Billy Butlin's wallet. This becomes the MacGuffin of the tale, which is fairly entertaining, but mainly bizarre, and the thought occurs that perhaps the whole concept arose from the similarity of the names 'Billy Butlin' and 'Billy Bunter.'

Cromer and Poppyland

Railways came late to Norfolk, especially its furthest-flung area, the north-east coast. There wasn't the economic magnetism to attract them, and when they arrived there was a feeling among those who had appreciated the tranquillity of those spots that an Eden had been disrupted.

The target was the attractive fishing village of Cromer, a select watering place in the 1870s when Charles Harbord, Lord Suffield of Gunton Park, saw the commercial possibilities of taking a railway there. He became chairman of

the East Norfolk Railway, which groped its way to Cromer in March 1877, by which time it was being absorbed by the Great Eastern.

The station, opened as Cromer, was renamed Cromer High after the Second World War, but it was always literally high, being on a ridge a mile from the seafront. The first excursions came in that same year of 1877, overwhelming the village. *Railways of Cromer*, a booklet by Glenys Hitchings and Del Styan, quotes the *Argos*, a local paper of the time, to the effect that the trippers 'lacked sadly the comforts to be met with at other seaside towns on this coast'. Accommodation was 'woefully deficient', and 'those who were so selfish as to oppose the formation of the railway will show no alacrity in allowing space for the erection of lodging houses.'[18] In *The British Seaside Holiday*, Kathryn Ferry brackets Cromer with Eastbourne, North Berwick and Bournemouth as a place that wished to 'maintain its privileged clientele by deterring excursionists'. A hallmark of such places, she suggests, is a zig-zag walkway up a cliff, facilitating genteel strolling. Cromer developed one, as did Bournemouth, Scarborough and Folkestone.

On some unknown, but momentous, day in the summer of 1883, Clement Scott, drama critic of the *Daily Telegraph*, arrived at Cromer station from London. He couldn't find anywhere to stay: 'In that red-roofed town, the centre of all that was fashionable and select, there was not a bed to be had for love or money.' Scott, deterred by the exclusivity of Cromer, was about to put an even more exclusive destination on the map. He walked east along the cliff to the village of Overstrand, where he came across a windmill, with the miller's red-brick cottage alongside. His request to lodge there was answered in the affirmative by the

miller's daughter, Louie Jermy, and so began the legend of 'Poppyland', whose component elements (aside from the poppies that grew along the Cromer clifftops) were Louie Jermy herself, the villages of Overstand and Sidestrand, and a clifftop graveyard once belonging to a church that had fallen into the sea.

Scott first wrote about Poppyland in an article headlined by that word in the *Daily Telegraph* on 30 August 1883. His *Poppy-Land Papers* were collected in book form in 1886, with his poem about the graveyard, 'The Garden of Sleep', forming the prelude. It was not very good – 'In music of distance, with eyes that are wet,/It is there I remember, and there I forget!' – and Scott was generally prone to sentimentality, but he struck a chord with Poppyland, and the ever-increasing visitor numbers prompted an expansion of the town. In the 1890s Cromer would acquire a gas works, a town hall and many large hotels, including the Royal Links Hotel, overlooking the Royal Cromer Golf Club, and the Hotel de Paris, opened on the front in 1895.

In a sense, Scott had foreshadowed this. In a rare downbeat interlude in *Poppy-Land Papers* he recounts a conversation that took place in or near Cromer station with a 'cynic'. This cynic found it telling that 'The best view of Cromer was to be had from the railway station.' In other words, the station was key to the town's fortunes. The cynic 'dilated on the tardiness of the speculative builder about the fields and pasture' of this ideal spot.[19]

In June 1887 Cromer had acquired a second station, Cromer Beach, a quarter of a mile from the cliffs, and the creation of a railway subsumed into the Midland & Great Northern Joint Railway in 1893. Whereas the GER's trains to Cromer station came directly from the south (from Norwich Thorpe station via North Walsham), trains to Cromer Beach

came from the south-west – from Norwich City station, via Melton Constable and Sheringham. The new station generated more trippers and more neurosis. On 16 July 1887 the *Norfolk Chronicle* reported that 'The cheap trips of the Great Eastern and Eastern & Midlands Railways have brought crowds of all sorts of conditions of men, women and children to the broad sands of hitherto exclusive Cromer.' The writer feared 'that the Cromer beloved of artists and wearied brain workers is about to be lost to us for ever'.[20]

In 1902 the Chairman of the GER, Lord Hamilton, opening the town's new pier, said that 'Cromer was not a place where one could invite cheap trippers from all parts of the country,' and recommended that Cromer citizens maintain the 'exclusivity' of their town. As Hitchings and Styan point out, these were 'Strange and rather disingenuous words from a man whose company had done so much to destroy any exclusivity the town once had.'[21]

As their rivalry increased, the GER and the M&GNJ accelerated their trains from London, and a modest 'race to Cromer' began. The GER won it. Its *Cromer Express* of 1896 took 2 hours 55 minutes from Liverpool Street. The M&GNJ's *Cromer and Sheringham Tourist Express* took an hour longer from King's Cross. In 1905 *the Norfolk Chronicle* described how the trippers arriving at the two stations coalesced to form a 'parade' to the front on the Bank Holiday Monday. Meanwhile, a more rarified influx was occurring at Overstrand.

In 1906 the coastal villages were brought into the railway fold, when the M&GNJ and the GER, operating together as the Norfolk & Suffolk Joint (the outfit, already characterised as the 'double-jointed' railway, that specialised in small stations linking barely extant coastal resorts), opened their line from Mundesley to Cromer via Trimingham and Overstrand. Also in 1906, and in the same spirit of co-operation,

a connection was formed between the lines to Cromer and Cromer Beach.

It was the Poppyland legend that had inspired this cat's cradle of lines around Cromer. The GER's posters advertised 'the Charm of Poppyland', those of the M&GNJ 'the Royal Route to Poppyland'. Scott died in 1904, so we don't know whether he blamed himself for the railway's encroachment on his idyll. A BBC film called *Poppyland* aired in 1985, with Alan Howard as Scott and Phoebe Nicholls as Louie Jermy. It suggested a romantic connection between the two, which probably didn't exist. Scott is made plainer speaking than in real life. He laments that Cromer has 'become rather a vulgar place' and, as for Overstrand, 'not far from now this will no longer be Poppyland but bungalow-land.' But the bungalows never came. An inter-war LMS and LNER poster used a painting by Walter Dexter of the East Cliff at Cromer to depict 'Cromer: Gem of the Norfolk Coast', and the view of the town's parish church, which has the highest bell tower in Norfolk, is uninterrupted.

Overstrand prospered, but in a tasteful way, and for the rich. Edward Lutyens left his mark there, building a few mansions to commission. My wife and I went to Overstrand by car a couple of years ago. We found it silent and full of large, reserved houses, which tended to have names rather than numbers. 'I like all these green-tiled Deco roofs,' said my wife. 'Very tasteful.' On a village noticeboard we read of 'Ladies' Racketball' and 'Overstrand Conservative Club Quiz every Wednesday'. Overstand is the 'fourth poshest place in Norfolk', according to the *Eastern Daily Press*, and it should know. The beach, accessed by cliff walkways, was completely uncommercialised.

In 1912, an article in the *Great Eastern Railway Magazine* contended that the days of Poppyland were over; that 'golf is

to Cromer now what the Garden of Sleep was in early days.' The railways began fading along with the legend. In the 1920s staff were withdrawn from Trimingham and Overstrand stations. In L. P. Hartley's novel, *The Go-Between*, set in Norfolk, a genteel, cuckolded character is called Trimingham. In 1953 the line between Mundesley and Cromer closed. In 1954 Cromer High closed; all trains would use Cromer Beach, henceforth shorn of its 'Beach' suffix. In 1959 most of the rambling, countrified M&GNJ network was closed down. As people recalled its engines, liveried in Golden Ochre (also known as Autumn Leaf), what had been characterised as the 'Muddle and Go Nowhere' was wistfully remembered as the 'Missed and Greatly Needed'. It seems fitting that a travelogue of 1958 called *Let's Go to Cromer* opens with a car approaching rapidly by road. There's no mention of Poppyland in *Let's Go to Cromer*, and golf is indeed foregrounded instead, with footage of the Royal Cromer and several putting greens. It's a very hearty film, boasting that in Cromer there is 'bowls and tennis to inter-county standard'.

Today, Cromer and Sheringham are served by the attractive Bittern Line from Norwich, a community rail operation, counterpart to the Wherry Lines serving Lowestoft and Yarmouth, and using the same smart new bi-mode trains. The station before Cromer, Roughton Road, is 'new', opened in 1985 when North Norfolk was otherwise in the railway doldrums, to serve newly built housing in south Cromer. On the face of it, this station has nothing to do with holidays, but who knows how many people have been inspired to buy houses in Cromer having been on holiday there?

Roughton Road is a plainer station compared to most on the Bittern; the same goes for Cromer itself, which seems, at first glance, an adjunct of a huge Safeway supermarket. This

was built on the goods yard in 1991. The station roof had gone by then, and the whole complex is described as 'mostly boarded up' and 'Just a place to get off and on, really' in *Cromer Train*, an artfully gloomy BFI short film of 1984, narrated by Dr Tony Hare, a botanist and broadcaster who sounds exactly like Baldrick in *Blackadder*. There are shots of a two-car DMU approaching Cromer through heavy rain, of muddy fields, a wintry sea, beach huts destroyed by the waves. The word 'Cromer' is just about legible in white stone on a railway embankment overgrown with weeds.

The original, half-timbered station building survives, although it hasn't been in railway use since 1970, when it became home to a builders' merchant. On the bricked-up windows at the rear are some simple, attractive murals depicting seaside scenes. The windows at the front are covered by steel shutters and 'Keep Out' signs. Above the main entrance is the name of the nightclub that occupied the building until recently: Bouncers.

Cromer is a stub-end station. Trains reverse out before continuing to Sheringham, terminus of the Bittern Line, a ten-minute trip that gives glimpses of the sea between trees, smart stone villas and a few caravans. Sheringham station on the Bittern Line, which has all the glamour of a bus stop, is thoroughly upstaged by the other Sheringham station, lying on the other side of the road, the one belonging to the pre-served North Norfolk Railway. This is like a hallucination, with its dark blue enamel signs denoting BR Eastern Region, green and cream valanced canopy, milk churns, old suitcases and trunks theatrically arrayed. In 2010 the whole of Shering-ham turned out to see the re-opening of the level crossing that connected the two stations – so the locomotives of the NNR occasionally have a run out on the Bittern Line.

The North Norfolk Railway, which runs between Holt

Mural on the wall of the old station building at
Cromer, latterly a nightclub called Bouncers.

and Sheringham, is a living memorial of the Midland & Great
Northern Joint, and widely known as 'the Poppy Line', one
of many ways in which the Poppyland legend has been resur-
rected. My memory of having ridden the line is not of poppies
but of the elemental landscape: the way the wide cliffs give
way to the wider sea, such that the journey is all about the light.

As for Cromer, I recall it as a place where coach parties,
staying at the Hotel de Paris, took their evening meal at
about 5.30 p.m., but it has gone upmarket recently. A couple
of Old Etonians of my acquaintance have started frequent-
ing it. There are fewer charity shops, more vintage clothes
shops; fewer fast-food outlets, more delicatessens. In Cromer
Museum, a curator said the town had done well out of Covid.
'Staycations, you know. A lot of people have discovered it or
rediscovered it. Of course, there's a price to pay.' I asked him

what he meant. 'Oh, you know, shops selling scented candles and so on.'

Southwold

Pevsner described Southwold in Suffolk as 'one of the happiest and most picturesque seaside towns in England'. It is, accordingly, one of the most expensive. The little houses around the fifteenth-century church are dwarfed by the 4x4s of their owners; even so, they go for around half a million each. Not for nothing is Southwold known as Hampstead-on-Sea. On Sunday mornings the chiming of the church bells combines with the jangle of White Burgundy bottles being dropped into the recycling bins at East Green. The Lord Nelson pub, which dates from *c.* 1700, serves food but does not keep condiments on the tables because they look ugly.

The town has the highest second-home ownership in England and Wales; only about 40 per cent of the houses are occupied year-round. I rented one of the more modest houses for summer use when my children were young, and it would not do to mention this when playing pool with strangers in the bar of the Blyth Hotel. If I had done, my opponents' appreciative knocking of the cue end on the floor when I made a decent shot would have abruptly ceased. Over the years I have seen the elimination from Southwold of shops selling useful things like cigars, second-hand books and electrical goods in favour of dried flowers, fancy soaps and relentlessly monogrammed summer clothing.

Between 1879 and 1929 Southwold was served by a railway, a 9-mile branch from Halesworth on the East Suffolk line, and it's tempting to view the relatively late date of the railway's arrival through a class prism; to imagine Southwold resisting the railway for fear of excursionists lowering the tone. But

the delay was less to do with Southwold's exclusivity than its smallness. Did it merit a railway? 'Only just,' was the answer, so it was built on the cheap: a single line in the unusual 3-foot gauge and lightly engineered, except for a swing bridge over the Blyth estuary, where Southwold Harbour exists in a sort of Arthur Ransome dreamworld.

The attitude of the town towards the line is hard to gauge. That it would bring in holidaymakers was perhaps welcomed, as compensation for the decline of the town's fishing industry. And Southwold was not as genteel in those days: there was rope and salt-making as well as fishing, and there was, and still is, Adnams brewery. Then again, old photographs show passengers on the railway as looking quite posh, and Southwold was safe from the travelling masses: they would naturally make for Lowestoft or Great Yarmouth, both served by direct trains from Liverpool Street, whereas those bound for Southwold had to traverse a footbridge at Halesworth station, which was surrounded by a great hinterland of goods yards, in order to board one of the four trains that ran to the town every weekday.

The little Southwold tank engines had amusingly tall chimneys and were numbered 1, 2 and 3 (aka *Southwold*, *Halesworth* and *Blyth*). They were usually painted dark blue, the livery of the nearby 'big' railway, the Great Eastern, whose only connection with the Southwold was to service the locos, always finishing the job off with a new lick of dark blue, that being the colour lying closest to hand. All trains were mixed – passenger and goods – and the carriages, painted a dull red, were arranged like trams, with two long benches facing one another. In first class, the benches were covered with carpet. There were balconies on the ends for a sunny day, and hot water bottles were available in first class when it *wasn't* sunny. Lighting was by oil lamps. The train ran – at no more

The Southwold Railway – rather too brash for the townsfolk.

than 16 mph – through fields, calling at progressively more idyllic and tranquil places: Wenhaston, Blythburgh (where it looped around the vast, luminous Holy Trinity Blythburgh, known as the 'Cathedral on the Marshes'), then over the swing bridge and across Southwold Common.

Reg Carter, a cartoonist for the early *Beano*, who was born in Southwold, perhaps undermined the line by characterising it as ramshackle and chaotic. In fact, it was competently run, albeit from an office in London (a foretaste of modern Southwold), and it did the serious work of transporting to Southwold the million bricks required to build the lighthouse. The shareholders received a dividend every year until 1922, when the railway began to experience severe competition from buses, which the council allowed within the town boundaries in 1928. The bus fares were cheaper than the train tickets, but they were perhaps favoured and promoted by the Southwold snobs. The buses took them where they wanted to go – to Halesworth, so they could catch the trains to London – but they didn't

bring the *Londoners* to *Southwold*. Or at least, not to the same extent as the Southwold Railway, whose trains connected with the London services.

The line might have been seen as comic, but not, apparently, charming. What is today the Blyth Hotel obviously didn't think much of it. The Blyth had opened in 1905 as the Station Hotel, but it changed its name after the First World War to the Avenue Hotel, boasting that it stood 'facing the Common and the golf links', whereas the thing it faced most directly was Southwold station.

In *The Titfield Thunderbolt*, the brash busmen are seen off by the little railway, but the Southwold line existed, despite appearances, in the real world, and the buses killed it. The last trains there and back ran in the misty afternoon and evening of 11 April 1929. A patronising newsreel film commemorated the event, taking its cue from Carter's cartoons. The opening caption reads, 'The Railway that is a Real Joke', with follow-ups such as, 'Has been known to complete the journey of nine miles to Southwold in fifty minutes!'

What survives of the line? Very little. In 1962 a police station was built on the site of Southwold station. The swing bridge across the Blyth is now a narrower footbridge, but it uses the stone abutments of the railway bridge, so it seems to have disproportionately big feet, like a puppy. The cutting across Southwold Common is now a footpath bounded by brambles, high hedges and wildflowers.

In 1996 the Southwold Railway Society, which is now the Southwold Railway Trust, was formed to rebuild and re-open the line. Every summer, the SRT's newsletter reported on the members' annual summer ramble along the route of the line: 'We reached the old bridge near the harbour: the rails are sinking into the mud ... More brambles than ever this time.'

This being Southwold, class issues have arisen. A significant number of people in the town oppose the restoration of the railway, and John Bennett, a Southwold architect and prime mover in the SRT, says, 'Every time we make a planning application it's mainly the second home owners who raise a hue and cry. Although they'd never say it outright, they don't like tourists.' Some members of the SRT are themselves second home owners, and they have a slightly different view: that opposition is down to simple NIMBYism, which can be met by careful tailoring of the planning applications. The SRT's policy is to buy up land on the old railway route whenever it becomes available, and it owns about a mile of the track bed at Wenhaston.

Meanwhile it has built a railway theme park on the site of an old gasworks just off the home straight of the old line as it approached Southwold station.

Here, a landscaped pond (which Mr Bennett calls a lake) is circumscribed by a 7¼-inch miniature railway, the Blyth Valley Light Railway, on which punters can have rides. There is also a stretch of 3-foot-gauge track, on which stands, and occasionally runs, a replica of number 3 engine (*Blyth*). Even though there is only about 80 yards of this track, it is interrupted by a beautifully made level-crossing gate with an oil lamp mounted on it. Anyone who has visited the Electric Picture Palace cinema at Southwold, which John Bennett created out of an old garage to 'recapture the experience of cinema-going in the mid-twentieth century', will recognise his witty, whimsical touch at Steamworks. Those riding on the light railway, for example, are furnished with proper old Edmondson tickets. I once turned up at Steamworks to see John and the Southwold vicar sitting on deckchairs watching the light railway while listening to jazz on a wind-up gramophone; both wore Panama hats. That Southwold vicar has

now left, but the new one is apparently 'even keener on trains than the last one'. (There is something very Ealing Comedy-ish about the railway situation at Southwold.)

The next stage of the SRT project might be for the 3-foot line to break out of Steamworks and head to the harbour, but most people in the town think number 3 engine will remain forever imprisoned in Steamworks; that the obstacles presented by planning and finance are just too great. The SRT people know they're in for the long haul. 'It won't happen in our lifetimes,' one of them said to me, which was *slightly* annoying since he was a good twenty years older than me. But other lines have been restored over a similar length and against what appeared a similarly insuperable wall of objection.

I often used to approach Southwold via the pretty East Suffolk line from Ipswich. I usually got off at the terminus, Lowestoft, taking a bus to Southwold, but sometimes I got off at Halesworth. Once, a pre-booked taxi having failed to turn up, I walked to Southwold; it took a couple of hours and I was nearly killed by a couple of cars as I cowered in a hedgerow, there being no footpath as well as no railway.

The Cockney Holiday Part 1 (Mainly Margate)

When Paul Theroux wrote, in *The Kingdom by the Sea*, his tour of the British coast, a book both vivid and jaundiced, that class could hardly be an 'issue' on a Bank Holiday train to Margate, he was presumably being sarcastic.[22] (Yes, Theroux is American, but he observes Britain with a laser-like eye.) I myself was defensively braced as I set off for Margate.

I took one of Southeastern's Javelin trains from St Pancras International to Margate via Chatham. After the clutter of the Medway towns, the horizon went dramatically flat; then

came an expanse of mud, sea and then Whitstable, the first seaside port of call.

Any enjoyment of the maritime scenes that followed was spoiled by noise. I had already moved seats twice before Gravesend, to get away from music being played out loud – without headphones – but this habit is always catching. If one person does it, others feel similarly emboldened, especially on a train heading to the seaside on a hot summer Saturday – a manifestation of the 'spirit of carnival' evoked by John K. Walton, perhaps. I then moved a third time, to escape a man (presumably drunk) who kept lunging towards his wife or girlfriend sitting opposite, as though he were about to hit her, but pulling his punch at the last minute – some in-joke between them, because she didn't seem to mind. They disembarked at Herne Bay with a pair of pink suitcases, but the general cacophony continued to Margate, and I regretted not having bought a first-class ticket, until I remembered that there are no firsts on the Javelins, but only one class, called Premier ('As good as first, but cheaper than second', says Southeastern.)

As soon as you alight from the train at Margate, you can smell the sea. There's a slight undertow of rotting seaweed, admittedly, but the point is: it doesn't smell of London. The present Margate station was built in 1926. English Heritage describes the style as 'monumental classical', and the stolid dignity of a library or museum is suggested by the beautiful parquet floor of the booking hall, which also features a huge arched window to complement the giant sky. 'The skies over Thanet are the loveliest in all Europe,' said J. M. W. Turner, who frequented Margate and only ever seems to have got there by paddle steamer, even though he lived until 1851, five years after the original station opened.

As you exit the station, the pleasures of the town – beach,

sea, Old Town, Turner Contemporary art gallery – are all in view to the right. As I passed the famous clocktower that since 1889 has counted down the holidays of millions of railway arrivals, it was mellowly chiming the hour, seemingly prefiguring a peaceful time on the beach. But though the tide was far out, it was impossible to find a spot where the rumbling drum'n'bass music radiating from a beach café could not be heard. I asked the woman at the counter, on which the speaker was propped, facing outwards, if she would mind turning down the music.

'We do have a licence for it, you know,' she said, after having been apparently stunned into silence for a moment. 'And you're the first person to complain.' She obviously didn't like the look of my white linen jacket any more than the young women on the train to Bognor had, but she agreed to turn the music down 'a bit'.

Such class-conscious conversations have long been staples of Margate life. Here is the opening of the entry about the town in *Bradshaw's Handbook* of 1863:

> There is not, in the whole range of our sea-side physiology, a more lively, bustling place than this said Margate: albeit, by those who are fettered down to cold formalities, and regard laughter as a positive breach of good breeding, it is pronounced to be essentially and irredeemably vulgar.

Margate was the nearest accessible seaside place for East Enders at the time. In 1830 the town was receiving 90,000 steamship visitors from London. Gravesend was receiving 130,000, but Gravesend was only a stand-in for the seaside, being very definitely on the Thames Estuary, whereas Margate almost faces the open sea, and you do want the

open sea. An opposite shore, when visible, is just so much clutter – something in the way.

'One of the most amusing places we know', Charles Dickens wrote in *Sketches by Boz*, 'is the steam-wharf of the London Bridge, or St Katherine's Dock Company, on a Saturday morning in summer, when the Gravesend and Margate steamers are usually crowded to excess.' Since most of the day would be spent on the steamer (five hours there, five hours back, with two hours in Margate), the trippers made the most of the journey. Old women, wrote Dickens, 'set to work at the demolition of heavy sandwiches, and pass round a wine glass, which is frequently replenished from a flat bottle like a stomach-warmer'. And there was always music on the steamers to Margate, just as there is, it seems, always music on the train today. Dickens describes how the women hand the flat bottle to a man in a foraging cap, by way of inducing him to play 'Dumbledumbdeary' on his fiddle for a certain child to dance to. Charles Graves, describing a trip taken on the famous Margate steamer, *Crested Eagle*, on a summer Saturday in 1930 or so, mentions 'twenty couples dancing to a gramophone and two tin megaphones'.[23] In the 1930s the steamer holiday traffic was rallying slightly, having been almost fatally undermined by the coming of the railways; there would be a regular service to Margate until 1967, and the preserved steamer *Waverley* still makes summer visits.

Exiled from the beach, I wandered around the buckled and bow-windowed Old Town, focus of Margate's vaunted gentrification, with its craft ale bars, delicatessens, vintage clothes shops. Widely available was the *Margate Mercury*, edited by Twinkle Troughton, which spoke of Margate Carnival, Margate Pride, Margate Soul. The adverts for wellness spaces, yoga studios, holistic crystal therapies and so on suggest that the seaside has reverted to being a therapeutic place.

Back at the railway station a rowdy drunk – clearly not a reader of the *Margate Mercury* – was being ushered into a police van. The station itself has been gentrified to the extent that there is a good coffee shop in the ticket hall and a large porcelain-tiled mural in the waiting room. This was created by the eminent designer Arnold Schwartzman, whose family ran the Majestic Hotel in Cliftonville, Margate's smarter annex. It bears the words 'T. S. Eliot' and 'Toilets', with the explanatory quote by Eliot, 'My name is only an anagram of toilets.' The second 'O' of his name contains a line from *The Waste Land*, part of which he wrote in Margate: 'On Margate Sands, I can connect nothing with nothing' – and what is that meant to convey? That you too can connect nothing with nothing in Margate, much as I had done in my conversation with the beatbox woman?

Eliot travelled to Margate in October 1921 for his 'nerves', or in today's language his 'mental health'. In *The Waste Land: A Biography of a Poem*, Matthew Hollis writes, 'A Hunter's Moon hung over Margate for Eliot's arrival.' (Hollis is a poet himself, after all.) That autumn progressed 'as if summer would never end: the desert year, it would come to be known.' There was a drought in Kent, 'the grasses of Thanet were scorched, its countryside a patchwork of yellow and dried tubers.'[24] Did Eliot observe this arid scene from a train on the way to Margate? We can assume so, because Hollis does note that Eliot *departed* by train after his month-long convalescence, but he doesn't describe either journey. Eliot would have gone by the South Eastern & Chatham Railway, from either Charing Cross or Victoria, and since he lived near Marble Arch, probably the latter. But where exactly did he alight, because there were three Margate stations of the time? We had better untangle the knot of Thanet railway history.

The South Eastern Railway, built principally to connect London to Dover, arrived at Ramsgate and Margate in 1846, by a long north-easterly branch from Ashford, much to the disappointment of the paddle steamer people, whose operations immediately became summer-only. Trains departed at first from London Bridge, but the SER extended to Charing Cross in 1864 and Cannon Street in 1866, an encroachment on the river that was further bad news for the paddle steamers. Margate services went first to Ramsgate Town, on the south side of the tip of the Thanet headland, which was a terminus. They then reversed out, running diagonally to the north side of the tip and a station called Margate Sands. A chord was built in 1964, cutting the corner and allowing Margate trains to bypass Ramsgate Town.

In the early 1860s the SER's rival, the London Chatham & Dover Railway, developed the Chatham Main Line, which approached Margate directly from the west, in effect creating resorts as well as stations at Herne Bay, Birchington-on-Sea and Westgate-on-Sea. (Whitstable was already up and running, thanks partly to its earlier railway connection – to Canterbury.) The SER opened two stations at Margate, Margate West and Margate East, and connected these to Ramsgate by a line curving around the tip of Thanet, calling at, and waking up, sleepy Broadstairs on the way. The LCDR's station at Ramsgate was, like that of the SER, a terminus. It was situated right on the front, approached by tracks descending steeply through a tunnel, and called Ramsgate Harbour.

After the railway grouping of 1923, the newly incumbent Southern Railway created a simpler curvature at the tip of Thanet. The connection between Margate Sands and Ramsgate Town was closed, as were those two stations. Ramsgate Harbour station was also closed, and a new Ramsgate station

Ramsgate Harbour station, perhaps the optimal
conjunction of trains and the sea.

was opened on the curve. Margate West station was rebuilt
and renamed Margate, while Margate East station was closed.
Simon Jenkins approves of the 'new' Ramsgate station, observ-
ing that its big windows, copies of the three end windows of
New York's Grand Central, 'flood the booking hall with shafts
of light'.[25] But the station is a mile inland, while Ramsgate
Harbour was on the front. In fact, on both 3 August 1891 and 24
March 1915, runaway trains approaching it through the angled
tunnel crashed onto the beach.

To rail fans, old photos of Ramsgate Harbour station
might suggest a giant seaside attraction or amusement,
albeit with a horizontal turntable instead of a vertical Ferris
wheel, and after its closure in 1926 the station site did indeed
become a funfair, latterly known as Merrie England. In 1936 a
2-foot gauge electric railway was opened through the disused
tunnel, the better to connect the funfair to the town. It was
built by Henry Greenly, engineer of the Romney Hythe &
Dymchurch Railway and the Rhyl Miniature Railway, and

was opened by Lieutenant-Colonel Edwin Charles Cox, Traffic Manager of the Southern Railway, who remarked that as the traffic manager of the largest electric rail service in the world, he was now opening what was probably the smallest. To alleviate the claustrophobia of an entirely sub-terranean line, the tunnel was decorated with illuminated scenes depicting Switzerland, Canada, the Netherlands, Japan and Egypt. In the war, the railway tunnel was sup-plemented by a warren of air raid shelters, and tours of the complex are now offered by the Ramsgate Tunnels tourist attraction.

Today, trains go to Margate either from Victoria via Chatham – which used to be called going 'Up Chatham' – or from St Pancras International via Chatham or Ashford. Those class-less Javelin trains of Southeastern utilise the High Speed 1 line as far as Ebbsfleet when going 'Up Chatham', or as far as Ashford if going via that town. I travelled back from Margate on the slower service towards Victoria, which was largely quiet, with many passengers asleep after a long day in the sun. I broke my journey at Whitstable for a drink with the novelist Tim Lott in the Old Neptune pub, which is not so much beach-side as actually on the beach.

Tim has become a DFL, or a 'Down From London', as metropolitan types who have moved full-time or part-time to the coast are known on Thanet – a cohort the London *Evening Standard* was obsessed with, perhaps because every new DFL represented a lost reader. 'The old ravers head to Margate,' Paul Flynn wrote in the *Standard* on 10 May 2024. 'The gays to St Leonards. Fancy types that need at least one boutique hotel in their immediate sightline gravitate to Broadstairs or Deal.' In that same month Tim wrote, on his Substack, Tim Lott's Writing Bootcamp, that he'd chosen

Whitstable because, like Hastings, Ramsgate and Margate, but unlike Bournemouth or Worthing, it was not

> sepulchral ... There's a lot of old geezers like me, living off their pensions and putting framed posters on the wall of the Roxy Club 1976 or such like. I suddenly find I look like every other man on the high street – wrinkled, balding, dressed North London urban with trimmed beards and a spring in our step.

Tim is a part-timer in Whitstable, keeping a small flat in London. He usually travels down on Sunday evenings, back on Wednesdays. The Javelin trains from St Pancras have been cited as a cause of the DFL movement, but Tim goes from Victoria because, although the trains are slower and more infrequent, they're 'slightly cheaper'.

Tim often shuttles up and down the coast on the trains. He likes Broadstairs: 'Unspoilt, but not chocolate box.'

'Margate?'

'I quite like going to the Turner Contemporary, but there's a lot of woke nonsense. There's some nice old vintage shops, and I like Dreamland. I go to gigs there.'

'How deep do you think the gentrification goes?'

Tim shrugged. 'There's still a lot of rough trade in Margate, you know. A lot of herberts looking for trouble.'

The Cockney Holiday Part 2: Southend

After a false start as a genteel watering place, Southend rivalled Margate as the East Enders' bolthole. It became the second main destination of the Thames steamers, and would evolve into 'Sarfend', 'East London's seaside', most visitors probably ignoring the caveat that, like Gravesend, it is on

the Thames Estuary rather than the open sea. Southend was so entangled with the metropolis that you could get there on the Tube, or so the Tube maps implied, and some visitors to Temple Underground station probably think you still can, because a map dating from 1931 displayed on the station frontage shows Southend as the ultimate destination of the 'District Railway' (before it became the 'District Line').

The London, Tilbury & Southend Railway arrived in Southend in 1856, its line running from Fenchurch Street via Tilbury to the station now called Southend Central, which it had hoped to locate near the pier, but which it shifted inland at the insistence of seafront property holders. The Great Eastern arrived there via a branch from its main line in 1889, opening a station located further inland still and now called Southend Victoria. Intense competition between them drove down excursion fares. Today, Southend Victoria is the busier station of the two, but the LTSR route is more interesting.

The original tenant of Fenchurch Street was the London & Blackwall Railway, which served the docks in complicated and Dickensian circumstances. For thirty years all trains to Southend went via Tilbury, which must have struck Victorian day trippers as a reprise of the London docks they had already passed through, delaying the onset of a more recreational landscape. In the mid-1880s a new, more countrified route to Southend was opened, running from Barking to Pitsea and skirting what John Betjeman, a great advocate of the Southend run ('quite the most enjoyable expedition from London between mid-day and teatime'), called 'the wide enormous marsh of Essex'.[26] This route became, and remains, the 'main line' to Southend.

I arrived at Fenchurch Street on a greyish weekday in early summer. It was mid-morning. Two hours earlier, I would have been going against the tide of commuters descending

the escalators from the raised concourse and spilling out into the City. It had taken me a while to find Fenchurch Street; it always does. It has no Tube station, and it's as if an attempt had been made to hide a main-line London terminal. At peak hours Fenchurch Street is small but busy; off-peak, it just seems small. John Betjeman describes Fenchurch Street as 'less messed about than any London terminus', and his TV film of that same year, *Thank God It's Sunday*, opens with an aerial shot of the curved trainshed roof.[27] All very poignant in retrospect, because in the 1980s an office block was erected on top of the station, and the Victorian interior was gutted.

'The LTSR traffic at Southend boomed in the early 1900s,' writes Oliver Green in *Discovering London's Railway Stations*. 'Season ticket sales nearly doubled between 1902 and 1909 as City office workers took advantage of cheap fares and fast trains to move out to the coast and commute from Westcliff and Southend.'[28] Ever since, there has been an equivalence between Fenchurch Street and London Victoria: they are the London termini most associated with seaside visiting and seaside living, hence the gimmicky name of the operator from Fenchurch Street, C2C.

C2C is a decent operator, but the name suggests tackiness, as does the interior colour scheme of its Electrostar trains: turquoise, dark blue, puce and lime green are all involved. As the guard made his announcements, I realised that the cockney triumphalism of 'See it, say it ... sorted!' sounds completely natural when spoken on the Southend line. It was a pleasant trip; the guard friendly; the train quiet, the views absorbing.

The trains run on viaducts through the East End (hence the escalator up to the concourse at Fenchurch Street), and you feel privileged to be on a level with treetops and Victorian chimney pots – a Mary Poppins uplift not entirely quelled by

the regular appearance of glowering modern high-rises. At Limehouse, the Docklands Light Railway is present to the right, making good use of former LTSR infrastructure. To the left, at West Ham, Barking and Upminster, the roundels of the London Underground District Line appear.

In the early twentieth century, the District Railway had extended east into LTSR territory, sharing some of its stations. From 1910 to 1939 the LTSR and the District, both being broke, came to an arrangement whereby LTSR carriages ran from Ealing Broadway to Southend or Shoeburyness. The carriages were hauled by the District's electric locomotives to Barking, where the tank engines of the LTSR took over. Between about 1912 and 1915 the service was advertised by posters showing sailing barges off Southend in a romantic style, as if Southend were Venice, and carrying the dreamlike slogan, 'Southend by District Ry. Through Trains'. 'Posters like this, promoting pleasure trips, created some mixed messages,' 'the London Transport Museum website observes, 'when displayed alongside sombre army recruitment posters.'

London persisted until around Pitsea; then we were onto the marsh, with unexpectedly sunny skies above. On the left stood the remains of Hadleigh Castle, a ruin since the sixteenth century and a holiday herald for millions since the coming of the railway. To the right, at Leigh-on-Sea, I saw gentle, glinting waves, and the cranes and industry on the hazy opposite shore – probably Sheerness, which always seems to be hard at work when Southend isn't. Then came Chalkwell station, which adjoins a beach. The windows on the 'Up' side were full of an intense, blurred light that might have come from sea or sky.

For Charles Chaplin, the priority was to see the sea. He, his mother and his brother, Sydney, went to Southend for a 'holiday' lasting a day in 1895 when he was six years old,

Sydney having found a purse on a bus with seven golden sovereigns in it. Chaplin wrote that the family were living 'in the lower strata' at the time – figuratively and literally, since their home was a basement flat in Kennington. He doesn't describe the journey, but John Betjeman wrote that 'It must have been from Fenchurch Street that Charlie Chaplin set out with his mother and brother in the 1890s.'[29]

'My first sight of the sea was hypnotic,' Chaplin recalled:

> As I approached it in bright sunlight from a hilly street, it looked suspended, a live quivering monster about to fall on me ... What a day that was – the saffron beach, with its pink and blue pails and wooden spades, its coloured tents and umbrellas, and sailing boats hurtling gaily over laughing little waves.[30]

Soon after, the Chaplins entered the Lambeth workhouse. In 1957 Chaplin returned to Southend and 'looked in vain for the narrow, hilly street from which I had seen the sea for the first time ... At the end of the town were the remnants of what seemed a familiar fishing village with old-fashioned shop fronts. This had vague whisperings of the past.'[31]

That 'narrow, hilly street' is puzzling, since the obvious place to go for an immediate sea view from Southend Central station is the High Street, which lies directly around the corner and commands a view of the sea from its entire length. The street probably *was* narrower, and certainly more attractive, either in 1895 or 1957, than it is today, having been subject to the usual 1960s concretisation.

I walked down the High Street to the front, which is appealing insofar as it is old and stuccoed. The vast, vaguely baroque Palace Hotel (now the oddly named Park Inn by Radisson Palace) still projects Edwardian opulence, and there

must have been many disapproving stares from its windows at the raucous behaviour going on below. In *The Invention of Essex: The Making of an English County*, Tim Burrows writes, 'Those looking to keep the town better-heeled were aghast as its accelerating cockneyfication.' He cites a cartoon that appeared in the *Southend and Westcliff Graphic* sometime shortly after the passing of the Bank Holiday Act of 1871. It showed, writes Burrows, 'a well-fed couple, Mr and Mrs London, with their hundreds of children snaking in a queue as far as the eye could see behind them.'[32] He quotes a heart-breaking letter sent to a complainant from Southend by an excursion organiser. Southend, explained the organiser, was 'the only seaside resort that the very poorest of our London factory hands and matchbox girls can be brought to and taken home again for one and sixpence, a special fare organised by firms in London for their workers.'[33]

'When some of the match girls on the Bryant and May excursion missed the last train home from Southend in August 1892', Kathryn Ferry writes. 'they amused themselves until the early hours of the morning singing and dancing on the steps of the London Tilbury & Southend Railway station.'[34] The novelist Walter Besant affectionately called the East Enders visiting Southend, who 'instinctively laugh and shout to proclaim their happiness', 'children of nature', even though it was the unnatural railway that had taken them there.[35]

In 1990 I was commissioned by a magazine to write about Southend on a summer Saturday. The noise along the front was phenomenal. Radio Essex blared from speakers; as many people were drinking outside the pubs as inside (monitored by prowling police vans). An airshow was going on overhead, which culminated in a Harrier jump jet hanging screaming over the pier. The tide was out, which, in the case of Southend, means the black mud was *in*. The town was

Southend Pier Railway. The ride takes longer than you'd think.

exuberantly full of children and young people, but an old boy on the pier told me you never saw buckets and spades on the trains to Southend because of the mud.

This time around, Southend seemed tidier, less garish, but it might just have been less busy. The scruffy, nondescript pubs on the front were quiet; the pink brick buildings that once fronted the Kursaal funfair slept soundly. The Kursaal, opened in 1901, was the largest funfair in the south of England. It closed in 1973, flared back into life in the 1990s, but is closed again now. The LMS offered evening excursions to Southend, the two-shilling fare also giving free entry to the Kursaal.

Most people along the front seemed of retirement age, and this was also true of the passengers on the narrow-gauge electric train, various iterations of which have run along the pier since 1890. At this point it is obligatory to mention

that Southend Pier is the longest in Britain, at 1.3 miles, and that John Betjeman said 'The pier is Southend, Southend is the pier,' a soundbite that has eclipsed the fact that he was involved in the campaign to save the pier when it was threatened with closure after a fire (one of many suffered by the pier, along with other disasters) in 1976. When new trains were introduced in 1986, one of them was called *Sir John Betjeman.*

The carriage of the present train, dating from 2022, was mainly windows; a little lightbox, and the sparkle on the sea below suggested that it was benefiting from its own electric current. The couple opposite, probably in their late seventies, were reminiscing about Southend. '... The charabanc down from Willesden,' the man was saying. '... Never been so drunk as in that halfway house.'

'Yes,' replied the woman, 'and when we got here, everyone piling into the Kursaal and getting sick on the rides.'

The use of the word 'charabanc' was surprising. Surely it refers to those big, open-topped cars of the 1920s, with so many seats that they looked like a cinema audience on the move? But I later learned that the term was applied to the coaches that replaced the 'charas'.

A small aside about these competitors to the trains is in order.

In *Seaside 100*, Kathryn Ferry writes:

> By 1937 approximately 40 million passenger journeys were made by charabanc and motor coach, split equally between the two. Unlike the railways, mass motor transport was classless. Though the coach took longer, it was cheaper than the train and increasingly more comfortable than a third-class rail carriage.[36]

In *Char-a-bancs and Coaches*, Stan Lockwood pursues the same theme. 'It became the poor man's transport and opened up completely new vistas for many in the industrial areas, giving countless people their first glimpse of the sea and of parts of the countryside that they would never otherwise have known.'[37] Lockwood's book, which is full of photographs of interwar holiday scenes with captions like, 'Gossiping pedestrians seem completely oblivious to the 28-seater Leyland passing through Shanklin village,' or '20 charabancs ferrying members of the Bolton Co-Operative Society around Torquay,' inverts the modern left-wing perception that trains are the true people's mode, compared to automobiles.

His chapter called 'Railways Beware' describes how local trips evolved into long-haul ones using roofed-over vehicles. By 1929 six operators were running 'express coaches' between Great Yarmouth and London. 'The popularity of coach travel was badly affecting rail revenue, and the four main line companies protested that the public were using road vehicles instead of travelling by train – naughty public for daring to choose their own method of travel!'[38] Charles Graves describes a 'kaleidoscopic medley of motor-coaches' from Victoria Embankment to Southend. At the pub stop, 'Twenty motor coaches were drawn up before the only inn in sight. Half the passengers wore coloured paper hats. An old lady played the piccolo. Other old ladies joined in the chorus.'[39] He doesn't say where the pub stop – also known as the 'halfway house' – was located, but according to the website of the Billericay Community Archive, the King's Head, near Billericay on Southend Road, 'catered to passing charabancs on their way to Southend before WW1.' (The pub also sold spark plugs and petrol.)

Drinking was perhaps more embedded in coach travel than train travel – because of the halfway house, and because

coaches were usually hired by groups of friends; there were no disapproving strangers looking on. When, for that article of 1990, I asked a Southend policeman about troublemaking among day trippers, he answered with reference to coaches not trains: 'Somebody from one coach says something not too polite to somebody on another coach, and he gets a glass in the cheek. You've got to arrest two coachloads before you can find out who did it.'

In the 1930s the railway companies responded to the bus challenge by providing more catering on trains to the sea, and better accommodation generally. In 1933 the LNER introduced its Buffet Tourist Trains, in a jolly green and cream livery, and with two buffet cars per train. By the late 1930s, however, the Big Four had capitulated and begun buying up bus companies.

The train takes almost ten minutes to reach the end of Southend Pier, where a carriage from the old *Sir John Betjeman* set remains as what a pier employee said was a 'rain shelter', until swiftly correcting himself – 'sun shelter, I mean', which is presumably the official version. It might also be policy to suppress use of the word 'mud', which doesn't seem to come up in the pier literature. Yes, the pier was built to allow steamers to dock (and the historic *Waverley* still does every summer), but the reason it's so long is to clear the black stuff below.

Back onshore, I took the cliff lift to the garden square of Prittlewell Gardens. The day having become hot, houses' windows were wide open. Classical music, Bach, seeped from one, because Prittlewell Gardens is in seemly Westcliff, Southend's answer to Westgate or Cliftonville in Margate. In *The Invention of Essex* Tim Burrows describes how, in the late nineteenth century, Southend's 'establishment' had

proposed a zoning system: east of the pier should be for trippers, west 'for respectable visiting families and locals'.[40] But Westcliff, even though it had its own station, was stuck with Southend. They both overlooked the same muddy beach. A profounder corrective to Southend was available within the same county from the 1890s, though: at Frinton, 30 miles up the coast, summarised by Burrows as 'no amusements, no pier, no shorts at the golf club and certainly no public houses. Frinton today is retired stockbroker nirvana: they built the golf course before anything else.'[41] It's quite surprising that it had so potentially raucous a thing as a railway station, but it did, courtesy of the Great Eastern, from 1867, and it was visited by the gracious *Eastern Belle*, which never deigned to call at Southend.

I returned to Fenchurch Street via Tilbury, on a teatime train full of happy schoolkids who paid no attention to Tilbury's towering silos and pylons. At Purfleet we were passed by the Eurostar, heading away from the Dartford Crossing to destinations more glamorous than Southend, but not necessarily more interesting.

THE CONNECTIONS ARE LOST

Beeching and Before

In broad terms, two transport modes killed trains to the British seaside: cars (or cars and buses) and planes. The cars killed the trains; the planes killed the seaside, and Dr Beeching assisted the car cause with unjustified enthusiasm. He was the protégé of Ernest ('Ernie') Marples, Conservative Minister of Transport from 1959 to 1964. It wasn't too hard to make out that Marples was pro-car, since he possessed an advanced driving licence, drove a Jag and had founded a road building firm. It's hard to imagine him at the British seaside, except perhaps on some furtive trip to Brighton with somebody else's wife (his sex life was exotic). It seems fitting that when in 1975 Marples fled Britain to avoid being prosecuted for tax fraud, he went to a *foreign* seaside town: Monaco, although he did go by train.

Marples prided himself on being 'scientific'. Opening the first stretch of the M1 in 1959, he declared, 'It is in keeping with the bold scientific age in which we live.' Hence his appointment of Beeching, a number cruncher he head-hunted from ICI. Beeching's notorious report of 1963 came in the aftermath of the confused Railway Modernisation Plan of 1955. That had been highly ambitious for the railways,

projecting a £1.24 billion investment in, among other things, faster freight transfers and the mass replacement of steam by diesel traction. But it didn't stem the leakage of freight traffic to the roads, and the rushed 'dieselisation' yielded many impractical designs. Marples and Beeching now went in the opposite direction: retrenchment. With the railway deficit rising, Beeching sought to secure the 'profitable core' of the network by closing the least used stations and lines. He produced a map showing these as red dots, which should have been black spots, really.

Many were on the coast, especially in the West Country, East Anglia and Scotland, those stations being financially as well as physically marginal, owing to their seasonal traffic. Aldeburgh, Lyme Regis, Budleigh Salterton, Sidmouth, Bridport, Swanage, Minehead, Ilfracombe, Bude were among those destinations deemed surplus to requirements by Beeching. Had he never had a nice seaside holiday as a child? He wanted, for example, to close *all* the railways on the Isle of Wight. Beeching closed so many seaside stations that people might have been surprised in his aftermath to find one still open, or not have bothered looking for it in the first place but just climbed into the car. Paul Theroux's glum, amazingly accurate, three-page inventory of any typical British seaside town includes, 'The railway had been closed down in 1964 and the fishing industry folded five years ago. The Art Deco cinema was now a bingo hall ...'[1]

In total, Beeching proposed closing 2,363 stations (55 per cent of the network) and 6,000 route miles (30 per cent), and most of his proposed closures were implemented, either under the Conservatives up to 1964, or under Labour in the remainder of the decade. This is not the place to rehash the Beeching debate, but a few questions are in order. Marples, of course, commended Beeching's report to the House of

Commons as being 'based on actual research and scientific analysis', but what was scientific about Beeching's having based his calculations on a survey of only one week's railway traffic – and that in April, when not many people were going to the seaside? Was it worth throwing 70,000 railway workers on the dole, given that he came nowhere near eliminating the railway's deficit? How many people did Beeching kill, by encouraging them onto the roads when seat belts were still not compulsory? And if closing stations and lines was such a good answer to the railway's debt, why isn't it done today? The answer to that is the realisation of the social benefits of railways. The 'scientists' either didn't appreciate those benefits or deliberately ignored them.

Some of Beeching's seaside closures, on the Carnarvonshire line, at Hornsea, Silloth and so on, have already been mentioned; others we will come to. We have also noted some pre-Beeching coastal closures – those on the sprawling Midland & Great Northern Joint network, and others occurring during the Beeching era but not down to him, such as Blackpool Central and Hunstanton. As Richard Faulkner and Chris Austin write in *Holding the Line*, 'railway closures are as old as the railway itself.'[2] We begin with some early ones.

Colonel Stephens at Selsey (and Elsewhere)

Selsey is either a town or village depending on who you ask. It lies on the West Sussex coast, opposite the Isle of Wight, and is famous for the promontory called Selsey Bill, which is little more than a small seaward protrusion of the stony beach. Selsey lies 8 miles from Chichester, and to reach it by public transport you must take a train to Chichester, then a bus, the number 51, provided by Stagecoach.

The bus station at Chichester is just over the road from

the railway station, and that's the only good thing about it. The interior of the building seemed reserved for bus staff; passengers wait on exterior benches, theoretically protected from rain by a projecting balcony, but for some unfathomable reason – since it wasn't actually raining on the day of my trip – water was dripping from this balcony onto the only two unoccupied benches. The 51 runs about twice hourly. The driver was friendly, the fare reasonable at two pounds. It was a double-decker, and the half-dozen passengers all sat on the lower deck, possibly because they didn't feel like climbing the stairs, most being elderly.

The bus, having wound its way through the historical streets of central Chichester, was entering the suburbs when a wave of unease passed over my fellow passengers. Everyone seemed on the point of saying, 'What's going on?' when the bus came to a lurching stop. I thought we'd crashed, but it emerged from the hubbub that something unprecedented had happened on the 51. The driver had taken a wrong turning. 'This driver', one of the two women sitting in front of me explained: '... he's new, you see.'

The driver apologised. 'It's my first day on the 51, but don't worry, we'll soon be back on track.'

So it hadn't been a crash, and presumably the 51 crashes very rarely if at all, whereas the train that connected Chichester to Selsey from 1897 to 1953 crashed fairly regularly, once with fatal consequences. On the other hand, it was an attractive and characterful operation: one of the 'Colonel Stephens railways'.

Since the metaphorical ice on the lower deck had been broken by the wrong turning, I floated the name of Stephens. The woman in front said, 'Oh, yes, the Selsey tram man,' but her friend said, 'Colonel Stephens? Never heard of him.'

The Connections Are Lost

Colonel Holman Fred Stephens (1868–1931) was a mercurial, contradictory man; there's a contradiction even in his name. His father was the floppy-haired art critic, Frederic George Stephens, a promoter of the Pre-Raphaelite group, which included Holman Hunt, after whom Stephens was named. Not many products of a such a background would have gone on to serve an apprenticeship with the Metropolitan Railway, whose workshops were located (and this is perhaps even more alarming from the rarefied Pre-Raphaelite perspective) in Neasden, or to become a colonel in the Territorial Army, both of which Stephens did. He engineered and managed sixteen rural railways, mainly in the south of England, usually under the provisions of the Light Railway Act of 1896, which, with the intention of helping farmers at a time of agricultural depression, allowed railways to be constructed without the usual expensive infrastructure. Stephens began work on the Selsey line before the act was passed, but it was similar in nature to the lines he built under its provisions.

A typical Stephens line would be unfenced and without signals; if there happened to be a level crossing, the driver himself would get down from his engine – sometimes an adapted bus – to open the gate. Where his lines ran for any length of time alongside a road, they were called 'Tramways'. Passenger carriages would be combined with goods wagons, so passengers would find themselves shunted as goods were picked up or dropped off at the stations, which were mostly halts, garden shed-like if there was a building at all. There might be wooden platforms, or the platform might be the ground. Illumination was by oil lamps, and if this is beginning to sound beautiful and romantic, perhaps that's how the Colonel saw it. Little is known of his motivation, and his business records have been lost.

Posters advertising his lines would urge people to avoid the 'dusty and overcrowded roads', and Stephens can be interpreted as a proto-environmentalist. According to one of the 'Fascinating Facts' on the Colonel Stephens Society website,

> Stephens was an early recycler, before the term was coined. Wherever he went he used hotel notepaper for his correspondence. On at least one occasion he used the local town clerk's headed paper and envelope. He bought locomotives, carriages and wagons second- and even third-hand for his railways.[3]

Staff who wasted money would receive a severe memo. Staff who economised might be rewarded with a cigar (the Colonel chain-smoked cigars) or a gold sovereign. He once paid out of his own pocket so that a worker on the Selsey line could buy a new set of false teeth.

The last of the 'Fascinating Facts' is that 'He died alone in 1931.' A supporting sentence reads, 'Stephens died aged sixty-two in the Lord Warden Hotel, Dover, where he was a resident.' He left an estate of £30,000 (equivalent to about £1.4 million today) to be equally divided among four of the staff at his HQ, 23 Salford Terrace, Tonbridge. He donated his collection of Pre-Raphaelite paintings to the Tate.

Stephens's last un-smoked cigar is displayed in the wonderful Colonel Stephens Museum at Tenterden station on the Kent & East Sussex Railway, a deeply rustic preserved line that grew out of the Rother Valley Railway, a Stephens concern. The museum is housed in a corrugated iron shed; light, but somehow ominous, jazz plays as visitors survey memorabilia of the man and his lines. Behind a glass screen is the Colonel himself, in the form of a disturbingly lifelike

waxwork. He sits at his roll-top desk, surrounded by his own books and papers. You can just imagine him engaged in correspondence, crossing out the name of whoever's personal stationery he had purloined (or recycled) before scrawling his own and demanding to know why ten shillings had been spent on some unnecessary paint job.

Several of his lines served seaside resorts. He was briefly employed to troubleshoot on the perpetually broke Isle of Wight Central Railway; he also managed, for a longer time, the Weston, Clevedon & Portishead Light Railway (1897–1940), which was the second railway into Weston after the Bristol & Exeter had arrived in 1841. It ran slowly through the streets of Weston and Clevedon. The standard trains of the line comprised a couple of ancient four-wheeled carriages and a second-hand Terrier (one of William Stroudley's neat little tank engines for the LBSCR), but when running through the sleepy streets of Weston, as they did when approaching that station, these little trains looked big. A photograph in John Scott-Morgan's book, *Railways of Arcadia*, shows a poster advertising excursions on the line: between Weston-super-Mare and Clevedon 'every Wednesday and Saturday, commencing September 1939'.[4] Not an auspicious date, of course, and holidaymakers couldn't have saved the line even had peace endured. Most of its revenue had come from freight, the products of local quarries, and that was being lost to the roads. The story is told of a posh woman who had missed the last train from the main station at Clevedon, run by the GWR. She asked a porter how else she might get to Bristol, and was affronted when the man advised her, 'If I were you, I'd go to the WC & P.'

The Colonel also engineered the short Rye & Camber Tramway (1895–1939), initially to connect Rye with the Rye Golf Club at Camber. It is reputed to have been subsidised

A typically somnolent scene on a Stephens' railway, although maybe not if you were in that property with the windows open.

during 1901 by the golf club's bar takings, in return for letting caddies travel for only a penny. The line was later extended to take trippers to the great void of Camber Sands – a profitable undertaking, as it turned out. The R&C was 3-foot gauge, but most of the Colonel's lines were standard gauge, including the Selsey Tram, formally called the Hundred of Manhood and Selsey Tramway, Selsey being on the Manhood peninsula.

Holiday business made the Selsey Tram another of Stephens' successes, but it was ramshackle even by his standards. There were eleven halts, including Selsey Town and (between 1898 and 1907) Selsey Beach. A leaflet available in Selsey reads:

> The tramway hugged existing field edges, twisting and turning across the Manhood Peninsula with bends so tight that speeds over 15 mph were ruled out. In keeping with the Tramway's ramshackle nature, the rolling stock

was a ragged mismatch of ancient ex-works engines and, towards the end, petrol-driven buses with flanged wheels. Yet in its heyday excursions ran, packed with day trippers, from London to Selsey Beach Station. It declined rapidly in the 1920s ...

A two-minute film, *The Selsey Tramway*, shot in 1928, is available through BFI Player. It shows a railmotor, a boxy, carriage-like body atop a lorry chassis with petrol engine at the front, being started at Chichester, with difficulty, by an oily man turning a crank handle. A schoolboy looks down from the front window, appalled and fascinated. Behind this railmotor is a low-sided wagon full of luggage. There was a timetable, but it was not observed very closely. The driver might stop to let people pick blackberries.

Competition from buses killed the line. In 1919 it carried 102,292 passengers; in 1922, 60,203; in 1924, 31,352. Between Sidlesham and Selsey the only road into and out of Selsey (today's B1245) tangled with the line. According to the leaflet, 'Regular collisions occurred here between road vehicles and trains, eventually resulting in the driver of the tram having to walk across the road waving a red flag before the locomotive crossed.' The only fatal accident occurred on 3 September 1923; a tank engine called *Wembley* jumped the track and the fireman was killed.

Attempts to persuade the Southern Railway to take over the line having failed, it closed on 14 January 1935.

'Sounds like an eccentric,' observed the more talkative of the two women on the 51 bus, and the Colonel's London club was indeed the Eccentric. At this point we were nearing Selsey, passing wide, empty fields, and the talkative woman's companion was putting on a pair of sunglasses, even though

this was December. Selsey is famed for its high incidence of sunshine; it is also famed for its darkness at night, owing to its remoteness.

'There's a lot of that in Selsey,' said her friend, meaning eccentricity. She mentioned the astronomer Patrick Moore, who lived in the town for those dark skies, in a large, thatched house with several observatories in the garden. He would cut up cars on his large bicycle and was chairman of the Selsey Cricket Club. He was known for spending a fortune on the tombola at the annual Selsey fete and refusing to claim his prizes.

I asked the women how Selsey was faring. 'Dead in winter, overcrowded in summer,' said the sunglasses-wearer.

And would people like to see the railway revived?

'I wouldn't,' said sunglasses.

'*I* would,' said her companion.

A plaque marks the location of the Tramway's Selsey Town station, engine shed and goods shed; 1970s bungalows occupy the site. The exact location of Selsey Beach station is not known. It lay east of Selsey, towards Pagham Harbour, which is not a harbour and hasn't been for a few hundred years. It's a ghostly salt marsh and birdwatching venue. It flooded in 1910, prompting the raising of the tracks of the Tramway. A raised trackbed is just about discernible, and the Selsey Beach station seems to have been in the vicinity of a blue plaque commemorating the light classical composer Eric Coates, who in 1930 wrote 'By the Sleepy Lagoon' inspired by the view across the sea to Bognor. The royalties must have been good from that, since it became the theme tune of *Desert Island Discs*. Coates, who had a holiday home in Selsey, was entranced by the pink glow of Bognor in the evening, which turned out to be created by the gas works.

Railway carriage in retirement at Selsey.

Being so minimally engineered, the Colonel's lines did tend to fade back into the landscape. Some survived as independent concerns into the Grouping era, but most expired between the 1930s and the 1960s.

In the probable vicinity of the Tramway's Beach station there is a curious village, or colony of houses formed from or somehow incorporating vintage railway carriages, and the effect is of an ordinary bungalow having swallowed a carriage, without being able to quite digest it, so that it sticks out either end. Most of the carriages were vintage even back in 1920 when they were brought to Selsey, some making the trip to their final resting place on the Tramway. The colony, known as the Park Estate, was inaugurated by Jacob Berg, an East End tailor. A friend of his who was a traffic manager at Waterloo might have been the source of some of the carriages.

The Wivenhoe & Brightlingsea Railway

When discussing the Canterbury & Whitstable Railway, I mentioned another 'Crab & Winkle' and promised a third. This was the Wivenhoe to Brightlingsea Line in Essex. It opened in 1866 and closed in 1964, carrying oysters and sprats from Brightlingsea to Wivenhoe and trippers the other way. Wivenhoe was, and still is, on the branch running from Colchester on the Great Eastern Main Line to Clacton and Frinton, now provocatively marketed as the 'Sunshine Coast Line'. Brightlingsea, about 6 miles south of Wivenhoe, stands on Alresford Creek, at the mouth of the River Colne, and the line traversed the creek on a long iron swing bridge. A pamphlet about the line, *The Fighting Branch*, by Paul Brown, is atmospherically written:

> In the distance a streaming column of white smoke split the green of the marshland, and from out of the winter's afternoon the sound of the seabirds was superseded by the sound of steam. A black engine with a high chimney, pulling three carriages, rocked and swayed in the keen west wind. The herald of its coming had been the throb of bass wheel beats as it had crossed the swing bridge, its black silhouette being reflected by the sun onto the grey mud below ...[5]

That black engine signifies the time when the line was in the hands of the LNER. By 1963, when BR was running it, the black locos had given way to green two-car DMUs. In that year, a film called *River Ride,* available online through the BFI, was made by Edward Thorp, an undertaker from Leigh-on-Sea. According to the film notes, 'Thorp, known as "Chib", spent his weekends throughout the year visiting the rural railway lines in East Anglia with wife Edna and their dog, Micky.'

The film is in colour, and the dark blue Eastern Region enamel of the sign reading 'WIVENHOE, JUNCTION FOR BRIGHTLINGSEA' looks very lustrous. Watching it, you realise that guards and porters of the time were allowed to wear ties of any colour they liked beneath the uniform's dark jacket and waistcoat. Chib was very cheerful for an undertaker. 'Here's the driver's kettle,' he observes in his commentary. 'He's always ready for a cup of tea.' The commentary and train noise come and go in bursts. As the DMU skirts the Creek on a stony embankment, Chib says, 'C stands for caution, and it does look a bit rickety.' Silence for a while, then, 'Those posts you see in the water are connected to the yacht racing.' There's a sudden clip of sunbathers on the small beach at Brightlingsea, but in most of the footage a sea fret seems to be gradually, and silently, descending. The line was a Beeching closure, the pretext being the high cost of maintaining the Alresford Bridge.

Allhallows-on-Sea

The Hoo Peninsula, projecting between the Thames and Medway Estuaries, is one of two land masses that seem to float like clouds above the East Kentish hump, the other being the Isle of Sheppey. In 1882, the Hundred of Hoo Railway was built by the South Eastern Railway, at the request of some local farmers. After diverging from the North Kent Line at Hoo Junction, it ran across the middle of the Hoo Peninsula to Port Victoria, which the South Eastern Railway hoped would be the line's big earner as a freight terminal, but Port Victoria never escaped the shadow of Queenborough on Sheppey. A Pathé newsreel of 1947, *Lonely Station*, profiled the station master, Stephen Hills, who was also the porter, ticket clerk, signalman. 'There's a lot to do,' runs the gloomy

narration, 'but a lot of time to do it – only two trains call here now. Four tickets to collect is a rush, eight visitors is a crowd.' Mr Hills is shown performing humble tasks such as sweeping his wooden platform, which seems to have rotted in the sea (or estuarine) air.

In 1932 the Southern Railway tried to compensate for the eclipse of Port Victoria by opening a northern prong from Stoke Junction on the Hundred of Hoo line to Allhallows, a somnolent village surrounded by marshland. This the Southern intended to develop as a seaside resort on the scale of Blackpool, or at least Herne Bay. A poster for the opening of the line boasted that Allhallows-on-Sea was 'Facing Southend', as if that were any incentive to go there. Allhallows-on-Sea rated a mention in the Southern Railway's *Hints for Holidays* book of 1936, but then so did almost anywhere not overtly industrial on that company's network, which is why the book is 936 pages long. It described Allhallows-on-Sea as 'the latest holiday rendezvous on the S.R. system.' It was

> a place where the breezes blow fresh from the sea, and its popularity is likely to increase year by year. This is due to its fine sands, the splendid views of the river estuary, and the line of railway which the Southern Railway built especially to open up this new resort. Roads have been laid out, and building sites are available for those who like to 'get in early' in the development of the resort.'[6]

Perhaps they weren't totally confident, because they protested too much: 'It is safe to predict that in a few years' time Allhallows will be a good class residential town.' A photograph showed a moderately crowded beach, backed by nothing much inland.

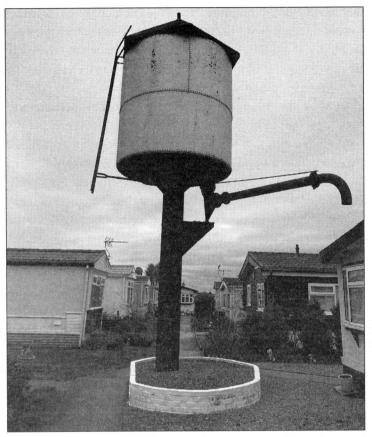

The watertower of Allhallows-on-Sea station: a defiant ghost.

Allhallows-on-Sea was about 12 miles from Gravesend but, more to the point, as a Southern Railway brochure of 1932 had it, 'only 37 miles from the city'. The brochure advertised 'Healthy Homes for Londoners – only 2 minutes from golden sands'. Direct services from Charing Cross, with morning and evening expresses, were laid on in case anyone wanted to live in Allhallows, but few houses were built, and the better market proved to be in cheap day returns. Allhallows-on-Sea

flourished moderately in the 1930s. A swimming pool, a restaurant and a pub, the Pilot, were built, but nothing as substantial as a hotel. So Allhallows-on-Sea was neither unspoilt nor quite established when the war intervened.

Invited to evoke the line in the 1950s, any student of railways might have described an old tank engine, or a DMU heading into a sea fret. The Allhallows branch was, like the rest of the Hundred of Hoo line, excluded from the Kent Coast Electrification Programme, and the whole lot closed in 1961. The holiday area at Allhallows is still called Allhallows-on-Sea, and here stands Kent Coast Holiday Park, operated by Haven Holidays. Accommodation is in fixed caravans and lodges. The railway station was demolished in the 1970s to make way for an estate of what are called 'mobile/park' homes that would once have been called prefabs. Anyone wanting to get there by public transport must take a train to Rochester, then a bus: forty-six minutes, thirty-one stops.

On a dark afternoon in January 2025, I drove there, passing wide, ploughed fields traversed by telegraph wires on which hundreds of birds sat. Beyond some postwar local authority housing lay the entrance to the Haven holiday camp. It resembled that of a military camp, with its red and white barriers, to be raised or lowered according to whether the approaching vehicle had authorisation. The gatekeepers were just as friendly as their colleagues in Caister, however. They didn't know where the old station had been located, but they directed me a little way down the road, and here I did see some 1930s architecture, in the form of the 'Pilot' pub – so called by the ceramics on the facade, but the 'British Pilot' according to the wooden sign out front. Another sign, over the door, read 'Open', but it wasn't: access was blocked off by steel gates. The question of the pub's name will soon be academic, because it's destined (as I later discovered) to be a

Co-Op. Across the road were the 'mobile/park' homes, and in the centre of this estate the water tower of Allhallows-on-Sea station remains, towering over the single-storey houses like a defiant ghost, with its elephantine hose threatening to dribble over the pitched roof of the house immediately below.

I crossed the marsh towards the sea; it took rather more than the two minutes the Southern Railway had promised. Ahead of me, beyond an embankment, passing ships seemed to be levitating, higher than the land. On either side were occasional thorny tangles, like unburnt bonfires. On the black waters of a creek, a couple of swans looked almost dazzlingly white. The beach did involve some seaweed-strewn rocks, but there were also the fabled golden sands, and beyond them the mud of the estuary, glinting somewhat, since a late-afternoon sun had grudgingly shown itself. To the east lay the great black hulks of gasholders, looking like things that had been burnt, but no other human was in sight. It was a beautiful scene, but not in the way the Southern Railway had intended.

The Case of Whitby

Whitby, with its harbour cosily enclosed by the stacked-up houses of the Old Town on the East Cliff and the faded Victoriana of the white hotels on the West Cliff, is my favourite seaside town. If I could live anywhere in the world, it would be in one of the Georgian ship captain's houses overlooking Pannett Park, with a flagpole in the garden. I have visited Whitby many times, and would have visited it many more, but for Dr Beeching and his accomplice in the railway marginalisation of Whitby, the Labour Prime Minister, Harold Wilson.

The line approaching Whitby along the coast from the north closed in 1958. That left Whitby with three railways:

one approaching up the coast from Scarborough to the south; another from Malton on the main York–Scarborough line; a third from Middlesbrough (the Esk Valley Line), which lies north-west of Whitby. Beeching proposed the closure of all three, prompting fury in Whitby.

Ernest Marples, Minister of Transport and Beeching's boss, responded by reprieving the line from Middlesbrough. But Peter Hardy, lined up as Labour candidate for Whitby in the 1964 General Election, cited a letter from Harold Wilson to the Whitby Labour Party saying all three proposed closures in Whitby would fall within the Labour manifesto's pledge to 'halt major closures' proposed by Beeching. Hardy did not win the Whitby seat; Sir Alexander Spearman, a Conservative, did, and he took up Hardy's contention. To abbreviate a long and sordid story, Wilson, and his Transport Minister, Tom Fraser, wriggled out of the promise to halt major closures, whether in Whitby or elsewhere. They claimed they were bound by the Transport Act of 1962 which had authorised the Beeching closures, a position that, as Richard Faulkner and Chris Austin point out in *Holding the Line*, contradicts the 'fundamental principle of our democracy [that] no Parliament may bind its successors'.[7]

The surviving Whitby line, the one via Middlesbrough, was inconvenient if you lived in York, as I did when a boy. It made for an eight-hour round trip. Today the diesel multiple units running to Whitby along the Esk Valley Line are supplemented, and upstaged, by the steam trains of the North Yorkshire Moors Railway, which intercept that line at Grosmont. Everyone in Whitby stops and smiles as the NYMR locos bring their plumes of steam and packed carriages to Whitby's harbour-side station.

The line from Scarborough to Whitby is now an off-road cycle track and footpath. Paul Theroux walked the old line,

marvelling at the 'stupidity' of the closure, and resenting the way some of the stations have become private houses, 'the superbly solid Victorian railway architecture now the merest forcing-house for geraniums and cats'.[8]

In 1966 Frank Dean, a railwayman and cinematographer, made a short film about the closed line, *A Sentimental Journey*. In his lugubrious narration, Dean sounds like a working-class Alan Bennett. He begins, 'The North Eastern Railway proclaimed its Scarborough to Whitby branch as twenty-one miles of the most picturesque railway in the British Isles.' There's footage of the green seven-car DMU that ran on the last day of public working, 6 March 1965, climbing past dry-stone walls to Ravenscar, which stands on 600-foot-high cliffs, and was the summit of the line. There's been a hotel at Ravenscar since the 1890s; in the 1930s there was a single camping coach next to the station, a bathetic sight, given that the Ravenscar Estate Company had tried to develop the place as a major resort. The plan foundered on the remoteness of such clifftop amenities as were created from the rocky beach far below the cliffs.

There are shots in the film from happier times: dresses belonging to the Robin Hood's Bay station master's wife fluttering on a clothes line; the train skirting the very edge of the clifftops, as though in a game of 'dare'. The film shows the last official train along the line on 31 October 1967, carrying, in two brake vans, a party of demolition contractors 'anxious to bid for removable assets'. They all wear long black coats and green flat caps, like members of some sinister cult.

Hayling Island

On YouTube there's a short film with the long title, *Ride the Hayling Island Branch Line in 1960 on a Summer Saturday.*

It shows the operation of this famous branch in that year. The commentary, given by a well-spoken woman with an old-fashioned railway-announcer voice, begins, 'A small tank engine, built more than ninety years before, is joining its short train.' And there, straightaway, is part of the charm of this branch. It ran from Havant on the West Coastway Line, south to Hayling Island, which lies a fifth of a mile off the mainland, with Langstone Harbour to the west and Chichester Harbour to the east.

As the tank engine joins its train, the discrepancy is almost comic, as if an ant were proposing to drag a maggot. The tank engine is black, although the bright sunlight and the coarse grain of the 8 or 16mm film make it look a shimmery blue. It belongs to the Terrier class of small, powerful engines. Their smallness, and their ability to tread lightly, was the reason they were put to work on the Hayling Branch, which crossed from Langstone on a rickety wooden viaduct. The coaches hauled in the 1960 film are not exactly brand new themselves, being ex-Southern compartment stock. Their dark green livery complements the green and gold landscape through which they pass. The film shows how the intensive, summer Saturday service – two trains each way every hour – was operated over the 4½ -mile branch, using three Terriers and two sets of two coaches.

The theme is the old world against the new. The Havant terminus, 'with its electrics to Waterloo, Portsmouth and Brighton', is depicted as belonging to the new. The branch line trains are in the old world. As they approached Langstone (which the railway called 'Langston'), the first of the two intermediate halts, they crossed the only road to Hayling Island, often interrupting the increasingly large volume of traffic heading towards the road bridge. In the early part of the film, shot on the *morning* of that summer

Saturday, half a dozen cars are queuing at the level-crossing gates as the train passes. Later in the day the queue stretches beyond the edge of the frame, and those fuming Bedford camper vans and Austin A40s are beginning to look menacing. 'How unpopular must the trains have been,' the narrator speculates, 'stopping the traffic four times an hour on the busiest day of the summer.' In the footage, the crossing keeper seems harassed as he stands on the line, looking at the cars. Apparently he had difficulty holding them back at busy times. In winter there would be fewer cars, but he might have to hold them up for just one passenger, boarding or alighting at Langstone.

The train obviously had its fans at the time, though. It passes a blazered youth sitting on an embankment and holding out a microphone. 'Sound recording,' says the narrator, crisply. 'Photography,' she adds, as the train passes another well-turned-out enthusiast, this one holding an 8mm camera. The film is entirely hypnotic, the velvety green meadows giving way to the glimmering water as the train traverses the viaduct. The only vertical elements are the telegraph poles and the mast of the occasional small sailing boat.

The narrator of the film reminds us that the scene might be 'bleak' in winter, with a gale blowing over Langstone Harbour. But John Scott-Morgan appreciated the scene in winter, too, discerning 'something ... ghostly, about the sight in winter of a Terrier after dark, with white frothy steam coursing out of its long black chimney, hauling a train of two or three dimly yellow lit, non-corridor carriages, as it fussed its way towards Langstone Halt'.[9]

The narrator mentions that one of the guards on the train, Sam Walder, was used as the model for the above-mentioned Southern Railway mascot, Sunny South Sam. He was

a 'cheerful' man (it would be scandalous if he were anything less), who would delay the train's departure if a late straggler were approaching along the platform.

The film raises an expectation of modern Hayling Island that it can't always meet – especially on a gloomy day. It has five miles of sandy beach, but the victory of the automobile is signified by giant car parks, which are probably useful for the many visitors who bring recreational hardware, Hayling having become a centre for windsurfing, kite-surfing and paddle-boarding. The piers of the railway bridge remain, west of the road bridge, along with the pivot where it opened to let boats through. If the bridge were ever rebuilt there are still some Terriers left to traverse it. Of the fifty, about ten survived into preservation. I once did an engine driving course on the one called *Stepney* – a veteran of the Hayling Island Branch – at the Bluebell Railway. I was torn between thinking it a jumped-up antique kettle and being terrified of it.

Ventnor and the Isle of Wight

'The Isle of Wight is disappointing at first,' wrote Henry James in 1875.

> I wondered why it should be, and then I found the reason in the influence of the detestable little railway. There can be no doubt that a railway in the Isle of Wight is a gross impertinence; it is in evident contravention to the natural style of the place. The place is minutely, delicately pic-turesque, or it is nothing at all. It is purely ornamental; it exists for the entertainment of tourists … Never was there a better place for sacrificing to prettiness; never was there a better chance for not making a railway. But

now there are twenty trains a day, and the prettiness is twenty times less.[10]

Reading this, one is torn between thinking it was none of his business, James being American (albeit an Anglophile, resident in Rye), and that he might have had a point. In the mid-nineteenth century, half a dozen companies built more than thirty stations and more than fifty miles of railway on an island only 23 by 13 miles in extent. But they were appealing railways, to those whose romanticism took a different form to James's. They used antiquated rolling stock bought second-hand from the mainland, and visitors of a certain age would have kept experiencing moments of déjà vu, on seeing, for instance, a rake of carriages formerly of the Metropolitan Railway, or a tank engine ex of the North London Railway, all enjoying a new lease of life in less smoky circumstances.

Those companies had crystallised into three before 1923, when the island's network was taken over by the Southern Railway, which began refreshing the lines with some new old trains: coaches formerly belonging to the London Brighton & South Coast Railway and the London & South Western Railway, and the O2 class suburban tank engines of the latter, displaced from the mainland by the electrification. Those O2s were craned off boats at the port of St Helen's. 'It was always remembered against an engine called *Bonchurch* that it was dropped into the sea while being landed at St Helen's, and it stayed there for several days before being retrieved,' Michael Robbins writes in *The Isle of Wight Railways*. 'This made no difference to its performance on the line.'[11] The trains carried some coal, but were mainly passenger-oriented, and it seems logical that the island's one named train was called the *Tourist*. Between 1932 and 1953 it ran from Ventnor to Freshwater via

Newport, taking just over an hour, effectively traversing the full width of the island via its centre.

By 1956 about half of the lines had closed – not enough for Dr Beeching, who proposed the closure of all the rest. After local protests (82,000 names on a petition of May 1964), part of the main tourist route, Ryde to Shanklin – built by the Isle of Wight Railway and running north to south down the east of the island – was reprieved. But the southern section of that line, from Shanklin to Ventnor, would have to go, since its final approach was through a long and deep tunnel, costly to maintain. It was decided to electrify the surviving line, and since it ran south from Ryde Pier through a tunnel whose trackbed had been raised to obviate flooding, the trains would have to be small. So new exhibits would be brought to the railway museum that is the Isle of Wight: Standard Stock Tube trains dating from 1923. They began running on what is today called the Island Line in 1967. In the late 1980s it was felt something slightly less old was needed, so 1938 Stock Tube trains were brought over. These in turn were replaced in 2020 by trains that middle-aged visitors might recognise from spots like Earl's Court and Upminster, since they are tarted-up D78s, which began running on the District Line in 1980.

I brought my bike with me to 'the Island', as the locals call it, and since the South Western Railway's Desiro from Waterloo to Portsmouth was largely empty, I just propped it next to my seat. The Desiro was quite a pleasant train, and the guard was *very* pleasant. He asked questions about my bike. Not 'Have you got a ticket for that?' (I had not), but 'How long have you *had* that? It must be older than you are!' A couple of hours later, I was wheeling it through large and gloomy Portsmouth station to the Wightlink catamaran terminal,

which had all the glamour (and the suspect-looking vending machine) of some provincial bus station.

The catamaran was a cinematic experience, though, what with the heavy rain falling diagonally into the dark Solent. This was late September 2023. In my 1970s boyhood, when I would have been on a ferry rather than the 'cat', heading for a family holiday, it was always sunny on the Solent. As the town of Ryde came into view, my reaction was unchanged from boyhood days: a patronising urge to congratulate the residents on having created a town that looked much like those on the mainland – but slightly more attractive, with a hint of the Riviera in the white and pastel buildings.

In his poem of 1935, 'To A Writer on His Birthday', W. H. Auden wrote,

August for the people and their favourite islands.
Daily the steamers sidle up to meet
The effusive welcome of the pier ...

That's how it ought to have been, but this wasn't August, and it wasn't 1935. Ryde Pier is the world's oldest seaside pleasure pier, and Britain's second longest after Southend. It's really three piers: one for trains, one for cars, and a walkway, made from the tramline that closed in 1969. In his memoir, *Babycham Night*, Philip Norman said of the modern-day structure, 'for those who have not landed here before, the impression must be of some vast, seagull-haunted scrapyard.'[12] But at least the pier was open. It had often not been in previous months, owing to heavy maintenance work.

Philip Norman grew up on Ryde Pier. His father Clive ran its Pavilion entertainment complex, as it would be called today, had it not been demolished in the 1980s. He describes how, whereas the catamaran 'brings people by the dozen',

the ferry brought them 'by the hundred thousand', and they would crowd on the disembarkation side, threatening a capsize. New arrivals would be petitioned by three amplified voices as they alighted. One was that of a British Rail man with a strong Welsh accent, who rolled his Rs. He announced that the tramway lay to the right for those not going beyond Ryde itself; the train lay to the left, 'for services to Rrryde Esplanade, Rrryde St Johns, Brrading, Sandown, Shanklin, Wrroxall and Ventnor.' Another, smoother voice, came from the pier head rock shop: 'Hello there, ladies and gentlemen, just across here at the shop, you've got plenty of time, we'll serve you straight away ...' This was Archie Vernon, arch enemy of Clive Norman, whose own spiel, issuing from loudspeakers on the Pavilion's seaward facing perimeter, began, 'Morning coffee and biscuits, tea, minerals and light refreshments are now being served on the sun-roof or in the restaurant upstairs.'[13] So the scene is set for a tale – like a dark Ealing Comedy – of professional and emotional rivalry at the pierhead.

On the relaxed Island Line, the guard sold me a ticket when we reached Ryde Esplanade, a pretty Victorian station that clashes with the ex-Tube train. 'Oh, it's you,' the guard said, when he noticed a woman sitting nearby. 'Is your sink still blocked?' I rode the line to Shanklin, which has one platform and one track, where before it had two of each. There is also that memorial to 'Jarge', the unofficial outside porter. A big sign beyond the emphatic buffer stop reads 'Welcome to Shanklin'. There's a small café in the old ticket office, where another conversation between locals was going on, a man saying, with a rueful laugh, to the woman behind the counter, 'No, because this time, you see, it's my *lower* back.'

There are many closed-down stations on the island that I could have visited. I don't know most of the places that

have lost their lines simply because they have lost their lines, so I've never been there. Ventnor seemed a good choice: it's often cited as the most beautiful town on the island, and it was easy to get there – by cycling along the Red Squirrel Trail, which follows the closed-down line from Shanklin for most of the way.

The track ran straight, and my successive targets were a series of brick bridges that had obviously been railway bridges. A small wooden café stood in a field; it was called the Railway Café, and it was closed. The trail runs out before Ventnor, which is no surprise. Because of landowners' objections, the line was required to approach the town through a long tunnel beneath St Boniface Down. The line emerged from a chalk cliff, high above the town.

After an interlude of taking wrong turns on my bike, I was staring up at that cliff. An old postcard in my collection, dating from the early 1900s, shows the station, which opened in 1864, created from an old quarry. It looked like a station in the Old West: there was the drama of the landscape; the station building resembled a ranch house; the turntable was enclosed by a picket fence, and while no trains were in view, there were plenty of horses, attended by thin men on high-crown bowlers. The back of the card was blank, but there was a short inscription at the top of the image. It read, 'Your Arthur would like this,' and was signed 'Jeanne' – one woman to another, probably. There's another image of it on the website of the Ventnor & District Local History Society. This dates from 1965, a year before closure, and the station is surrounded by cars. 'In winter', reads the accompanying commentary, 'the guard was sometimes the only person to get off. Taxi drivers would sit stationary in their vehicles in the forecourt and pass the hours making woollen rugs.' A crude hoarding on the station roof reads 'Southern Railway',

even though that had ceased to exist nearly twenty years beforehand. Today the site is a light industrial estate. As is usually the case when light industry has supplanted a station, the businesses are car-oriented. I saw a woman crying in a dented Mini. Perhaps the crash had only just occurred; or she might have been in tears over the cost of repair.

I cycled down to the front, not easy, given my bike's worn brakes and the steepness of the descent. I was surprised to read in *The British Seaside* by John K. Walton that in the inter-war period Ventnor had seventeen lodges approved by the Cyclists' Touring Club, an organisation whose favoured places 'reflected the inter-war preoccupation with fresh air, exercise and scenery'.[14]

I arrived at the small, reddish beach. Behind me was Ventnor, stacked up like a job lot of Regency villas, most with fancy canopies and balconies. Immediately behind me was a small museum-cum-shop called Blake's. There were pictures of old Ventnor on the walls, almost as many of the station as of the sea. The shopkeeper, or curator, was a middle-aged woman. She 'just about' remembered the station: 'My dad used to go up there with his cart and offer to take the tourists' luggage down the hill. Of course, when he took it up again at the end of the holiday – that's when he earned his money.'

And would she like to see the line restored?

'We all would; the town hasn't been the same since.'

Ventnor had two stations, because there was also Ventnor West, opened by what became the Isle of Wight Central Railway and closed in 1952. The main building is now a large, desirable house in a leafy Ventnor avenue. There's a plaque on the façade and a subtle image of a train on the stained glass over the door. John Betjeman preferred to approach Ventnor by the Isle of Wight Central (that is, from Cowes rather than Ryde), as he said in a BBC radio talk, *Ventnor, Isle of Wight*, of

1 September 1950. He appreciated the way its trains would 'glide through alder-bordered meadows, past the thatched farms and greeny-grey stone cottages of inland Wight'.

Henry James, on the other hand, travelled down from Ryde, having deigned to take that 'objectionable conveyance', the railway. The train, he found, 'rumbles along very smoothly, and stops at half a dozen little stations, where the groups on the platform enable you to perceive that the population consists almost exclusively of gentlemen in costumes suggestive of unlimited leisure for attention to cravats and trousers ...' We will cut him off there, to spare ourselves various tortuous qualifications and caveats, and pick him up again in Ventnor:

> It is a well-regulated little watering-place, and it has been subjected to a due measure of cockneyfication. But the glittering ocean remains, shimmering at moments with blue and silver, and the large gorse-covered downs rise superbly above it. Ventnor hangs upon the side of a steep hill, and here and there it clings and scrambles, it is propped and terraced, like one of the bright-faced little towns that look down upon the Mediterranean. To add to the Italian effect, the houses are all denominated villas, though it must be added that nothing is less like an Italian villa than an English one.[15]

He wouldn't have seen it without the railway.

Padstow

Padstow was deprived of its railway in 1967 by Dr Beeching. The main route that served it, the old North Cornwall Railway, is now considered part of the lost network of former

London & South Western Railway lines known as the 'Withered Arm'. But there is nothing withered about Padstow on a sunny summer Saturday. After a tour of car parks on the hill above the town, I eventually found one with a space. Descending on foot through crowds of prosperous-looking tourists, their pink faces bright against the town's grey slate, I headed to the harbour, where I vaguely knew the former station to be located. Enquiries about its exact whereabouts met blank looks. Finally, an assistant in the Padstow Bookseller bookshop pointed the way, adding that the building now houses the offices of Padstow Council and the town museum.

It's quite surprising that it has not become a Rick Stein fish eatery, because there are five of those in the town – enough for Padstow to be known as 'Padstein'. If Stein is the face of Padstow post-railway, its railway-era face is John Betjeman, who was open to the same accusation levelled at Stein: that he was an incomer and not a native Cornishman (Betjeman holidayed in Trebetherick, Cornwall, as a boy and acquired a second home there, in which he died in 1984), but it never was levelled at Betjeman. Of his many hymns to Cornwall, one of the best-known is his essay of 1952, 'Padstow'. To make sense of it, some historical perspective is needed.

Padstow was an isolated fishing village when the LSWR – which refused to concede the whole of the West Country to the GWR – aspired to reach it and other spots in North Cornwall. It did so via a protégé line, the North Cornwall Railway, which by 1899 spanned the 45 miles from the LSWR's station at Halwill Junction in Devon to Padstow via Launceston and Wadebridge, a harbour town on the river Camel, 5 miles upstream from Padstow. Wadebridge was also served by a connection to Bodmin, which lay to the south, the LSWR having acquired the isolated Bodmin & Wadebridge Railway

The railway set-up at Padstow, with the South
Western Hotel trying to get in on the act.

in 1846. When, in an outbreak of friendly relations, the GWR
also connected to Bodmin from the Great Western main line
in 1887, the chocolate and cream of its carriages would be
seen running through to Padstow alongside the salmon and
brown of the LSWR.

A postcard dating from about 1920 shows everything in
place. The small, stone station with its single platform; the
siding connecting to the harbour opposite, with the wooden
shed for the transfer of fish from boat to train. (Fish to
London was the main inter-war freight traffic, along with
other perishable foodstuffs carried on the daily 'Up-perisher'.)
Looming over the scene is an austere gothic building on a
nearby hill. This was called at the time the South Western
Hotel, which suggests it was an LSWR railway hotel, but
it wasn't. It was built quite independently by a local ship-
owner, John Cory. In the early 1930s it became the Metropole
Hotel, emphasising the connection to London. The hotel is

artistically done out today, and seems full of sunlight, belying its grey exterior. In the lobby there are racks of inverted, expensive Hunter-brand wellington boots, with the injunction 'Explore the Shore', there being no beach at Padstow. In the 1920s and 1930s the holiday passenger traffic ran the fish a close second, and Padstow was one of the many destinations served by the *Atlantic Coast Express* of the Southern Railway. It was probably by this train that John Betjeman usually reached Padstow.

'Launceston, Egloskerry, Otterham, Tresmeer, Camelford – and so on, down that windy line. I know the stations by heart'. He gets them in the wrong order, since Tresmeer came before Otterham when heading west, but he makes us 'see' those stations lying north of Bodmin Moor, with their 'slate- and granite-built waiting rooms, the oil lamps and veronica bushes'. The train enters the 'flat marsh' of the Camel and comes to Wadebridge. The 5 miles between it and Padstow provided Betjeman with 'the most beautiful train journey I know … See it on a fine evening at high tide with golden light on the low hills, the heron-haunted mud coves flooded over, the sudden thunder as we cross the bridge over Little Petherick creek.'

He describes Padstow as 'a fishing port and a shopping centre' and 'less touristy' than St Ives, but when he wrote his essay the fishing was in decline, and in 1959 the fish dock would be cut off from the station. Betjeman's essay shows no foreshadowing of the railway's doom. He says he can reach Padstow 'any day from Waterloo', even though Cornwall is 'another country', and it's surprising, from today's perspective, that Waterloo ever did send trains that far.[16] Waterloo is the only London main line terminus not to have a hotel of its own, and its association with clerkly nine-to-five is symbolised by its Underground connection to Bank.

Today a car park stands on the land between the station and the waterside. The fish shed survived until 2000, when it was being used for cycle hire. The old trackbed into Bodmin from the direction of Wadebridge is now the Camel Cycle Trail, and being near the old station on a sunny day is like being a spectator at the end of a cycle race. People come hurtling along the west bank of the estuary, to alight triumphantly, high-fiving their mates with cries of 'We did it!' etc., before returning their bikes to the several hire places. In the literature about the Camel Trail there is never any mention that it was once a railway line, but that's all right, I suppose, a bike lane being the next best thing.

Will the railway ever come back to Padstow? It might come near.

The Bodmin Railway is a heritage line based at the old GWR station in Bodmin, Bodmin General. Its line runs from Bodmin Parkway on the Cornish Main Line via Bodmin General to Boscarne Junction, an obscure terminus, as even the Bodmin Railway's spokesman, Jimmy James, admits. 'At the moment, we're a railway to nowhere, but it's always been our aspiration to connect our line back to Wadebridge.' This would involve an extension of 4½ miles, which was costed before Covid at a million pounds a mile, a sum unaffordable by the railway.

The restored line would also have to run alongside the cyclists of the Camel Trail whose operator Sustrans is, says Jimmy James, 'not impressed' with the railway's plan. He doesn't think it will come to fruition in his lifetime, but he makes an excellent case for it. The line would reconnect Wadebridge (faded since it lost its railway) to the Cornish Main line, and since Wadebridge is only 4 miles from Padstow, a park-and-ride could ease the 'awful' summer road traffic to that town.

LEVEN (AND THE JOURNEY BACK)

In late June of 2024, I downloaded a map of the ScotRail network. On it I saw a short branch line running from Thornton on the Fife Circle Line to Leven in East Fife, with nothing to suggest it hadn't been there for 150 years or so. In fact, the line had reopened only three weeks beforehand.

In 1861 the Leven Railway merged with the East of Fife Railway to form the Leven & East of Fife Railway, running from Thornton Junction to Kilconquhar. These, absorbed by the North British Railway in 1877, became part of what was known as the Fife Coast Line when, in 1887, they were joined to the Anstruther & St Andrews Railway. The result was a line that roughly followed the outline of the Fife peninsula. In the late 1960s the stretch from Leven around to St Andrews (the majority of the line) fell to Beeching's axe. Levenmouth, the conurbation around the seaside town of Leven, was left as the largest area in Scotland without a railway, and people without private transport were deprived of the chance to experience the beauty of coastal East Fife, with its cobbled streets, rocky bays, quaint harbours and pastel-coloured houses. (Think Cornwall, but with an even colder sea.)

<p style="text-align:center">★</p>

Leven, Largo and Ellie had become established watering places by the 1840s, and the new railway made them even better established. In his book about the Fife Coast Line, James K. Corstorphine quotes from a work of the 1860s, *Handy Book of the Fife Coast*, by Henry Farnie:

> Here you see, in a crazy boat, some learned professor in company with an old fisherman, casting their lines in Largo Bay, eager in quest of flounders – there you see a venerable judge in fierce contest with a crab, which he is endeavouring with his silver-headed cane to wrench for its 'coy abode'.[1]

The Fife Coast Line was at its busiest during the Glasgow and Edinburgh trades holidays, when businesses closed and workers decamped either west to the Firth of Clyde and the Ayrshire Coast, or east to Fife. In 1910 the summer-only *Fife Coast Express* was inaugurated, running between Glasgow and Crail, a seaside town east of Leven. The 'down' service ran on late Friday afternoons, the 'up' on early Monday morning, enabling use of second homes by Glasgow businessmen. After the war the train, which lasted in mutating forms until 1959, comprised the luxurious, streamlined carriages formerly used on the LNER's *Silver Jubilee* express.

In the 1930s the LNER closed the four inland stations between Crail and St Andrews, but the coastal holiday trade was still good. In the summers of the late 1930s between twenty and thirty special trains a day ran into Leven, mainly from Glasgow. The line was also much used for shopping expeditions, north to Dundee or west to Edinburgh. There is the story of the suave gent who assisted an elderly lady to disembark with her Edinburgh purchases at St Monance. She thanked him profusely. 'Don't mention it,' he said.

'Wha me?' said the woman, 'Ah'll no tell a sowell.'

Another book about the line contains a charming evocation by Alan Goodwillie (a young trainspotter in the 1950s) of Leven station in the summers of that decade. The main station building incorporated the station master's house and a John Menzies bookstall, frequented by people looking for a beach read who were not necessarily intending to catch a train. People also dropped in for a drink from the drinking fountain, using the chained iron cup that lent a metallic taste to the cold water, or just for a sit down on the cast-iron platform benches. In a siding off the 'Up' platform stood a couple of ancient four-wheeled wagons full of gardening equipment for the tending of the station gardens and flower displays. 'The garden and benches formed a real suntrap,' Goodwillie recalled, 'and it was very pleasant to sit on a summer's day between trains and listen to the rail's "crunk" as they expanded in their chairs. The heat would also bring out the smell of creosoted sleepers to the nostrils, mixed with the scent of geraniums and other flowers from the station gardens.'[2] (All the stations on the line were noted for their floral displays, and it is a fitting, if melancholy, fact that Crail station would become a garden centre.)

The herring fishing was declining from the 1940s, and in the 1960s services dwindled back to the number of the 1860s. Along came Beeching, to inflict his usual trauma. There was much local anger when the plan to close the stations between Leven and St Andrews was announced.

On the early evening of Sunday, 5 September 1965, the last train between Crail and Leven ran from the former to the latter. Such was the demand that single tickets ran out, so some people were sold returns, even though there would be no return train. There was also disappointment that the last service was a DMU, and not a 'real' train, such as one hauled

by a Thompson B1 Class, the LNER workhorses associated with the line.

The locals were led to believe that Leven and St Andrews stations would remain open as railheads for East Fife, but St Andrews station closed on 4 January 1969. The last passenger train north to Leuchars departed at 22.30; on the journey, the communication cord was pulled five times in protest. On 15 January, a public meeting was held at Scoonie Hall, Leven, to demand that the town's station be kept open, Leven having been designated a special development district by the County Council. The town also relied on the line for tourism and commuting to Edinburgh. One protester said he would be unable to read the *Scotsman* on a bus, owing to restricted elbow room: in future he would be forced to buy the tabloid *Daily Record*. Nonetheless, the last passenger train left Leven at 8.25 in the evening on Saturday, 4 October. The line would continue to be used for occasional freight trains until 2001, but Leven station was demolished in 1973.

A campaign to restore passenger services began almost immediately, and came to fruition in the early summer of 2024. The restored 5-mile line, funded by the Scottish Government, reconnects Leven to Thornton via a new station at Cameron Bridge, with provision for eventual electrification. The new Leven station is utilitarian but prettily located next to the Leven River. Of the reopening, Dr Allen Armstrong, chair of the Levenmouth Rail Campaign, said, 'Levenmouth is back on the map and regeneration prospects aided by other projects in the pipeline are brighter now.'

There is now an hourly service to Edinburgh Waverley, where in June 2024 ScotRail handed out sticks of rock, by way of urging people to rediscover Leven as a holiday destination.

★

The journey back.

In the days before seaside resorts needed to be revived, people would more likely have carried a stick of rock on the journey back than the journey there – and they might not have had the heart to eat it. Sticks of rock don't taste the same inland, and the journey was usually, if not quite always, a sullen affair.

My screensaver during the writing of this book was *The*

Terminus, a painting of 1925 by Stanhope Forbes, founder of the Newlyn art colony in Cornwall. It shows a train about to leave Penzance station. The bustling scene is viewed from a high perspective: the second storey, perhaps, of the granite building created for the station by the GWR when it took it over from the West Cornwall Railway in 1876. It's a golden summer's evening, judging by the light beyond the station mouth, and the time shown by the station clock: 5.25.

A train on the 'Up' platform is being boarded – a London train, going by the well-heeled look of the passengers. One man holds a golf bag, but most don't carry luggage; the porters are dealing with that. My eye is always drawn to the back of a woman in an orange coat with white trim: she seems to signify the vivid colour of Cornwall in summer. The station bookstall, below the clock, is doing good business. No doubt there would have been copies of the GWR book, *Through the Window*, describing the sights to be seen between Paddington and Penzance, since it had been published only the year before, but since these people were travelling *from* Penzance, they'd have to read the book in reverse. Even though this is a departure scene, it is not melancholic. The people depicted seem to be old Cornwall hands; they will be back next summer, if not before, and similarly prosperous-looking types are waiting on the opposite platform to greet new arrivals.

But that's the exception. The journey back is more often a depressing chore, preceded by a period of penance, in which the seaside town might be experienced for a few last moments, under the oppression of everything having been packed away and the clock ticking down to train time. *Lewis Carroll: Interviews and Recollections* includes the following reminiscence from a woman who'd visited Eastbourne as a girl in the late 1870s.

On the last day of the holiday, everything was packed up, but we were allowed to go to the beach for a last paddle. I walked along a breakwater, fell in, and was soaked to the skin! Returning home along the beach, dripping wet, I came across my sister Mabel, sitting by a strange, elderly gentleman, who was making a pencil sketch of her in his notebook. Mr Dodgson, for it was he, looked me gravely up and down, and then tore a corner of blotting paper from his notebook and said, 'May I offer you this to blot yourself up with?'[3]

Stanley Broadwell, a regular correspondent of mine on railway topics, remembers that, whereas the journeys from Hull to Bridlington for the annual holiday 'would pass by in a flash of sweets, comics etc. and Dad calculating the speed of the train using his watch and listening to the "clicketty-clack" of the old style rails', the journey back seemed prolonged, 'the train always seeming half empty, the seats covered in sand, the refreshment car closed and bored staff.' Broadwell prompts the thought that a train journey back from the seaside might have been more irksome than a car journey back: in a car, you can at least experience your grief at the holiday's end in private.

A traveller returning from holiday might be somewhat consoled by having bought some souvenirs. These were often available in stations, and Arnold Bennett makes something of this conjunction in his novel *The Card*. Denry Machin, a young man on the make, holidays in Llandudno with two young women, Nellie and Ruth, the latter being his 'intended'. The women are leaving Llandudno before Denry, and he accompanies them to the station:

In a few minutes the bookstall on the platform attracted

them as inevitably as a prone horse attracts a crowd ...
Mixed up with papers and sixpenny novels on the book-
stall were a number of souvenirs of Llandudno – paper
knives, pens, paperweights, watch cases, pen cases, all
in light wood or glass, and ornamented with coloured
views of Llandudno, and also the word 'Llandudno' in
large German capitals, so that mistakes might not arise.

Denry breaks up with Ruth over her suggestion that he
buy her a crystal paperweight featuring a view of the Great
Orme, the headland north of Llandudno.

In *Worktowners at Blackpool*, one of Mass-Observation's
'Observers' notes that 'Gathering souvenirs eases the tran-
sition back to Worktown.' He then describes the 'trek to
the station' on the Saturday after the holiday began: the fear
of missing the appointed train back, and a general anxiety.
'There is no singing or loud talking in the waiting crowd.'
'The main contrast between arrivers and departers appears
to be that arrivers make loud noises,' another Observer
notes; 'departers don't.' There is also a greater conscious-
ness of time among the leavers. 'It will soon be over now'
is a repeated refrain. Some women were anxious about
being in the same carriage as drunken men, who had not
been so concerned about missing their train to desist from
calling into the many pubs on the way to Blackpool's two
principal stations. 'A study of thirty groups leaving the sands
showed that twenty-seven of them called in a pub between
the Central Pier and New Inn,' the latter being the Central
Hotel & New Inn, which was located next to Central station
– close enough to have fallen to the wrecking ball when the
station did. (One of the bars from the New Inn is now the
bar in the Grand Theatre, Blackpool.) Not surprisingly, in
view of the foregoing, the station lavatory was often a calling

point on the way to the train. Observer himself was 'bursting for a pee' on the train back to 'Worktown' (Bolton) and, since there was no urinal on the train, he discreetly relieved himself into his trousers.

On arrival at Worktown, Observer tried to locate his ticket as he approached the barrier. Eventually he found it, 'wet through and in a little ball ... I handed it to the collector and told him that I was sorry but I had to piss in my pants and he had quite a laugh about it.' [4]

That anecdote came to mind on one of my own recent return journeys from Blackpool North. It seemed most of the crowd kept waiting in the station concourse had been doing what most people in Blackpool do on a sunny summer's afternoon: 'luggage', for some of them, was a six-pack of beer. A violent game of British Bulldog was underway at one end; loud conflicting music played from two boom boxes. When we were finally allowed onto the train, a four-car EMU, the guard was reciting the list of calling points. The train was for York, via Poulton-le-Fylde, Preston, Blackburn, Accrington, Burnley Manchester Road, Hebden Bridge, Mytholmroyd, Sowerby Bridge, Halifax, Bradford Interchange, New Pudsey, Leeds, Garforth, Church Fenton. Then came the punchline: 'Toilet facilities will be unavailable for the full duration of this journey.' The usual 'Sorry for the inconvenience' was not uttered, possibly because it would have sounded too much like the guard was 'having a laugh'. I was getting off at Preston, but the journey to York would take two hours, forty-three minutes, so it was understandable that one young woman, spokesperson for a whole carriage of same, politely raised her hand as the guard walked past to enquire: 'Can you not wait for us if we go to the loo at a station on the way?' He entered into a quiet negotiation with them that was still ongoing as I disembarked at Preston.

Many British people old enough to have experienced the last years of the seaside's golden age – the 1960s and 1970s – would have taken a momentous train journey back: the last return they would ever make from a proper seaside holiday as opposed to a daytrip or weekend break. They might not have known it, but they were about to fall prey to the seductive images of aeroplanes in pastel blue skies displayed in the window of the local travel agent, perhaps along with a model plane, tilted at the aspirational angle of take-off and with brochures for 'the Continent' fanned out below.

In recent years – recent decades, even – there has been a modest reaction against the idea that 'holiday' equates with 'abroad'. Travis Elborough dates this to the first airing of the BBC show *Coast* in 2005:

> From Bournemouth to Broadstairs and Blackpool to Southend, soon no resort worth its (sea) salt was without its gastro-eateries or luxury boutique hotels. Art Deco wrecks like the Midland in Morecambe and the De La Warr Pavilion in Bexhill were restored. Art festivals came to Folkestone, and contemporary galleries with swish new buildings opened at St Ives (the Tate), Eastbourne (the Towner) and were in the pipeline for Margate (the Turner Contemporary) and Hastings (the Jerwood).[5]

Since Elborough wrote that, the staycation tendency arising from Covid has boosted the seaside return. The moral pressure against flying also plays a role now, along with the global warming to which aviation contributes. A modern-day Sunny South Sam might append a footnote to his temperature league tables, noting that, while these south coast resorts are 'sunny', they are not unbearably scorching.

Nonetheless, there is a certain irony, even campness,

about the movement. For instance, the middle-class renter or owner of a house in any of the above spots might display a model sailing ship in their front window, even though the only seagoing craft they use is a lilo. Or it might be that the model ship symbolises childhood, and a return to it via the seaside, because for the baby boomers the seaside was – until they bought their Margate bolthole – a phenomenon of childhood, a prelapsarian world of small pleasures: a paddle; a starfish in a rockpool; board games in the guest house when it rained; a time when fish and chips was cheap, Blackpool was not quite as bacchanalian as it later became, and the station clock at Scarborough was illuminated throughout the night.

Trains are more innocent, and more redolent of childhood, than cars, but it seems unlikely that any seaside revival will be accompanied by a seaside train revival. Apart from Leven, we have seen only one other case of a railway to the coast definitely re-opening: at Fleetwood. (At least, it was definite until Rachel Reeves axed the 'Restoring Your Railway' fund. The project is currently 'under review'.)

As a rail fan, of course, I regret this. Trains, even Sprinters, suit seaside towns better than cars. It's cars that cause the over-tourism; railways can relieve its effects, and what looks better: railway stations and sidings, or the car parks that have so often replaced them? But must we settle for riding to the coast in modest railway and elderly railway vehicles? An article in *Rail* magazine about the rise of leisure travel and the decline of commuting since Covid compares rattly Sprinters unfavourably with BR Mark 1 carriages: 'You don't get that unholy row from the engine as it revs up prior to departure. You don't feel every rail joint.' The piece is full of wistful evocations of the trains of Switzerland: 'The regional trains, most of which are double-deck, are great for looking

at the scenery. They all have big windows and they're very comfortable.' It reiterates the vision set out in a previous *Rail* editorial: 'Ironing board seats and misaligned window seats are gone. In their place must come guard's van-style storage areas and compartments where families can be together without disturbing others.'[6]

'Forward to the past' might be the name of that vision, and if railways do become more associated with leisure and pleasure, and less with the grind of commuting, perhaps dining cars, wide windows and well-upholstered seats really will return. What seems more certain, when it comes to the seaside trains, is that the ghosts will fade: people will forget that Newquay station was once twice the size; that there was a sprawling railway complex (albeit for small trains) where the police station in Southwold now stands; that people would go to Platform 1 at Paddington at 10.30, when the *Cornish Rivera Express* departed, not necessarily to board the train but to watch it leave, while imagining the seaside it was heading towards. They will forget that the GWR was once silly, or cynical, enough to compare those places to the real Riviera, just as they will forget that the Furness Railway called Grange-over-Sands 'the Naples of the North'. To an Edwardian child the anticipation of hearing the approach of the holiday train was 'delicious', as Philip Unwin wrote, but people are now so much more mobile than they used to be, and so much more familiar with the sea, as to make such anticipation 'all but incomprehensible'. I only hope this book has made it slightly less incomprehensible.

NOTES

1 Barry McLoughlin, *Railways of Blackpool and The Fylde: Britain's Premier Resort* (Kettering, Silver Link, 1996), p. 25.
2 Jeffrey Richard and John M. Mackenzie, *The Railway Station, a Social History* (Oxford, Oxford University Press, 1986), p. 311.
3 John K. Walton, *Blackpool* (Edinburgh, Edinburgh University Press, 1998), p. 77.
4 John K. Walton, *The British Seaside: Holidays and Resorts in the Twentieth Century* (Manchester, Manchester University Press, 2000), p. 87.
5 Simon Bradley, *Bradley's Railway Guide: A Journey Through Two Centuries of British Railway History, 1825–2015* (London, Profile, 2024), pp.282–3.
6 Lorna Frost, *Railway Posters* (Oxford, Shire, 2012), p.42.
7 Michael Palin, *Happy Holidays: The Golden Age of Railway Posters* (London, Pavilion Books, 1998), p.26.
8 Ibid, p. 9.
9 Ibid, p. 9.
10 Elliot, *On and Off the Rails*, p. 23.
11 Madeleine Bunting, *The Seaside, England's Love Affair* (London, Granta, 2023), p. 5.

1. The Trains Go to the Sea
1 W. J. Gordon, *Our Home Railways: How They Began and How They Are Worked, Vol. 2* (London, Frederick Warne, 1910), p.189.
2 Mae McEwan, *Troon Memories* (Glasgow, South Ayrshire Council, 1996), p. 25.
3 John Thomas, *A Regional History of the Railways of Great*

Britain: Vol. 6, Scotland: The Lowlands and the Borders (Newton Abbot, David & Charles, 1971), p. 115.

4 Ibid, p. 45.

5 Mike Page, *In the Tracks of Railway History: A Walk along the Line of the Canterbury & Whitstable Railway* (Whitstable, Whitstable Improvement Trust, 1991), p. 21.

6 Stuart Hylton, *What the Railways Did for Us: The Making of Modern Britain* (Stroud, Amberley Publishing, 2015), p. 101.

7 Ian Carter, *Railways and Culture in Britain: The Epitome of Modernity* (Manchester, Manchester University Press, 2001), pp. 252–3.

8 Margaret Drabble, *A Writer's Britain: Landscape in Literature* (London, Thames and Hudson, 2009), p. 183.

9 Alain Corbin, *The Lure of the Sea: The Discovery of the Seaside in the Western World, 1750–1840* (London, Penguin, 1995), pp. 1–5.

10 Ibid, p. 23.

11 Ibid, p. 53.

12 Winifred Gérin, *Anne Bronte: a Biography* (London, Allen Lane, 1976), p. 307.

13 Ibid, pp. 312–14.

14 annebronte.org.

15 J. Robin Lidster in *Scarborough Railway Station: From Steam Age to Diesel Era* (Hendon, Hendon Publishing Company, 1995), p. 2.

16 Bryan Perrett, *A Sense of Style: A Brief History of the Grand Hotel, Scarborough* (Ormskirk, Hugo Press, 2005).

17 Paul Atterbury, *Tickets Please! A Nostalgic Journey Through Railway Station Life* (London, David & Charles, 2006), p.182.

18 Tom Laughton, *Pavilions by the Sea: Memoirs of an Hotel Keeper* (London, Chatto & Windus, 1977), p. 3.

19 Ibid. p. 8.

20 Lidster, *Scarborough Railway Station*, p. 39.

21 Perrett, *A Sense of Style*.

22 Travis Elborough, *Wish You Were Here: England on Sea* (London, Sceptre, 2011), p. 58.

23 Hylton, *What the Railways Did for Us*, p. 99.

24 Christian Wolmar, *Cathedrals of Steam: How London's Great Stations Were Built and How They Transformed the City* (London, Atlantic Books, 2020), pp. 172–3.

25 Alan A. Jackson, *London's Termini* (Newton Abbot, David & Charles, 1969), p. 286.

26 Anthony M. Ford, *Pullman Profile No. 4: The Brighton Belle and Southern Electric Pullmans* (Southampton, Noodle Books, 2012), p. 83.

27 Simon Jenkins, *Britain's Hundred Best Railway Stations* (London, Viking, 2017), p. 117.

28 Ford, *Pullman Profile No. 4.* p.88.

29 Elborough, *Wish You Were Here*, p. 10.

30 John K. Walton, *The British Seaside: Holidays and resorts in the twentieth century* (Manchester, Manchester University Press, 2000), p. 15.

31 Walton, *Blackpool*, p. 46.

32 Walton, *The Blackpool Landlady*, p.16.

33 Arthur and Elisabeth Jordan, *Away for The Day: The Railway Excursion in Britain, 1830 to the Present Day* (Kettering, Silver Link Publishing, 1991), p. 49.

34 Barry McLoughlin, *Railways of Blackpool & the Fylde: Britain's Premier Resort* (Kettering, The Nostalgia Collection, 1996), p. 14.

35 Gary Cross, ed., *Worktowners at Blackpool: Mass-Observation and Popular Leisure in the 1930s* (London, Routledge, 1991), p. 61.

36 Ibid, p. 62.

37 Cross, ed., *Worktowners at Blackpool*, p. 64.

38 Bunting, *The Seaside*, p. 315.

39 Jenkins, *Britain's Hundred Best Railway Stations*, p. 230.

2. Some Railway-Made Resorts

1 Hylton, *What the Railways Did for Us*, p. 101.

2 Lorna Hogger, blog.railwaymuseum.org.uk, *The Railway That Brought the Beach to Your Bathroom*, 18 July 2012.

3 Quoted in victorianlondon.org, 'Health and Hygiene – seawater bathing'.

4 Alan Dowling, *Cleethorpes: The Creation of a Seaside Resort* (Bognor Regis, Phillimore, 2008), p. 52.

5 Jordan and Jordan, *Away for the Day*, p. 59.

6 Dowling, *Cleethorpes*, p. 44.

7 Ibid, p. 103.

8 Ian Nalder, *Golf and the Railway Connection* (Newbattle, Scottish Cultural Press, 2003), p. 19.

9 Ibid, p. 119.

10 Ibid, pp. 121–2.

11 Bernard Darwin, *Golf* (London, Burke, 1954), p. 30.

12 Sidney Heath, *The Cornish Riviera* (London, Blackie, 1911), p. 7.

13 Quoted in Geoffrey Body, *Riviera Express: The Train and Its Route* (Bristol, British Rail (Western) and Avon Anglia Publications), 1979.

14 Roger Burdett Wilson, *Go Great Western: A History of GWR Publicity* (Newton Abbot, David & Charles, 1987), p. 83.

15 S. P. B. Mais, *The Cornish Riviera* (Great Western Railway, London, 1928), p. 78.

16 Sally Festing, *Barbara Hepworth: A Life of Forms* (London, Penguin, 1996), p. 142.

17 Mais, *The Cornish Riviera*, p. 7.

18 Michael Sagar-Fenton, *Penzance: The Biography* (Stroud, Amberley, 2015), p. 206.

19 Ibid, p. 211.

20 Jack Simmons, *The Express Train and Other Railway Studies* (Nairn, Thomas and Lochar, 1994), p. 66.

21 S. P. B. Mais, *The Cornish Riviera*, p. 116.

3. Some Middlemen

1 Ella Pontefract and Maria Hartley, *Yorkshire Tour* (London, Dent, 1939), p. 292.

2 Oliver Carter, *An Illustrated History of British Railway Hotels 1838–1938* (St Michael's, Silver Link, 1990), p. 37.
3 Quoted in John Christopher and Campbell McCutcheon, eds, *Bradshaw at the Seaside: Britain's Victorian Resorts* (Amberley, Stroud, 2015), p. 93.
4 Paul Fincham, *East Anglia* (London, Faber, 1976), p. 78.
5 Stanley C. Jenkins, *The Lynn & Hunstanton Railway* (Oxford, Oakwood Press, 1987), p. 5.
6 Chris Hawkins, *Great Eastern in Town and Country* (Pinner, Irwell Press, 1991), p. 16.
7 Fincham, *East Anglia*, p. 78.
8 Clement Scott, *Poppy-Land Papers*, 1886, p. 121.
9 Alwyn Turner, *Little Englanders: Britain in the Edwardian Era* (London, Profile, 2024) p. 184.
10 Malcolm R. White, *Railways of Suffolk* (Lowestoft, Coastal Publications), p. 35.
11 W.A. Dutt, *The Norfolk and Suffolk Coast* (London, T. F. Unwin, 1909), p. 308.
12 Jenkins, *The Lynn & Hunstanton Railway*, p. 50
13 Ibid., p. 134.
14 David Dunning, *Hornsea: A Reluctant Resort* (Hornsea, David Dunning, 2013).
15 Dunning, *Hornsea*, p. 59–60.
16 Ibid, p. 65.
17 Ibid, p. 80.
18 Dunning, *Hornsea*, p. 6.
19 Morton N. Cohen, ed, *Lewis Carroll, Interviews and Recollections* (London, Macmillan, 1989), p. 185.
20 Benedict Le Vay, *Britain from the Rails: A Window Gazer's Guide* (Chalfont St Peter, Bradt, 2009), p. 277.
21 Jenkins, *Britain's 100 Best Railway Stations*, p. 120.
22 John Surtees, *Eastbourne's Story* (Eastbourne, SB Publications, 2005), p. 35.
23 Steve Woods et al, *Eastbourne, All Change! 170 Years of Railway History* (Eastbourne, Eastbourne Heritage Centre, 2020).

24 Donald Thomas, *Lewis Carroll: A Portrait With Background* (London, John Murray, 1996), p. 238.

25 Paul Jordan, *Are You Being Served? Eastbourne's Department Stores Remembered* (Eastbourne, Eastbourne Heritage Centre, 2022).

26 Thomas, *Lewis Carroll*, p. 253.

27 Ibid, p. 255.

28 Woods et al, *Eastbourne All Change! 170 Years of Railway History*.

29 Surtees, *Eastbourne's Story*, p. 78.

4. The Passenger Experience

1 Alan A. Jackson, *The Middle Classes, 1900–1950* (Nairn, David St John Thomas, 1991), p. 306.

2 Ibid, p. 306.

3 'Luggage', Jack Simmons and Gordon Biddle, eds, *The Oxford Companion to British Railway History* (Oxford, Oxford University Press, 1997), p. 300.

4 Philip Unwin, *Travelling by Train in the Edwardian Age* (London, Steam Past, 1979), p. 13.

5 Kathryn Ferry, *The British Seaside Holiday* (Oxford, Shire, 2009), p. 14

6 Palin, *Happy Holidays*, p. 7.

7 Cross, *Worktowners at Blackpool*, p. 225.

8 Jackson, *The Middle Classes*, p. 307.

9 M. V. Hughes, *A London Child of the 1870s* (Oxford, Oxford University Press, 1946), p. 85.

10 Unwin, *Travelling by Train in the Edwardian Age*, p. 13.

11 John Elliot, *On and Off the Rails* (London, Steam Past, 1982), p. 27.

12 Philip Henry Goss, *Tenby: A Seaside Holiday* (London, John van Voorst, 1856), pp. 4–7.

5. Beside the Seaside

1 Baker, *Railways to the Coast*, p. 29.

2 Hughes, *A London Child of the 1870s*, p. 89.
3 Hughes, *A London Child of the 1870s*, p. 90.
4 Ivor Brown, *Summer in Scotland* (London, Collins, 1952), p. 278.
5 Bernard Darwin, from *Tee Shots and Others*, 1911, quoted in *Golf* (London, Burke, 1954), p. 31.
6 Ibid.
7 R. W. Kidner, *The Cambrian Railways* (Oxford, Oakwood Press, 1954), p. 21.
8 Darwin, *Golf*, p. 32.
9 le Vay, *Britain from the Rails*, p. 178.
10 Baker, *Railways to the Coast*, p. 166.
11 Bill Bryson, *Notes from a Small Island* (London, Doubleday, 1995), p. 196.
12 Bradley, *Bradley's Railway Guide*, p. 178.
13 le Vay, *Britain from the Rails*, p. 176.

6. Class Issues

1 Walton, *The British Seaside*, p. 4.
2 Jackson, *The Middle Classes*, pp. 298–9.
3 Jack Simmons, *The Railway in Town and Country: 1830–1914* (Newton Abbot, David and Charles, 1986), p. 244.
4 Andrew Emery, *A History of Bournemouth Seafront* (Stroud, The History Press, 2008), p. 21.
5 W. A. Hoodless, *A–Z of Bournemouth: Places, People, History* (Stroud, Amberley, 2022), 'Railway Must Be Hidden'.
6 Michael Williams, *The Trains Now Departed*, (London, Preface, 2015), p. 287.
7 Jenkins, *Britain's 100 Best Railway Stations*, p. 139.
8 Billy Butlin, *The Billy Butlin Story: A Showman to The End* (London, Robson Books, 1982), p. 20.
9 Butlin, *The Billy Butlin Story*, p. 82.
10 Butlin, *The Billy Butlin Story*, pp. 84–85.
11 Lucinda Gosling, *Country Life*, 6 August 1921.

12 David Cuppleditch, *The John Hassall Lifestyle* (Witham, Dilke Press, 1979), p. 119.

13 Colin Ward and Dennis Hardy, *Goodnight Campers! The History of the British Holiday Camp* (London and New York, Mansell, 1986), p. 63.

14 Kathryn Ferry, *Holiday Camps* (Oxford, Shire, 2011), p. 55.

15 Elborough, *Wish You Were Here*, p. 153.

16 Malcolm Barker, *The Golden Age of the Yorkshire Seaside* (Ilkley, Great Northern Books, 2002), p. 17.

17 Butlin, *The Billy Butlin Story*, p. 243.

18 Glenys Hitchings and Del Styan, *Railways of Cromer* (Cromer, Cromer Museum, n.d.), p. 9.

19 Clement Scott, *Poppy-Land Papers* (Carson and Comeford, 1886), p.79.

20 Hitchings and Styan, *Railways of Cromer*, p. 12.

21 Ibid.

22 Paul Theroux, *The Kingdom by The Sea: A Journey Around the Coast of Britain* (London, Hamish Hamilton, 1983) p. 7.

23 Charles Graves, *And the Greeks*, p. 199.

24 Matthew Hollis, *The Waste Land: A Biography of a Poem* (London, Faber 2022), p. 290.

25 Jenkins, *Britain's 100 Best Railway Stations*, p. 123.

26 John Betjeman, *London's Historic Railway Stations* (Harrow, Capital Transport, 1972), p. 36.

27 John Betjeman, *Thank God It's Sunday* (TV film), 1972.

28 Oliver Green, *Discovering London's Railway Stations* (Shire, Oxford, 2010), p.67.

29 Betjeman, *London's Historic Railway Stations*, p. 35.

30 Charles Chaplin, *My Autobiography* (London, The Bodley Head, 1964), pp. 17–18.

31 Ibid.

32 Tim Burrows, *The Invention of Essex: The Making of an English County* (London, Profile, 2024), pp. 53–54.

33 Ibid, p. 83.

34 Ferry, *The British Seaside Holiday*, p. 27.

35 Burrows, *The Invention of Essex*, pp. 55–56.
36 Kathryn Ferry, *Seaside 100: The History of the British Seaside in 100 Objects* (London, Unicorn, 2020), p. 140.
37 Stan Lockwood, *Char-a-Bancs and Coaches* (London, Marshall Harris & Baldwin, n.d.).
38 Ibid.
39 Charles Graves, *And the Greeks*, pp. 191–3.
40 Burrows, *The Invention of Essex*, p. 55.
41 Ibid, p. 62.

7. The Connections Are Lost

1 Theroux, *The Kingdom by The Sea*, p. 294.
2 Richard Faulkner and Chris Austin, *Holding the Line: How Britain's Railways Were Saved* (Hersham, Oxford Publishing, 2012), p. 10.
3 colonelstephenssociety.co.uk.
4 John Scott-Morgan, *Railways of Arcadia*, (Bromley, P. E. Waters and Associates, 1989), p. 94.
5 Paul Brown, *The Fighting Branch: The Wivenhoe and Brightlingsea Railway Line 1866–1964* (Colchester, Scribe Publishing, 1975), p. 4.
6 Anon, *Hints for Holidays* (London, Southern Railway), p. 720.
7 Faulkner and Austin, *Holding the Line*, p. 41.
8 Theroux, *The Kingdom by The Sea*, p.73.
9 John Scott-Morgan, *The Hayling Island Branch* (Barnsley, Pen & Sword, 2019), p. 294.
10 Henry James, 'English Vignettes', *English Hours* (James R. Osgood and Co., 1875), pp. 251–2.
11 Michael Robbins, *The Isle of Wight Railways* (South Godstone, Oakwood Press, 1953), p. 20.
12 Philip Norman, *Babycham Night* (London, Macmillan, 2003), p. 4.
13 Norman, *Babycham Night*, pp. 5–7.
14 Walton, *The British Seaside*, p. 82.
15 James, *English Hours*, p.252.

16 Betjeman, 'Padstow', *First and Last Loves*, p. 217.

Leven (and the Journey Back)
1 James K. Corstorphine, *East of Thornton Junction: The Story of the Fife Coast Line* (Lower Largo, Wast-By Books, 1995), p. 40.
2 Andrew Hajducki, Mike Jodeluk and Alan Simpson, *The Leven and East of Fife Railway* (Usk, Oakwood Press, 2013), p. 299.
3 Cohen, ed, *Lewis Carroll, Interviews and Recollections*, p. 204.
4 Cross, *Worktowners at Blackpool*, pp. 224–5.
5 Elborough, *Wish You Were Here*, p. 19.
6 Richard Foster, *Rail*, 21 August–3 September 2024, 'Cultivating the Growth in Leisure Travel'.

ACKNOWLEDGEMENTS

I would like to thank, in no particular order, the following: Wendy and John Trevitt and Geoffrey Scargill, residents, and historians, of Cleethorpes; all at No.1 Pub, on Cleethorpes station; Anna Murphy of Grimsby Library; John Bennett and Oliver Densham of the Southwold Railway Trust; Stephen Bigg and Robert Sharp of the Bluebell Railway; Bob Clifford of the Colonel Stephens Railway Museum, Tenterden; Graham Aiken, of the Green View guest house, Silloth; David Boyd, for information about Leven; Helen Turner, for memories of long-distance trains to the coast; Callum Duff, of the Saltburn OneFifty Plus Facebook page; Eddie Lawler, Scarborough resident; John Scott-Morgan, author of *The Light Railway: A Journey Along the Narrow and Bucolic* and many other railway books; Professor Paul Salveson, railway historian.

PICTURE CREDITS

INDEX

Index

Index

Index

Index